ROCK

THE CULTURE IN PICTURES

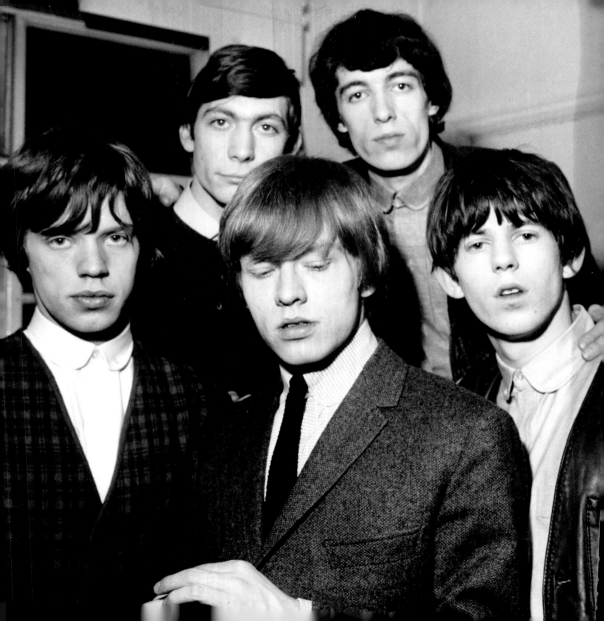

ROCK

THE CULTURE IN PICTURES

mirrorpix

AMMONITE
PRESS

First published 2012 by
Ammonite Press
an imprint of AE Publications Ltd,
166 High Street, Lewes, East Sussex, BN7 1XU

Text © AE Publications Ltd, 2012
Images © Mirrorpix, 2012
Copyright © in the work AE Publications Ltd, 2012

ISBN 978-1-907708-31-2

British Cataloguing in Publication Data. A catalogue
record of this book is available from the British Library.

Editor: Ian Penberthy
Series Editor: Richard Wiles
Picture research: Mirrorpix
Design: Gravemaker+Scott

Colour reproduction by GMC Reprographics
Printed and bound in China by C&C Offset Printing Co. Ltd

Such nice boys
Page 2: The sensational
new R&B and blues
band The Rolling
Stones, backstage
at The Great Pop Prom
at the Royal Albert
Hall, London.
15th September, 1963

Eternal rockers
Page 5: Francis Rossi
(L) and bass player
John Edwards of
boogie rock band
Status Quo, on stage at
the Clyde Auditorium,
Glasgow, Scotland.
10th October, 1999

At the mike
Page 6: U2 singer
Bono performing
with the band at the
Glastonbury Festival
in Somerset.
25th June, 2011

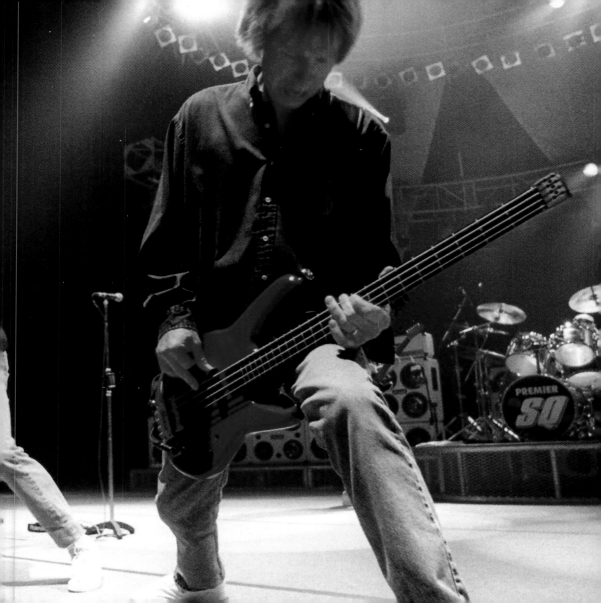

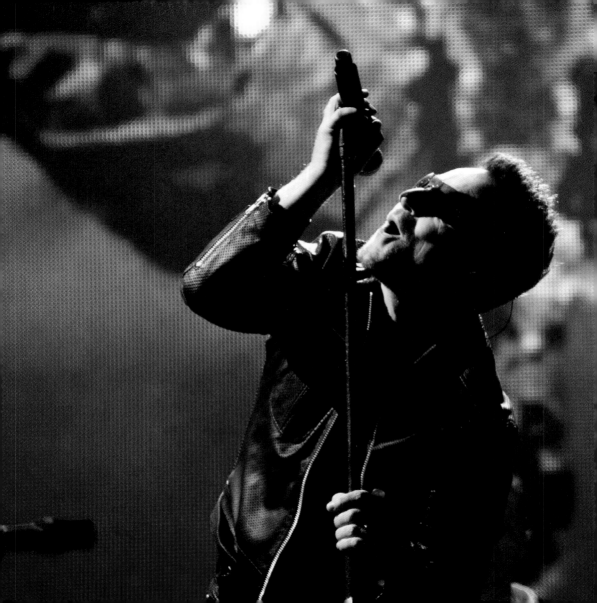

Introduction

Rock music has its roots in 1950s rock 'n' roll – itself a fairly simple genre that grew out of the southern United States and was heavily influenced by rhythm and blues and country music – but the many variations of rock also draw on elements of blues, folk, jazz and even classical music. It burst on the global scene in the early 1960s. At a time when popular rock 'n' roll artists, such as Elvis Presley and Britain's Cliff Richard, were eschewing the raw, fast-tempo music that had brought them to prominence in favour of softer, more 'middle-of-the-road' ballads, early rock musicians began introducing numbers with a harder beat and an irresistible driving rhythm, creating a distinctive sound that would develop and endure for decades.

ROCK presents a fascinating and eye-opening visual record, spanning nearly 50 years, of the multi-faceted musical genre, the original exponents of which were famous for their adoption of long hair, and 'sex, drugs and rock 'n' roll' excess.

In the pages of this book, over 300 images from the vast Mirrorpix photographic archive illustrate the world of rock music, from its beginnings in the early 1960s to the present day; from the boundary defying prog rock and hallucinogenic psychedelic rock; the outrageously camp glam rock and avant-garde poise of art rock; to the massive sound of heavy metal and the stripped-down three-chord anarchy of punk rock; by way of the vocal harmonies of folk rock and free-form improvisation of jazz rock fusion.

These images capture the atmosphere of rock gigs and arenas, at festivals and in the recording studio. News pictures expose the notoriously hard living lifestyle of rock stars – and trace their longevity into the 21st century – while portraits of band members and their families reveal the softer side of the business.

Here are the stars, the legends, the bit players and those whose careers burned brightly for but a short time before they faded into obscurity or their lives were cut cruelly short by tragic circumstance. All have had their part to play in the great, enduring story of rock music.

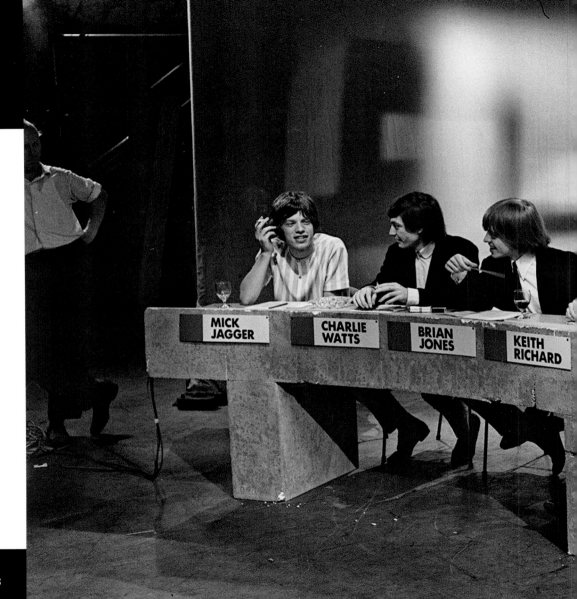

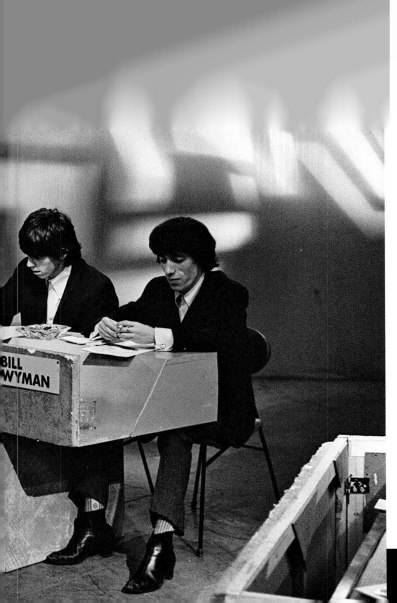

JURY SERVICE

THE ROLLING STONES AT SHEPHERD'S BUSH TV STUDIO FOR A RECORDING OF THE POPULAR SHOW *JUKE BOX JURY*. THE BEATLES HAD SERVED AS THE JURY THE YEAR BEFORE.

27th June, 1964

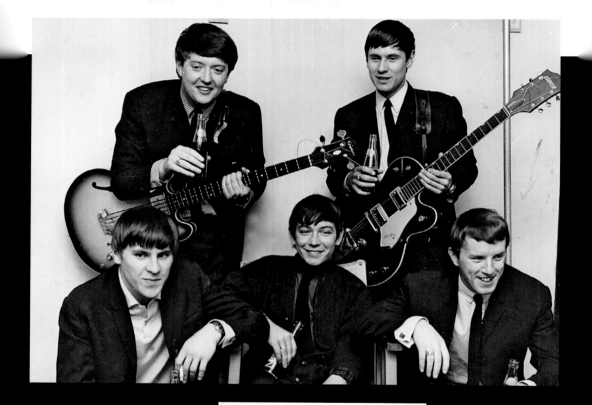

Geordie lads
The Animals, formed in Newcastle in the early 1960s, were known for their strong, bluesy sound. L–R: Alan Price (keyboards), Chas Chandler (bass), Eric Burdon (vocals), Hilton Valentine (guitar), John Steel (drums).

4th July, 1964

Blues men
Progressive rock band The Moody Blues created a fusion of rock and classical music. L–R: Clint Warwick (bass), Graeme Edge (drums), Denny Laine (lead guitar/vocals), Ray Thomas (harmonica/vocals), Mike Pinder (piano/vocals).
1965

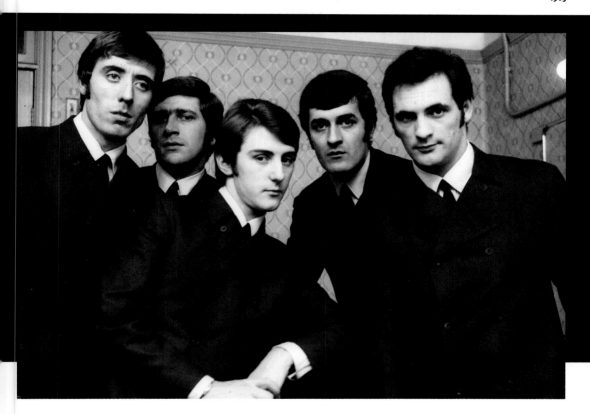

HARD OF HEARING

ROLLING STONES FANS AT STOCKTON-ON-TEES SHOW THEIR
APPRECIATION OF THE BAND.

1st September, 1964

BEFORE THE GIG

THE ROLLING STONES BACK-STAGE AT THE GREAT POP PROM, ROYAL
ALBERT HALL, LONDON, PUT ON IN AID OF THE PRINTERS PENSION
CORPORATION.

15th September, 1963

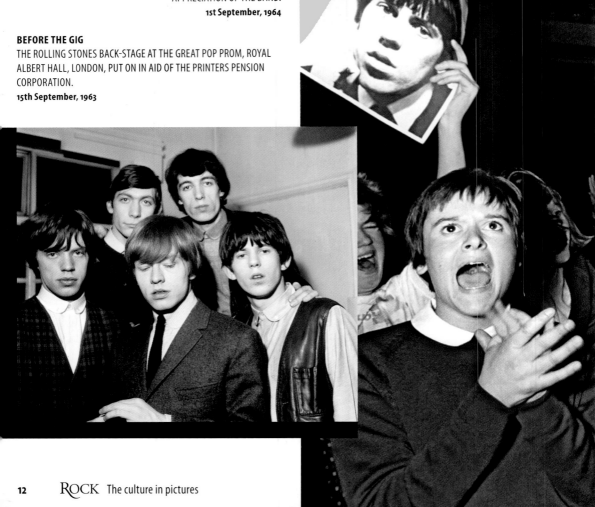

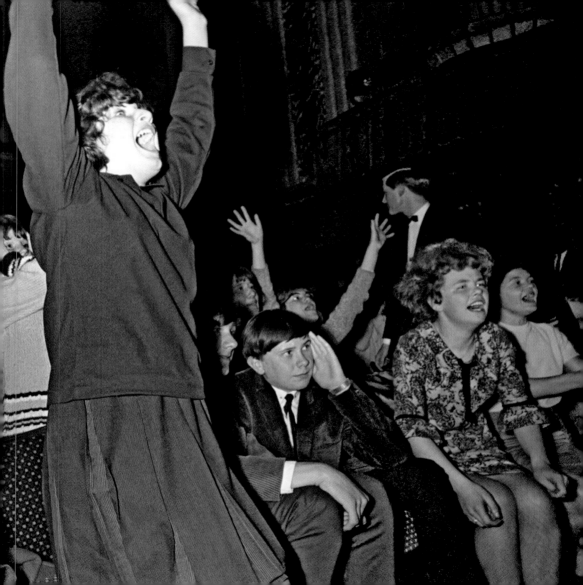

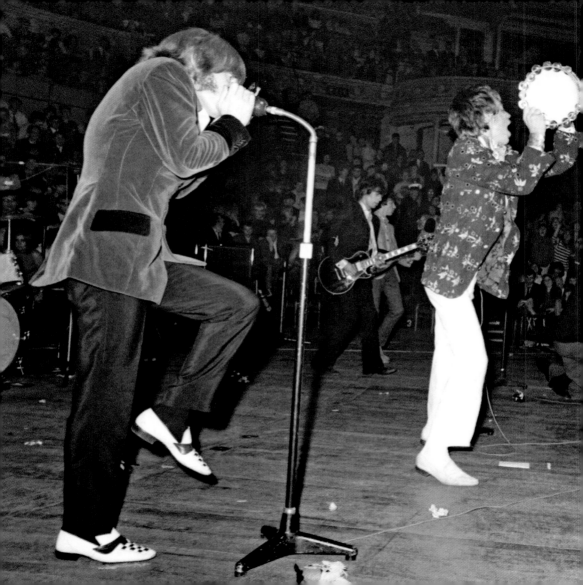

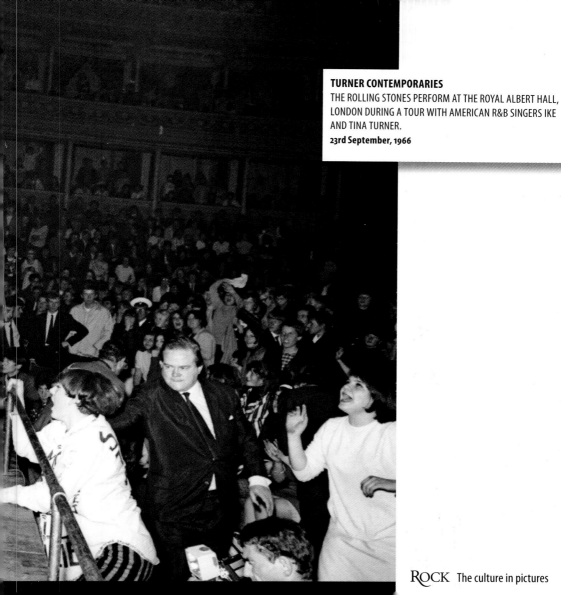

TURNER CONTEMPORARIES

THE ROLLING STONES PERFORM AT THE ROYAL ALBERT HALL, LONDON DURING A TOUR WITH AMERICAN R&B SINGERS IKE AND TINA TURNER.

23rd September, 1966

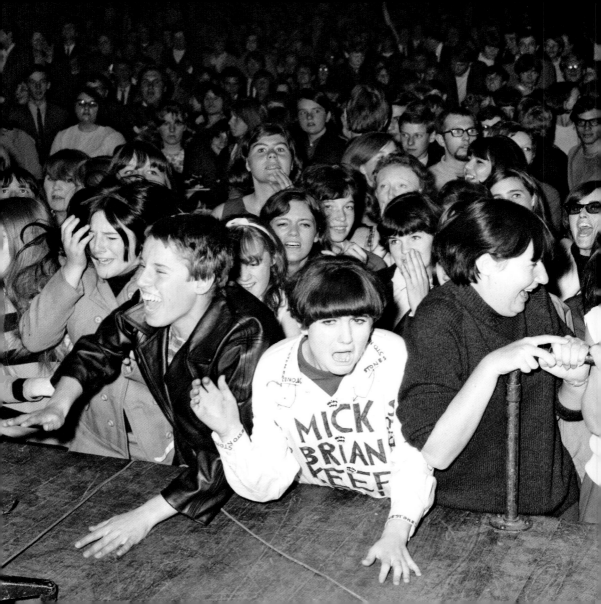

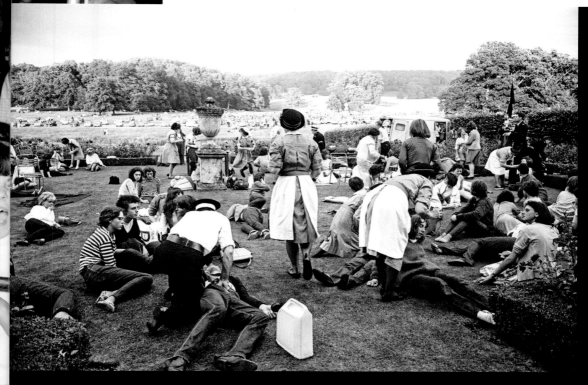

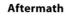

Aftermath
Above: Exhausted fans are attended to in the grounds of the Marquess of Bath's stately home, Longleat, during a Rolling Stones outdoor gig.
2nd August, 1964

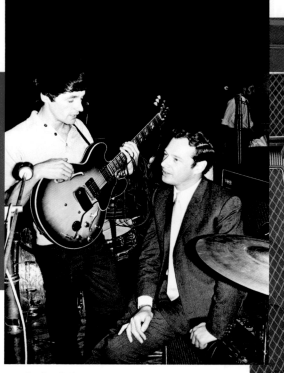

Musical soirée

Denny Laine of The Moody Blues chats with Beatles manager Brian Epstein at the Royal Festival Hall, London. The band was appearing in Epstein's Evening of Popular Music for the Commonwealth Arts Festival.

21st September, 1965

Clapton is mod

Eric Clapton of The Yardbirds talks music with Lady Willis. Lord Willis had recently denigrated mods in the House of Lords, so a group, including the band, descended on his home in Kent to try to change his mind. Although taken aback, Willis invited the mods into his home to discuss the matter and afterwards listened to an impromptu concert.

1964

Pretty boys
Above: The Pretty Things, co-founded by Dick Taylor, an early member of the Rolling Stones, and dubbed the Stones' ugly cousins by the press, (L–R) Viv Prince, John Slack, Dick Taylor, Brian Pendleton, Phil May.
24th May, 1965

Key players
Right: Hard rock band Spooky Tooth, who were unusual in adopting two keyboards (organ and piano) in their line-up.
1968

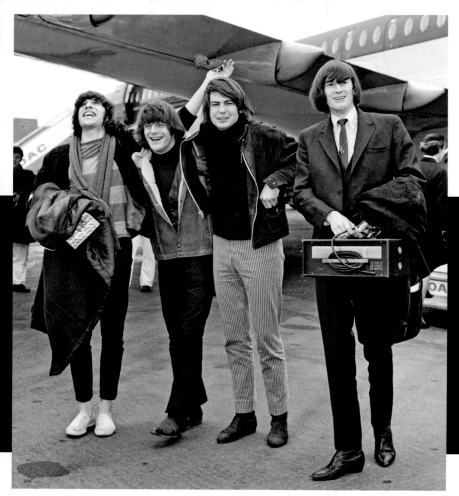

POLITICAL JOKE
RIGHT: JEREMY THORPE, AT THE TIME LIBERAL PARTY LEADER, ENJOYS A JOKE WITH JIMI HENDRIX AFTER A CONCERT AT THE ROYAL FESTIVAL HALL, LONDON. HENDRIX IS CONSIDERED TO BE THE GREATEST GUITARIST IN MUSICAL HISTORY.
25th September, 1967

TOUCHING DOWN
AMERICAN BAND THE LOVIN' SPOONFUL ARRIVE AT LONDON AIRPORT FROM NEW YORK.
13th April, 1966

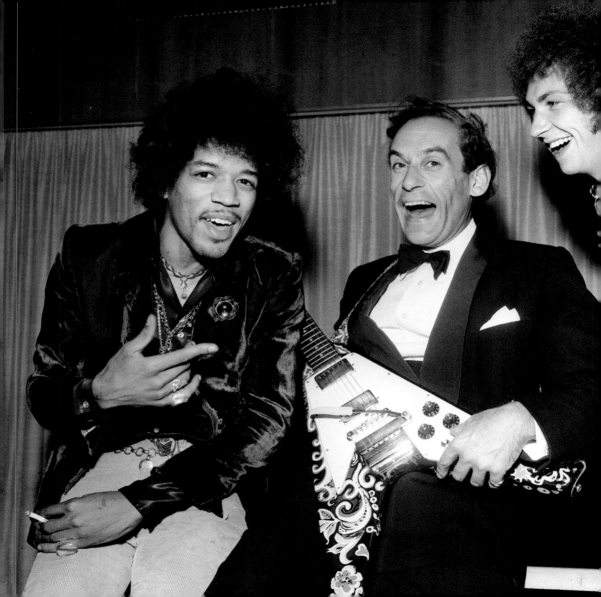

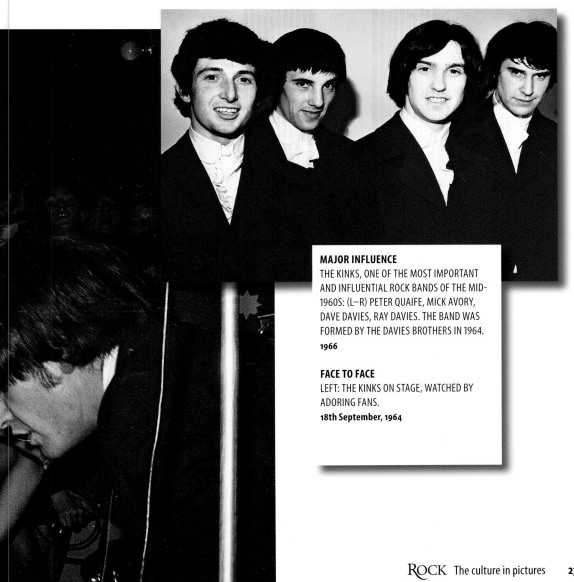

MAJOR INFLUENCE
THE KINKS, ONE OF THE MOST IMPORTANT
AND INFLUENTIAL ROCK BANDS OF THE MID-
1960S: (L–R) PETER QUAIFE, MICK AVORY,
DAVE DAVIES, RAY DAVIES. THE BAND WAS
FORMED BY THE DAVIES BROTHERS IN 1964.
1966

FACE TO FACE
LEFT: THE KINKS ON STAGE, WATCHED BY
ADORING FANS.
18th September, 1964

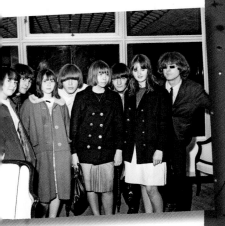

Headline act
Above: American band The Byrds press-gang four fans for a photo-op in London.
2nd August, 1965

Folk roots
Right: The Byrds on stage at The Imperial Ballroom, Nelson, Lancashire. The band had their roots in folk music.
4th August, 1965.

Popping the question
Facing page: Actress Gillian French with The Animals and her husband-to-be Michael Jeffrey (R), the band's manager, at their pre-wedding reception in Marylebone, London. By this stage, Dave Rowberry (second R) had replaced Alan Price on keyboards.
24th June, 1965

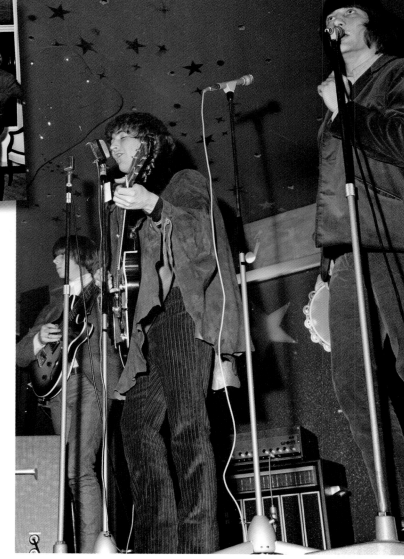

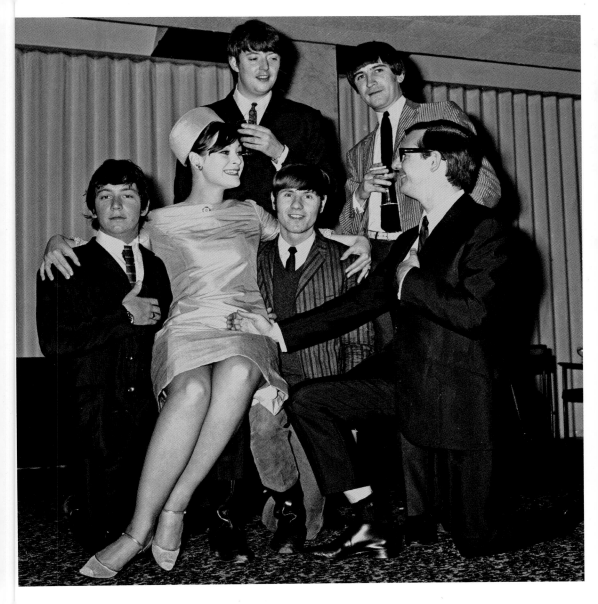

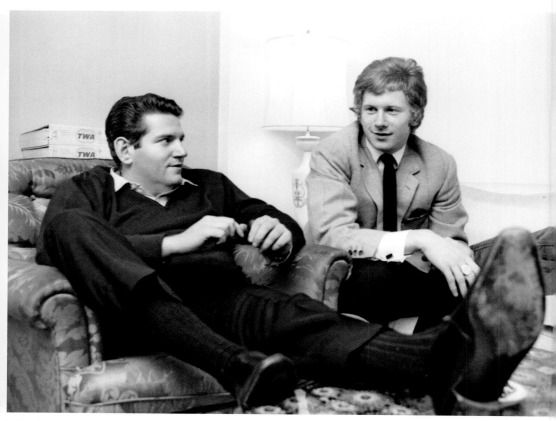

Wheeler-dealers

American businessman Allen Klein (L) and Andrew Loog Oldham, manager of the Rolling Stones, discuss Klein's involvement in the management of the band. Klein would eventually obtain the rights to most of their pre-1971 releases as a legal settlement after they fired him. Keith Richards called this "the price of an education."

24th August, 1965

ROCK The culture in pictures

Blues 'birds

Blues rock band The Yardbirds: (L–R) Chris Dreja, Jim McCarty, Keith Relf, Paul Samwell-Smith, Jeff Beck. Beck, who had replaced Eric Clapton in March, 1965, would be fired from the band in October, 1966.

24th February, 1966

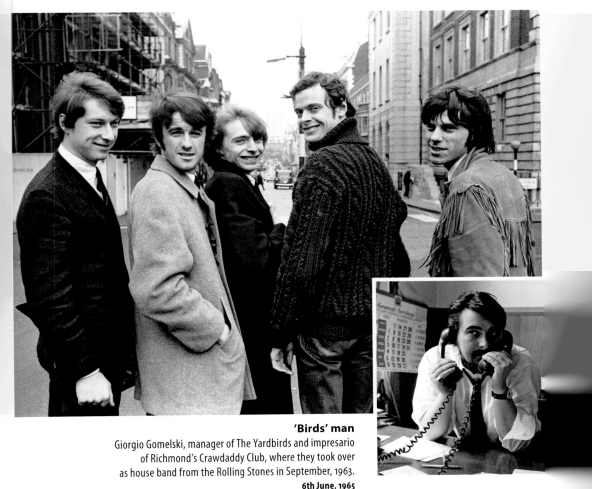

'Birds' man

Giorgio Gomelski, manager of The Yardbirds and impresario of Richmond's Crawdaddy Club, where they took over as house band from the Rolling Stones in September, 1963.

6th June, 1965

ROCK The culture in picture

Walkies in the rain
Mod band The Small Faces look bemused during a photo-op with baby alligators: (L–R) Steve Marriott, Ian McLagan, Kenney Jones, Ronnie Lane. The band produced some of the most acclaimed mod and psychedelic music of the late to mid-sixties.
18th April, 1966

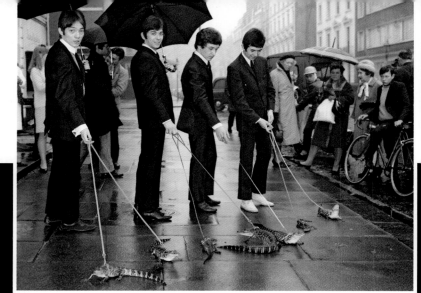

Publicity stunt
The Small Faces and model Sally Noel show off some natty outfits.
1966

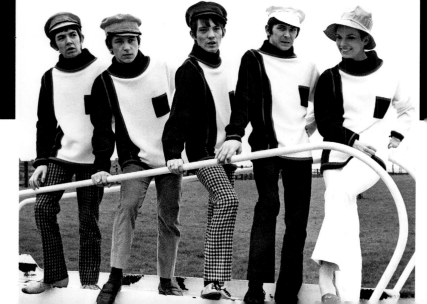

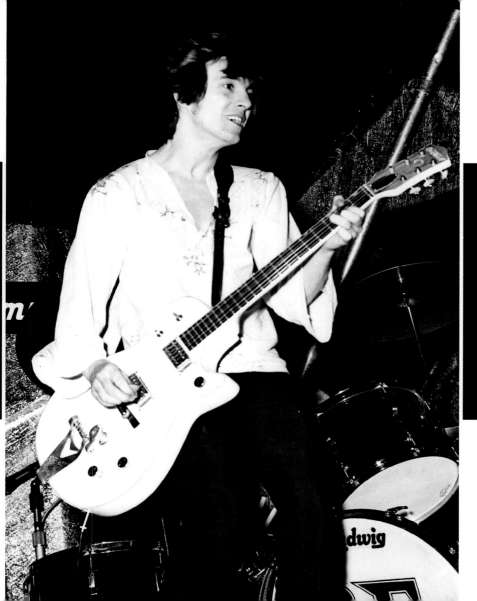

Front man
Steve Marriott,
lead singer of The
Small Faces, was
renowned for his
vocal ability.
1967

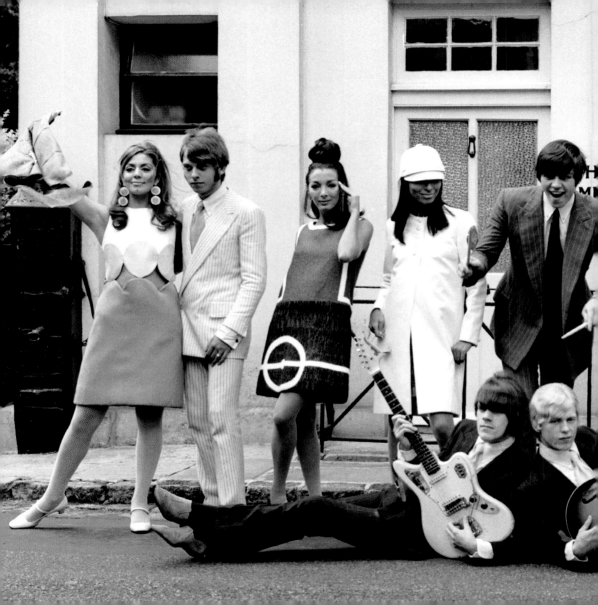

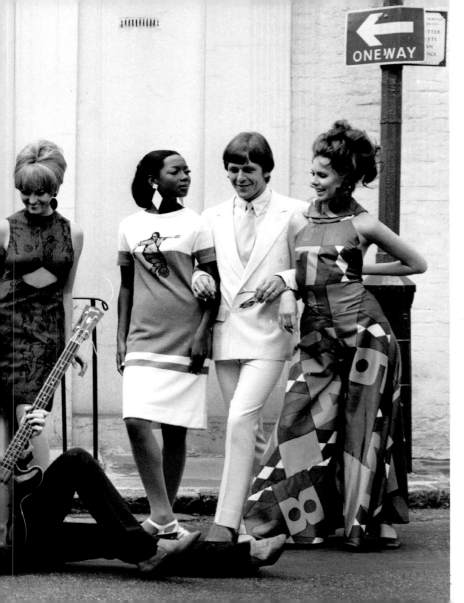

DON'T MOVE
BRAZILIAN FASHION MODELS
POSE IN LONDON WITH
MEMBERS OF THE MOVE,
WHO WERE THE RESIDENT
BAND AT THE NEARBY
MARQUEE CLUB IN WARDOUR
STREET.
19th June, 1966.

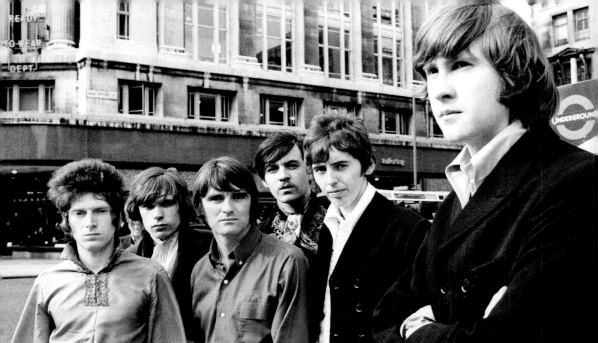

PROGRESSIVE BAND
PROCOL HARUM, WHO WOULD HELP LAY THE FOUNDATION FOR PROGRESSIVE ROCK AND SUBSEQUENTLY SYMPHONIC ROCK. THEY ARE BEST KNOWN FOR THEIR 1967 RELEASE, *A WHITER SHADE OF PALE*.
7th June, 1967

PET SOUNDS
LEFT: ROGER DALTREY, VOCALIST WITH MOD BAND THE WHO, TRIES OUT A NEW SONG ON HIS SALOUKI DOG, MOUSE.
19th September, 1966

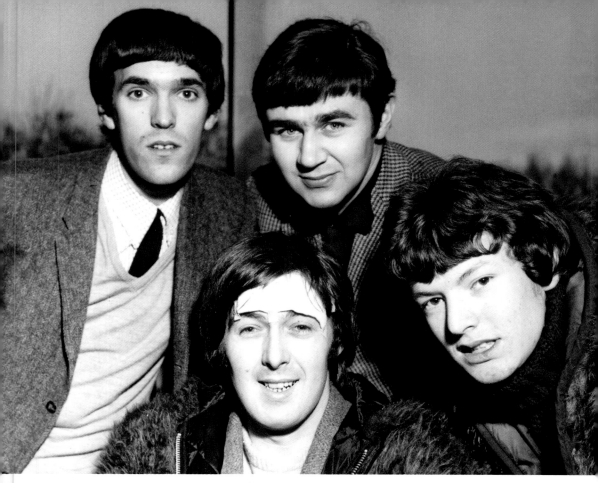

CHART TOPPERS
THE SPENCER DAVIS GROUP: (CLOCKWISE, FROM TOP L) MUFF WINWOOD, PETE YORK, STEVE WINWOOD, SPENCER DAVIS.
THE BAND HAD A UK NUMBER ONE WITH *KEEP ON RUNNING* IN LATE 1965.
10th January, 1966

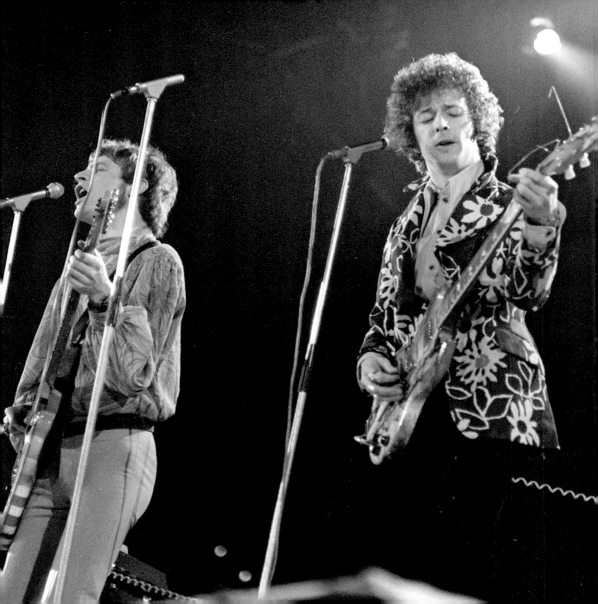

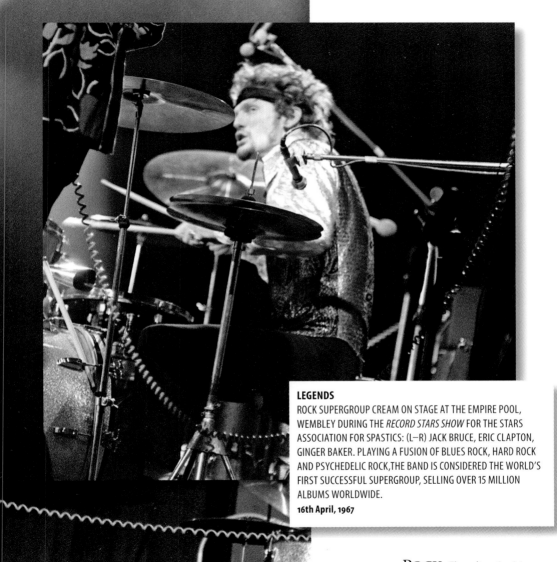

LEGENDS

ROCK SUPERGROUP CREAM ON STAGE AT THE EMPIRE POOL, WEMBLEY DURING THE *RECORD STARS SHOW* FOR THE STARS ASSOCIATION FOR SPASTICS: (L–R) JACK BRUCE, ERIC CLAPTON, GINGER BAKER. PLAYING A FUSION OF BLUES ROCK, HARD ROCK AND PSYCHEDELIC ROCK, THE BAND IS CONSIDERED THE WORLD'S FIRST SUCCESSFUL SUPERGROUP, SELLING OVER 15 MILLION ALBUMS WORLDWIDE.

16th April, 1967

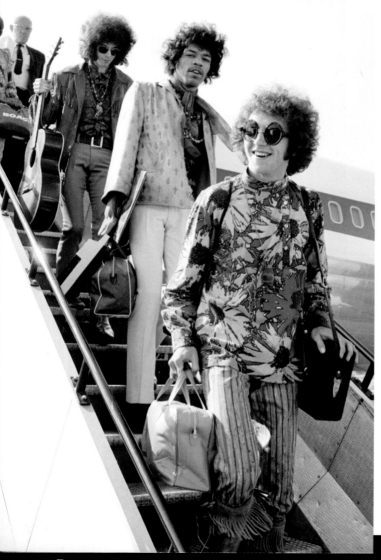
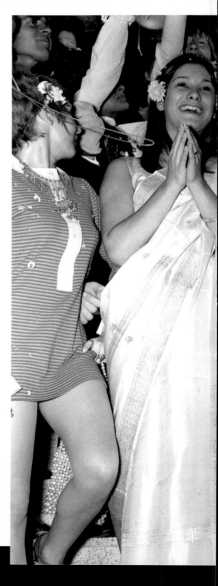

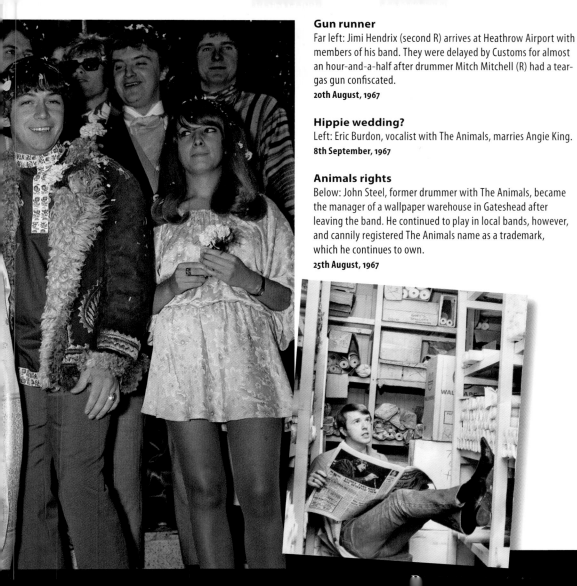

Gun runner

Far left: Jimi Hendrix (second R) arrives at Heathrow Airport with members of his band. They were delayed by Customs for almost an hour-and-a-half after drummer Mitch Mitchell (R) had a tear-gas gun confiscated.

20th August, 1967

Hippie wedding?

Left: Eric Burdon, vocalist with The Animals, marries Angie King.

8th September, 1967

Animals rights

Below: John Steel, former drummer with The Animals, became the manager of a wallpaper warehouse in Gateshead after leaving the band. He continued to play in local bands, however, and cannily registered The Animals name as a trademark, which he continues to own.

25th August, 1967

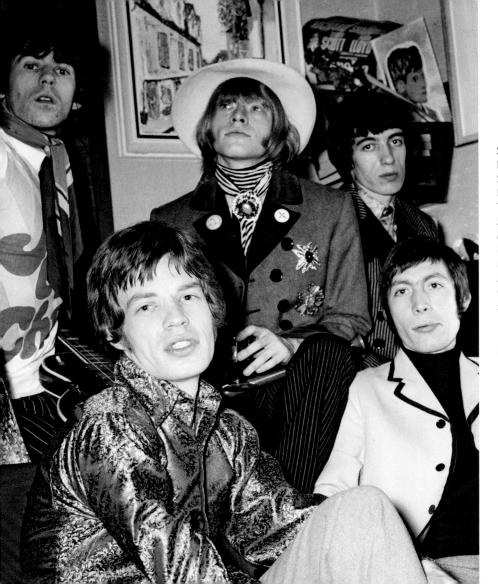

SHOWTIME
LEFT: THE ROLLING
STONES BACKSTAGE
BEFORE APPEARING ON
THE TELEVISION SHOW
*SUNDAY NIGHT AT THE
LONDON PALLADIUM*.
L–R: KEITH RICHARDS,
MICK JAGGER, BRIAN
JONES, BILL WYMAN,
CHARLIE WATTS.
22nd January, 1967

CROWD CONTROL
RIGHT: POLICE STRUGGLE
TO CONTAIN FANS AT
THE PREMIERE OF THE
BEATLES' FILM, *YELLOW
SUBMARINE*, AT THE
LONDON PAVILION.
18th July, 1968

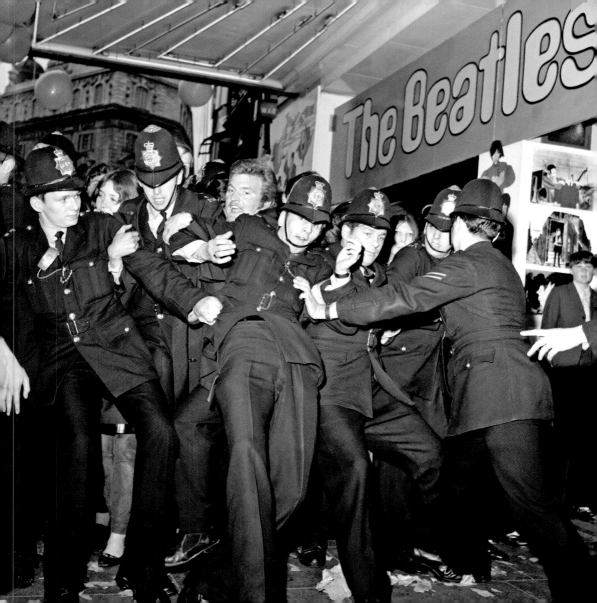

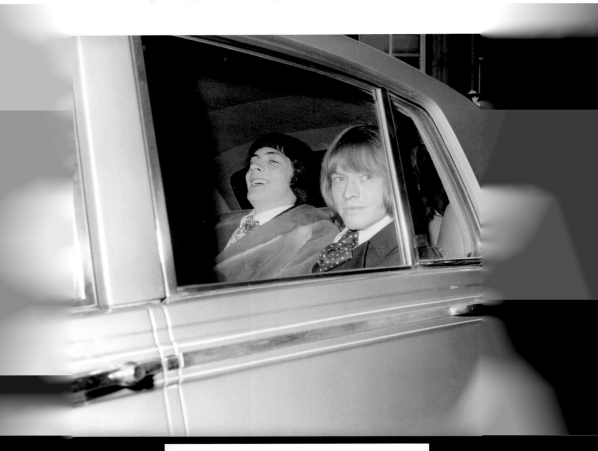

STASH 'N' HASH
ROLLING STONES GUITARIST BRIAN JONES (R) LEAVING WEST
LONDON MAGISTRATES' COURT WITH PLAYBOY PRINCE STANISLAS
KLOSSOWSKI DE ROWLA, KNOWN AS 'STASH' AND SON OF THE
ARTIST BALTHUS, AFTER BOTH WERE CHARGED WITH BEING IN
POSSESSION OF INDIAN HEMP.
11th May, 1967

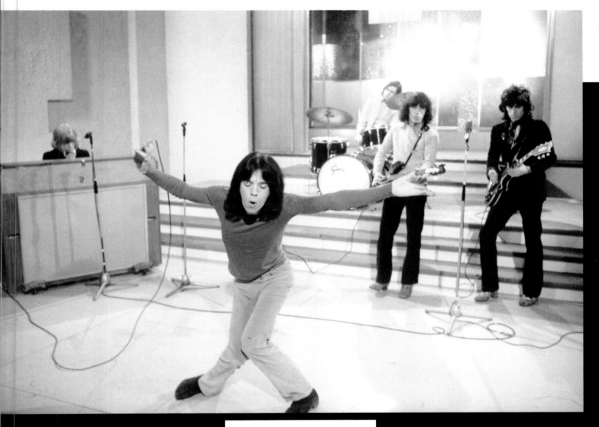

REHEARSAL TIME
THE ROLLING STONES DURING
REHEARSALS AT THE WEMBLEY
PARK STUDIOS FOR THE BAND'S
APPEARANCE ON THE *FROST ON
SATURDAY* TV SHOW.
29th November, 1968

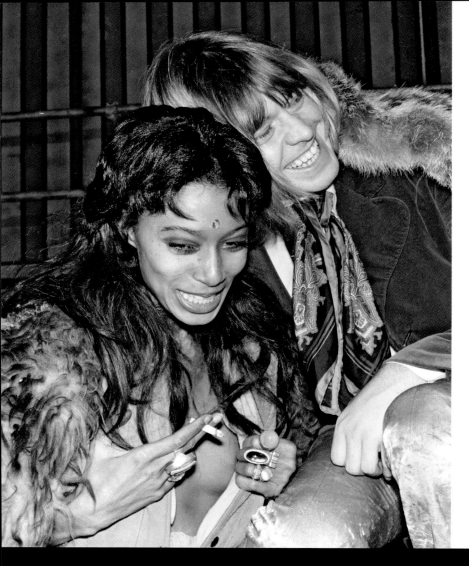

Last act
Left: Brian Jones during the filming of *The Rolling Stones' Rock 'n' Roll Circus*, which would be his final public appearance with the band. He is pictured with American model Donyale Luna.
11th December, 1968

Show bands
Right (L–R): John Lennon, Yoko Ono, Keith Richards, Mick Jagger, Charlie Watts, Brian Jones and Bill Wyman on the set of *The Rolling Stones' Rock 'n' Roll Circus* TV film. The film featured many top bands of the day playing in a big-top setting.
11th December, 1968

Fancy dressers
Bottom right (L–R): John Lennon, keyboard player Georgie Fame and Paul McCartney at a fancy-dress birthday party for Fame's girlfriend, Carmen Jiminez, at the Cromwellian Club in London.
8th January, 1967

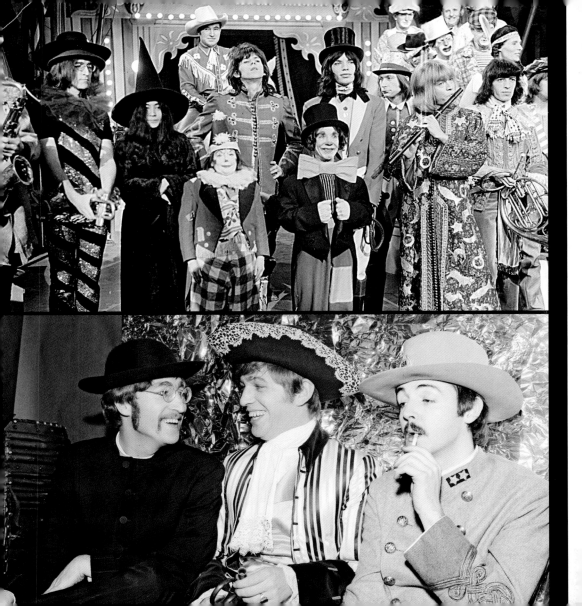

ON THE WALL
PROGRESSIVE/PSYCHEDELIC ROCK BAND PINK FLOYD, ONE OF THE MOST COMMERCIALLY SUCCESSFUL
AND INFLUENTIAL BANDS OF ALL TIME: (L–R) SYD BARRETT, RICHARD WRIGHT, ROGER WATERS, NICK MASON.
2nd September, 1967

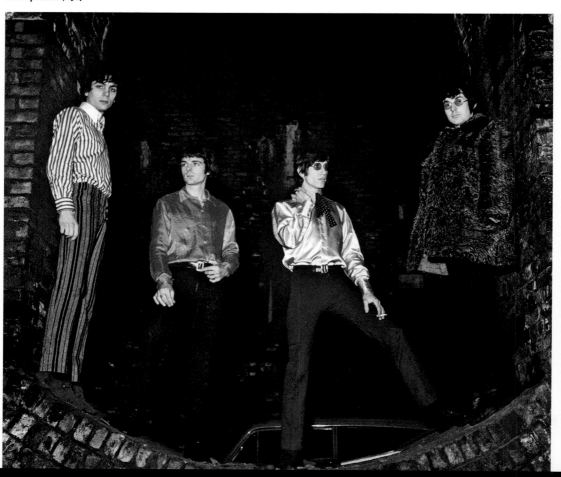

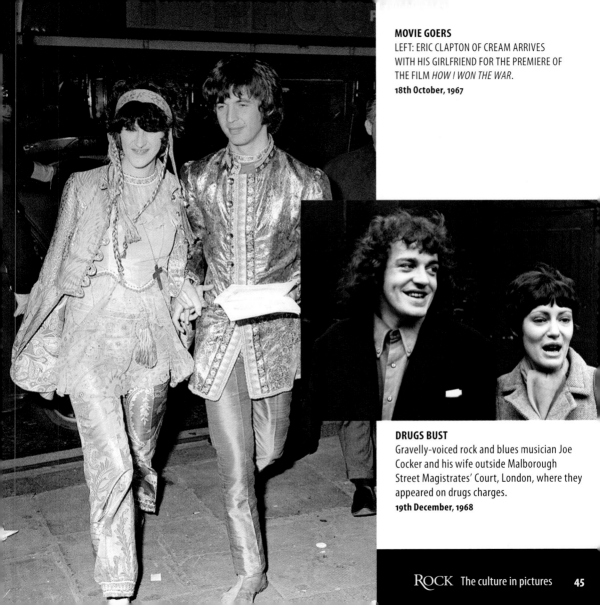

MOVIE GOERS

LEFT: ERIC CLAPTON OF CREAM ARRIVES
WITH HIS GIRLFRIEND FOR THE PREMIERE OF
THE FILM *HOW I WON THE WAR*.

18th October, 1967

DRUGS BUST

Gravelly-voiced rock and blues musician Joe
Cocker and his wife outside Malborough
Street Magistrates' Court, London, where they
appeared on drugs charges.

19th December, 1968

ALBUM LAUNCH

THE BEATLES AT THE LAUNCH OF THEIR ALBUM *SERGEANT PEPPER'S LONELY HEARTS CLUB BAND*. L–R: PAUL McCARTNEY, RINGO STARR, JOHN LENNON, GEORGE HARRISON. ALTHOUGH PRIMARILY A BEAT GROUP, THE BEATLES MADE A SIGNIFICANT CONTRIBUTION TO PSYCHEDELIC ROCK IN THE LATE 1960S.

20th May, 1967

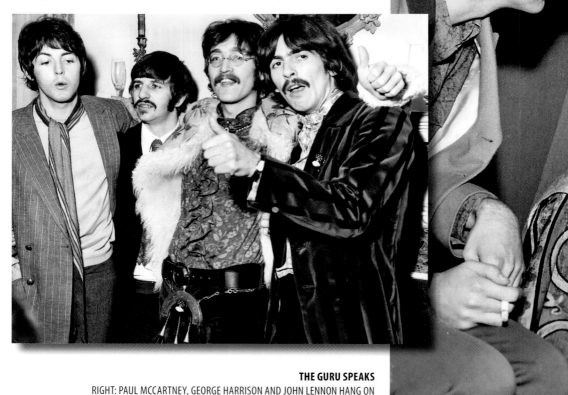

THE GURU SPEAKS

RIGHT: PAUL McCARTNEY, GEORGE HARRISON AND JOHN LENNON HANG ON THE WORDS OF THE MAHARISHI MAHESH YOGI.

August, 1967

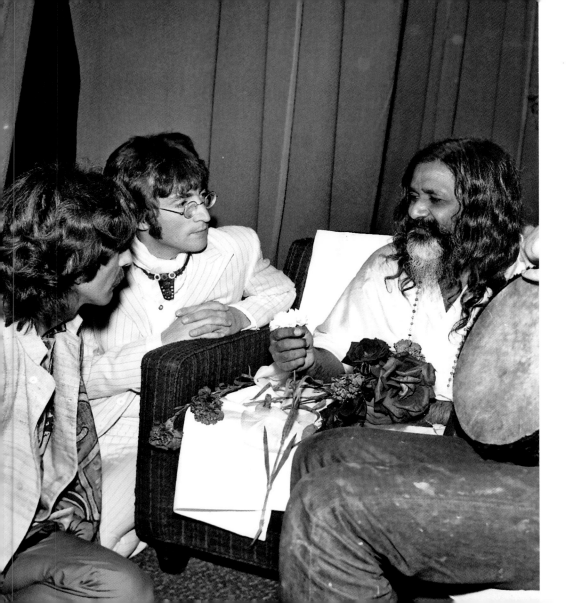

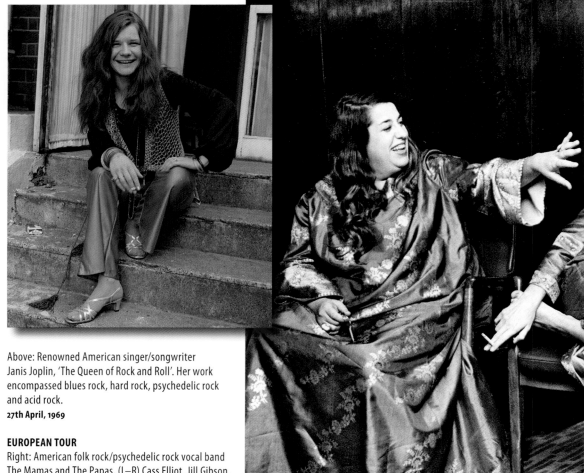

Above: Renowned American singer/songwriter
Janis Joplin, 'The Queen of Rock and Roll'. Her work
encompassed blues rock, hard rock, psychedelic rock
and acid rock.
27th April, 1969

EUROPEAN TOUR
Right: American folk rock/psychedelic rock vocal band
The Mamas and The Papas, (L–R) Cass Elliot, Jill Gibson,
John Phillips, Denny Doherty. They were in London prior
to touring in Europe, but would soon split up.
6th October, 1967

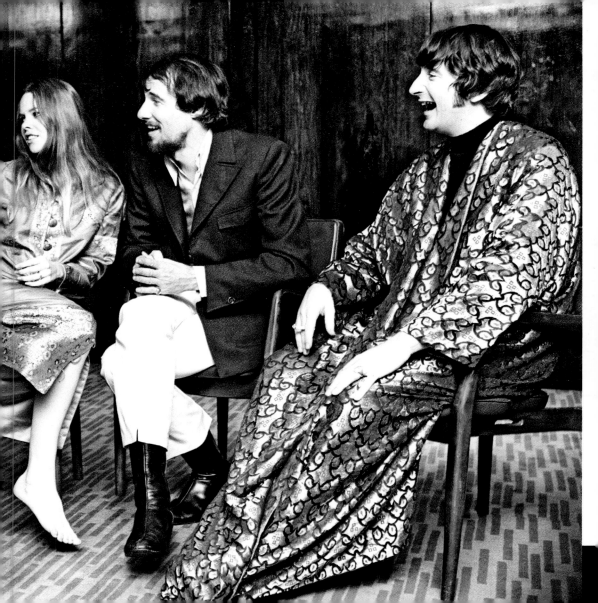

Five-piece combo

Below: Folk rock band Pentangle: (L–R) Terry Cox (drums), John Renbourn (guitar), Jacqui McShee (vocals), Danny Thompson double bass, Bert Jansch (guitar). The band only lasted for five years, but was reformed in 1981.

2nd December, 1969

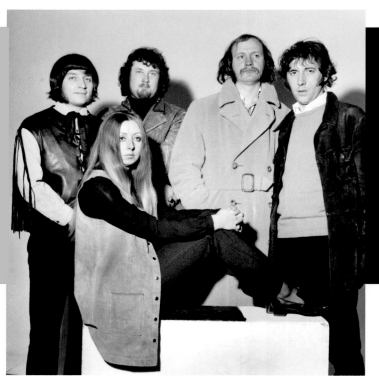

HEADING SOUTH

ABOVE: KEYBOARD PLAYER ALAN PRICE LEFT THE ANIMALS IN 1965 TO FORM HIS OWN BAND, THE ALAN PRICE SET. AFTER THREE YEARS, HOWEVER, HE DISBANDED THE GROUP AND HEADED TO LONDON TO CONCENTRATE ON TELEVISION WORK, RECORD PRODUCTION AND BAND MANAGEMENT.

13th October, 1968

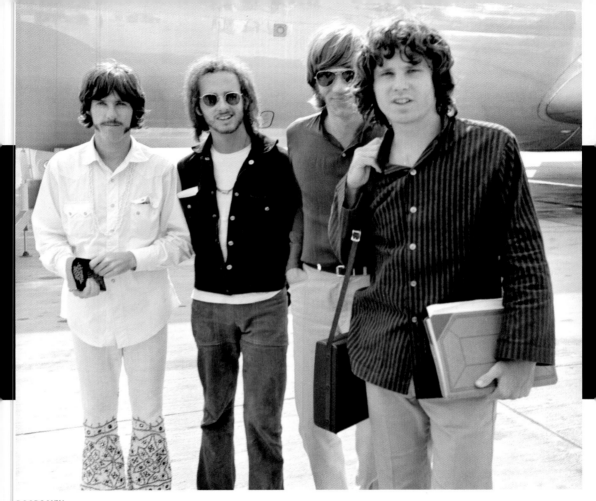

DOORS MEN
AMERICAN BAND THE DOORS ARRIVE AT LONDON'S HEATHROW AIRPORT. L–R: JOHN DENSMORE (DRUMS), ROBBY KRIEGER (GUITAR),
RAY MANZAREK (KEYBOARDS), JIM MORRISON (VOCALS). THE CHARISMATIC MORRISON, WHO DIED OF A SUSPECTED DRUG OVERDOSE
AT THE AGE OF 27, IS CONSIDERED TO BE ONE OF THE MOST ICONIC OF FRONT MEN IN ROCK MUSIC HISTORY.
3rd September, 1968

Final gig

Right: The Beatles give their last ever performance together on the roof of their Apple headquarters in London's Savile Row.

30th January, 1969

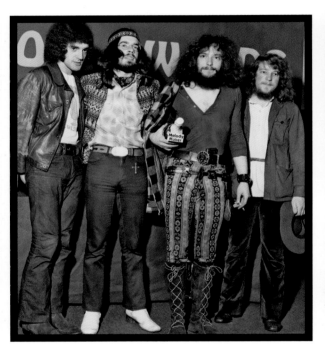

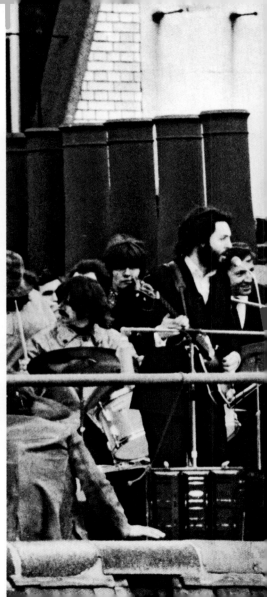

BIG SELLERS

ABOVE: ONE OF THE WORLD'S BEST SELLING BANDS, JETHRO TULL HAVE SOLD OVER 60 MILLION ALBUMS WORLDWIDE. THEY BEGAN PLAYING BLUES ROCK, BUT THEIR WORK EXPANDED TO ENCOMPASS FOLK ROCK AND HARD ROCK.

25th September, 1969

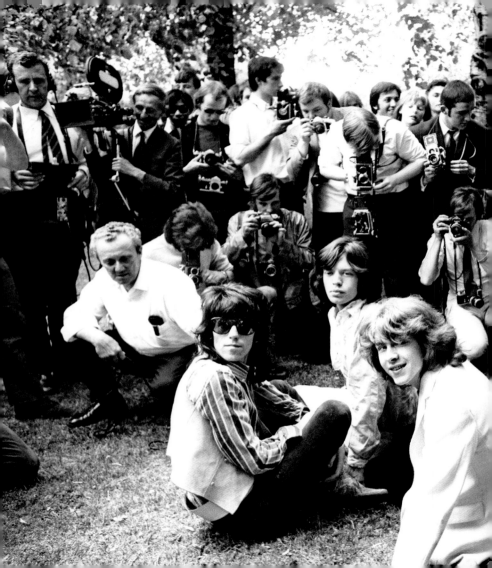

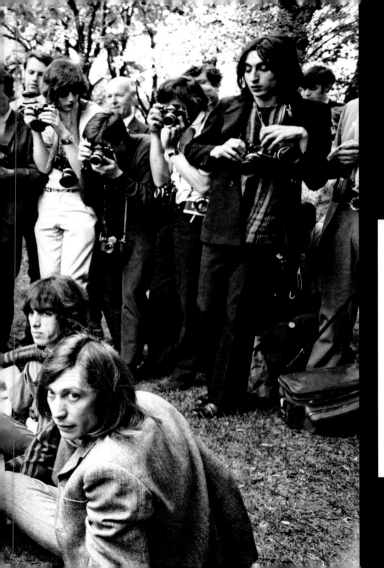

NEW STONE
THE ROLLING STONES AT A
PHOTOCALL IN HYDE PARK,
LONDON TO INTRODUCE
MICK TAYLOR (C), WHO
HAD TAKEN BRIAN JONES'
PLACE IN THE BAND. JONES
HAD BEEN ASKED TO LEAVE
BECAUSE HE WAS NO
LONGER CONTRIBUTING TO
THEIR MUSIC DUE TO DRUG
PROBLEMS. HE WOULD BE
DISCOVERED DEAD A FEW
WEEKS LATER.
13th June, 1969

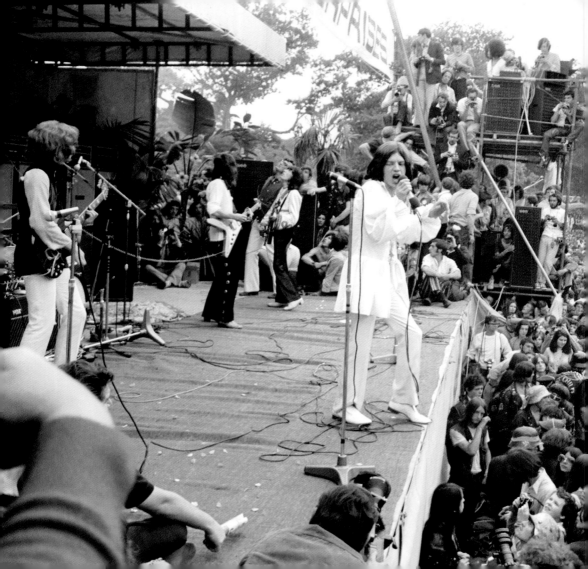

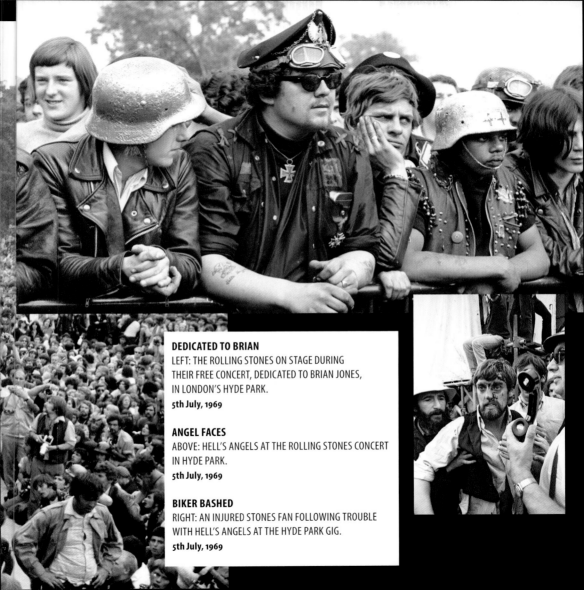

DEDICATED TO BRIAN
LEFT: THE ROLLING STONES ON STAGE DURING
THEIR FREE CONCERT, DEDICATED TO BRIAN JONES,
IN LONDON'S HYDE PARK.
5th July, 1969

ANGEL FACES
ABOVE: HELL'S ANGELS AT THE ROLLING STONES CONCERT
IN HYDE PARK.
5th July, 1969

BIKER BASHED
RIGHT: AN INJURED STONES FAN FOLLOWING TROUBLE
WITH HELL'S ANGELS AT THE HYDE PARK GIG.
5th July, 1969

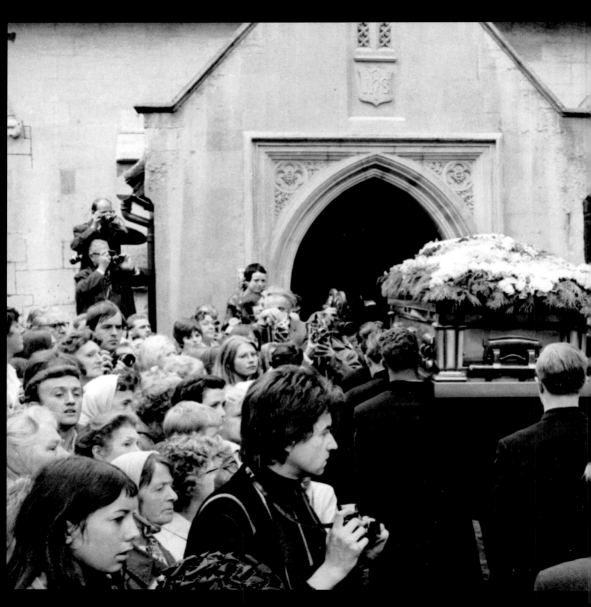

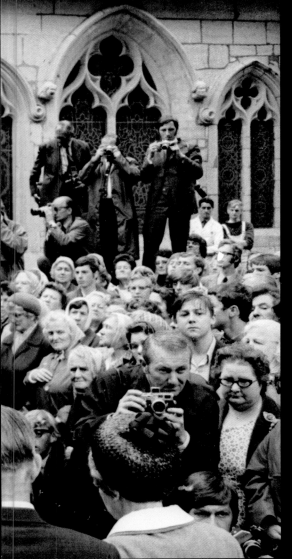

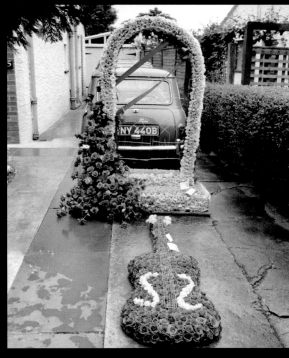

FAREWELL FLOWERS
ABOVE: FLORAL TRIBUTES TO BRIAN JONES FROM THE ROLLING
STONES AND THEIR 'GOFER', TOM KEYLOCK.
10th July, 1969

LAST JOURNEY
LEFT: THE COFFIN OF FORMER ROLLING STONE BRIAN JONES IS
CARRIED PAST CROWDS OF MOURNING FANS INTO CHELTENHAM
PARISH CHURCH FOR HIS FUNERAL SERVICE. HE HAD DROWNED IN
THE SWIMMING POOL OF HIS HOME IN EAST SUSSEX.
10th July, 1969

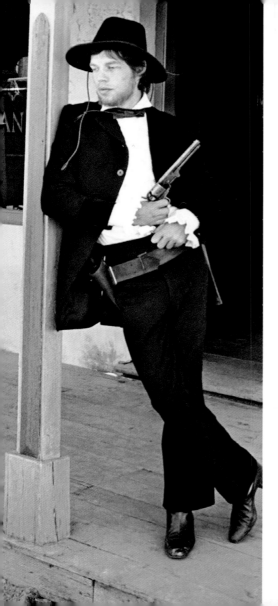

STARRING ROLE
MICK JAGGER IN AUSTRALIA
PLAYING THE FAMOUS
AUSTRALIAN BUSHRANGER
NED KELLY IN THE FILM OF
THE SAME NAME.
1st July, 1969

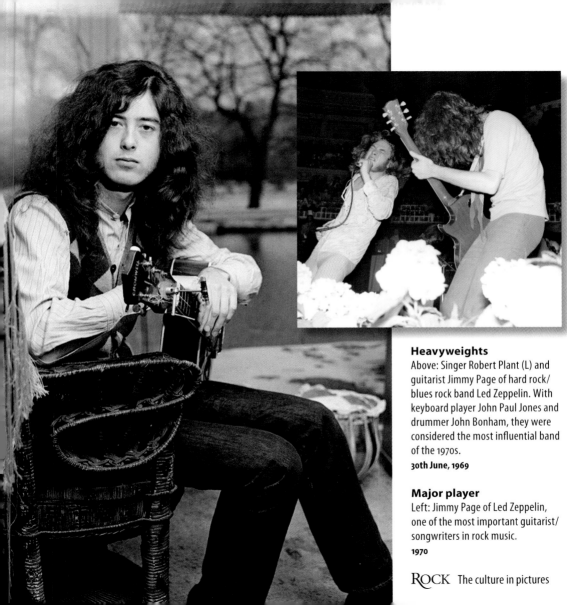

Heavyweights

Above: Singer Robert Plant (L) and guitarist Jimmy Page of hard rock/ blues rock band Led Zeppelin. With keyboard player John Paul Jones and drummer John Bonham, they were considered the most influential band of the 1970s.

30th June, 1969

Major player

Left: Jimmy Page of Led Zeppelin, one of the most important guitarist/ songwriters in rock music.

1970

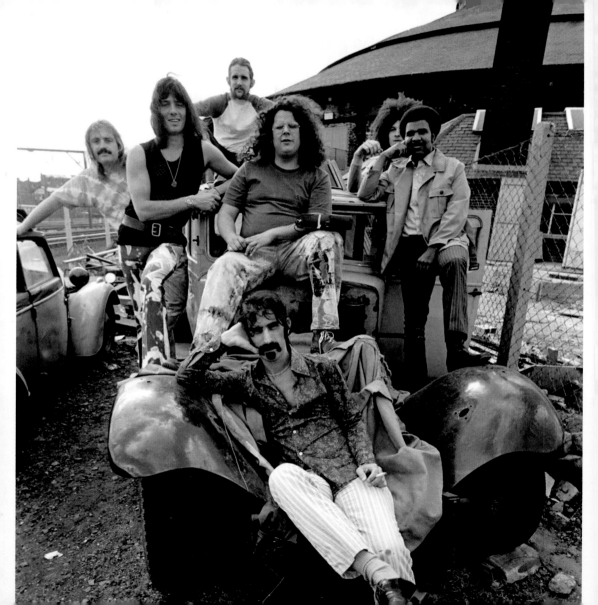

Waiting for a ride?

Left: Self-taught American singer/songwriter Frank Zappa (front) and his band, the Mothers of Invention, in London at the start of a UK tour. Zappa's work encompassed progressive, experimental and art rock. He is considered one of the most original guitarists and composers of his time.

2nd June, 1970

In the gutter

Right: Progressive rock band Supertramp, (L–R) Richard Davies, Roger Hodgson, Richard Palmer, Robert Millar, David Winthrop.

12th August, 1970

Band practice

Progressive rock band Barclay James Harvest prepare for a concert with a 60-piece orchestra.

24th June, 1970

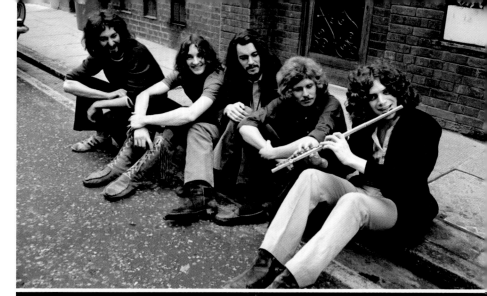

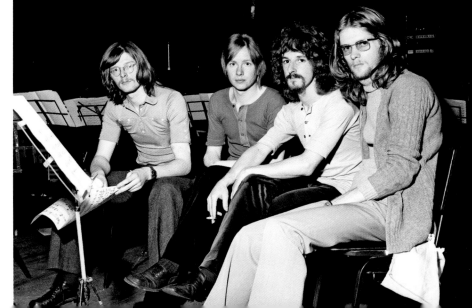

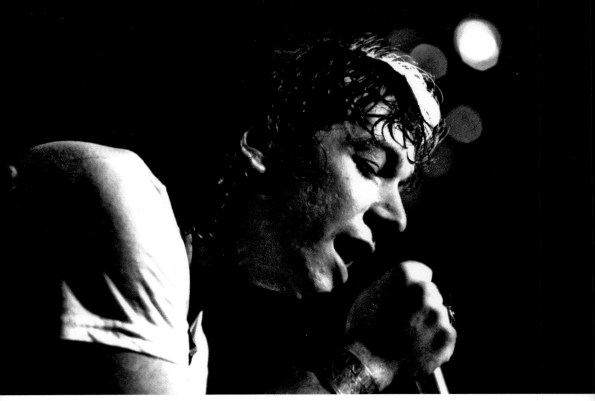

SOLO SINGER
ERIC BURDON ON STAGE AT
THE CITY HALL, NEWCASTLE.
THE GRITTY-VOICED SINGER
WAS PURSUING A SOLO
CAREER AFTER THE SPLIT
OF THE ANIMALS IN THE
PREVIOUS YEAR.
September, 1970

ROD AND MIKE

SINGER/SONGWRITER ROD
STEWART ON STAGE. THE
RASPING-VOICED VOCALIST HAD
COME TO PROMINENCE WITH THE
JEFF BECK GROUP IN THE LATE
1960S. WHEN THE BAND SPLIT UP,
HE PLANNED TO GO SOLO, BUT
WOULD SOON JOIN OLD FRIEND
RONNIE WOOD IN THE FACES.

1970

FRIENDLY ACT
Blues and pop rock band Fleetwood Mac was named by singer/guitarist Peter Green after his friends, Mick Fleetwood (drums) and John McVie (bass). L–R: Fleetwood, McVie, Jeremy Spencer (guitar/vocals), Danny Kirwan (guitar/vocals), Green.
26th January, 1970

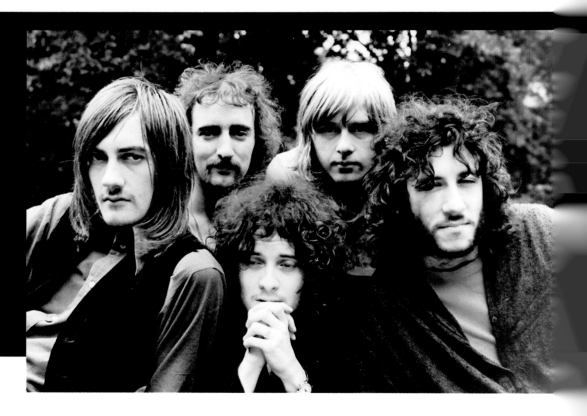

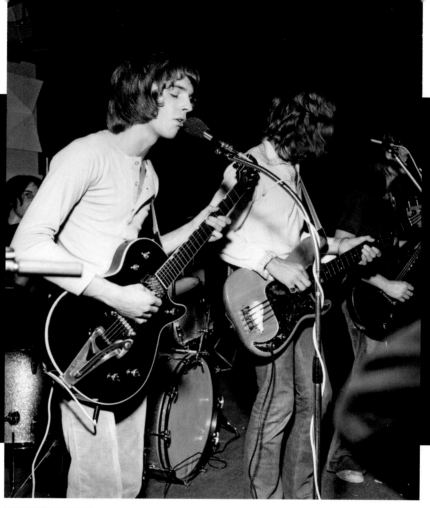

HUMBLE BEGINNINGS

Hard rock and rhythm-and-blues band Humble Pie, one of the first supergroups of the 1970s.
The original line-up featured Steve Marriott from The Small Faces, Peter Frampton (L),
lead singer and guitarist of The Herd, Greg Ridley, former bassist from Spooky Tooth,
and 17-year-old drummer Jerry Shirley.

1970

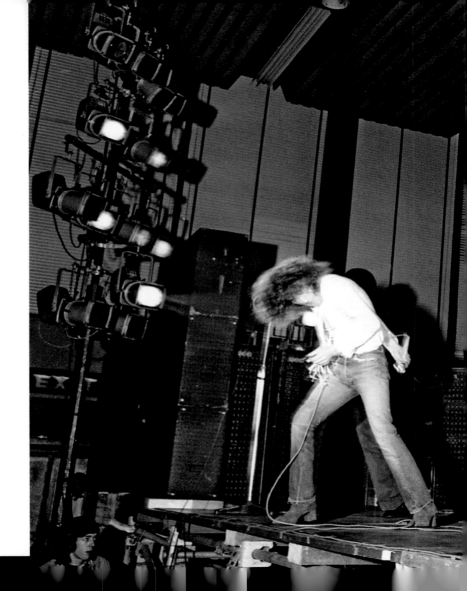

HIGH JUMP
THE WHO ON STAGE IN THE
LANCHESTER POLYTECHNIC
STUDENTS' UNION BUILDING.
THEY WERE PAID THE
GRAND SUM OF £1,200 FOR
THEIR APPEARANCE, BUT
THE UNION STOOD TO LOSE
MONEY, AS THE POLICE HAD
RESTRICTED THE AUDIENCE
SIZE FOR SAFETY REASONS.
28th November, 1970

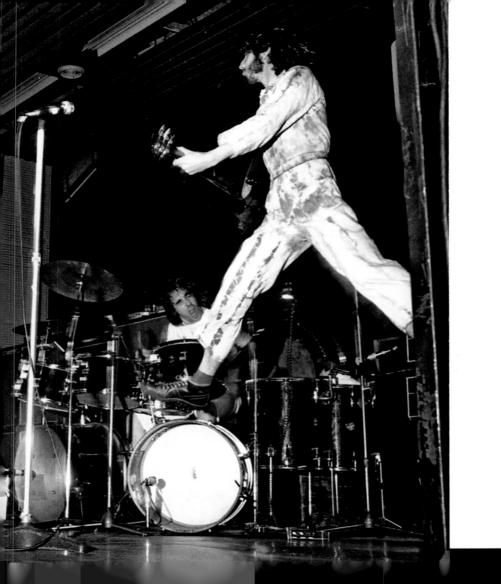

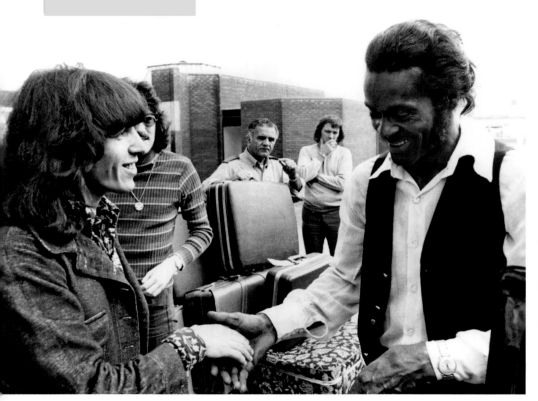

Hello Chuck!
Rolling Stones bass player Bill Wyman (L) shakes hands with rock 'n' roll legend Chuck Berry, following a chance encounter at London's Heathrow Airport. Berry had just flown in to take part in what was being hailed as the greatest rock 'n' roll show ever, which would take place at Wembley Stadium a few days later. The show featured many big-name artists from both sides of the Atlantic.

3rd August, 1972

DRUM SOUL
Ginger Baker, former drummer with supergroups Cream and Blind Faith. Baker's drumming was notable for its flamboyance, showmanship and use of African rhythms.

ROCK The culture in pictures

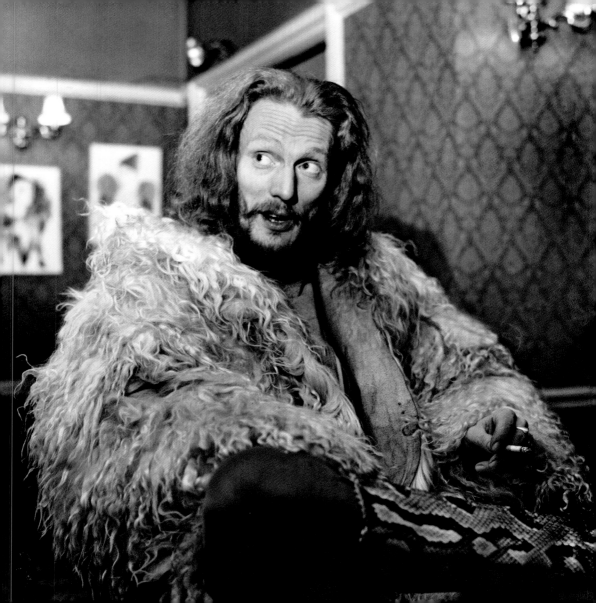

STONES PAIR
LEFT: CHARLIE WATTS
(DRUMS) AND
MICK TAYLOR
ON STAGE DURING
A ROLLING STONES
GIG AT THE CITY HALL,
NEWCASTLE.
4th March, 1971

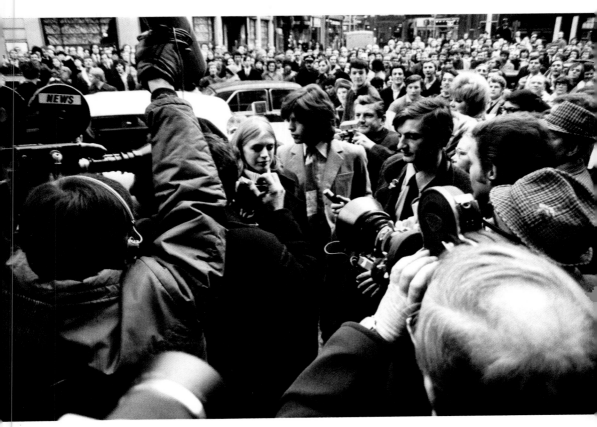

ON A CHARGE

MICK JAGGER OF THE ROLLING STONES (C) AND GIRLFRIEND MARIANNE FAITHFULL ARRIVE
AT MARLBOROUGH STREET MAGISTRATES' COURT, LONDON, WHERE THEY WERE TO
APPEAR ON A CHARGE OF POSSESSING CANNABIS RESIN. JAGGER WAS FOUND GUILTY,
BUT FAITHFULL WAS ACQUITTED.

26th January, 1970

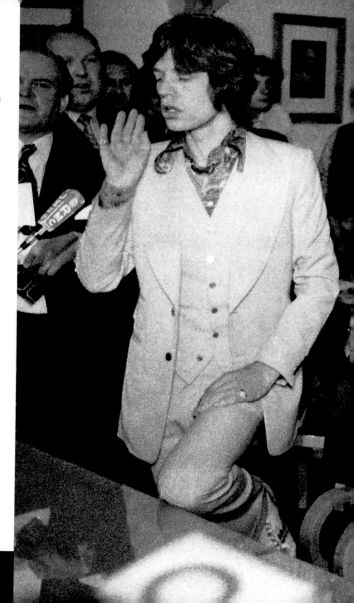

I DO

MICK JAGGER MARRIES NICARAGUAN ACTRESS AND MODEL BIANCA PÉREZ-MORA MACIAS IN SAINT-TROPEZ, FRANCE. FRENCH FILM DIRECTOR ROGER VADIM (SECOND R) AND FRENCH ACTRESS NATHALIE DELON (R) WERE WITNESSES. BIANCA WAS FOUR MONTHS PREGNANT AT THE TIME. AFTER DIVORCING MICK IN 1978 FOR HIS ADULTERY WITH AMERICAN MODEL JERRY HALL, BIANCA SAID, "MY MARRIAGE ENDED ON MY WEDDING DAY."

12th May, 1971

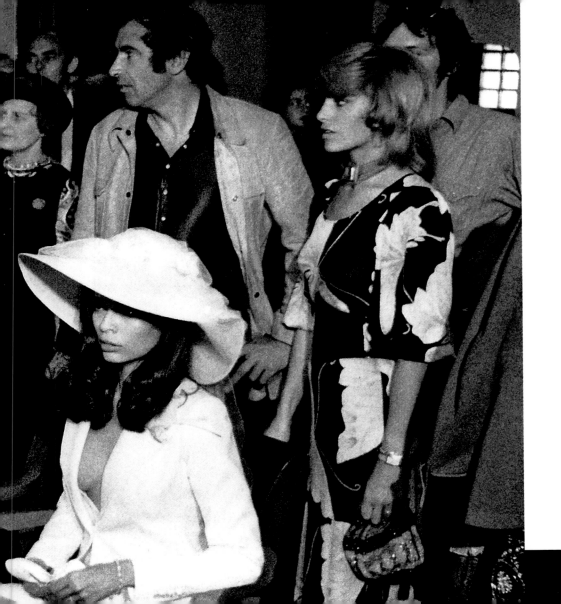

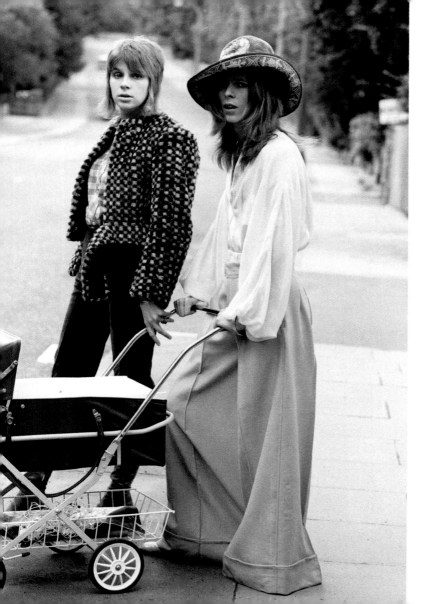

GLAMMED UP
GLAM ROCK/ART ROCK SINGER
DAVID BOWIE AND WIFE ANGIE
TAKE THEIR THREE-WEEK-OLD SON,
ZOWIE, FOR A WALK. BOWIE'S
SENSE OF VISUAL PRESENTATION
WOULD BE GIVEN FULL REIN IN
1972 WITH THE CREATION OF HIS
ANDROGYNOUS STAGE PERSONA,
ZIGGY STARDUST.
29th June, 1971

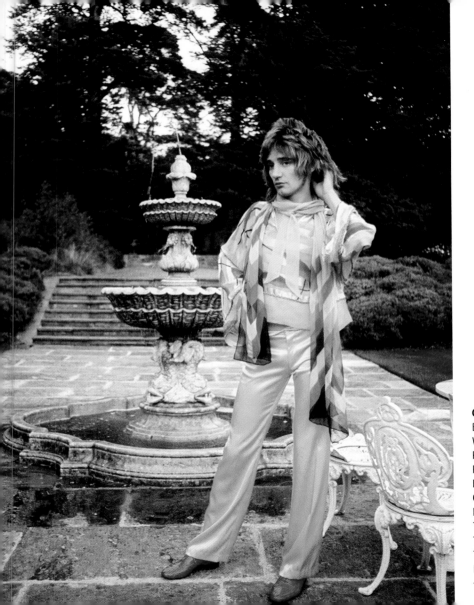

GROWING SUCCESS

BY 1973, ROD STEWART
WAS NOT ONLY APPEARING
REGULARLY WITH THE
FACES, BUT ALSO RAPIDLY
DEVELOPING HIS SOLO
CAREER, WHICH WAS
ENJOYING GREATER SUCCESS
THAN THE BAND. INEVITABLY,
THIS LED TO TENSION, AND
THE BAND WOULD SPLIT UP
IN 1975.

1st August, 1973

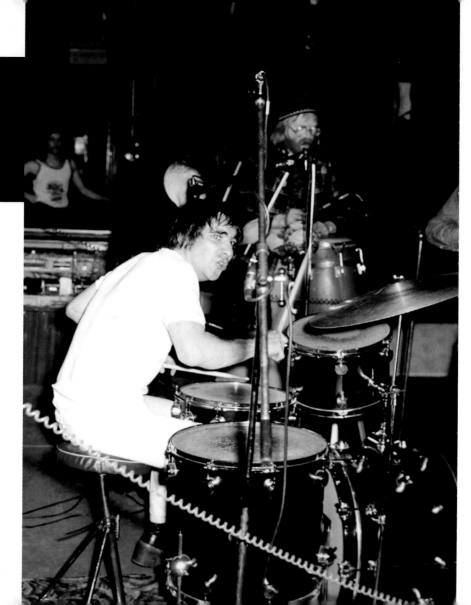

Sitting in
Keith Moon, drummer
with The Who,
plays a gig with old
friend Viv Stanshall
(background), best
known for his work
with the surreal Bonzo
Dog Doo-Dah Band.
16th February, 1973

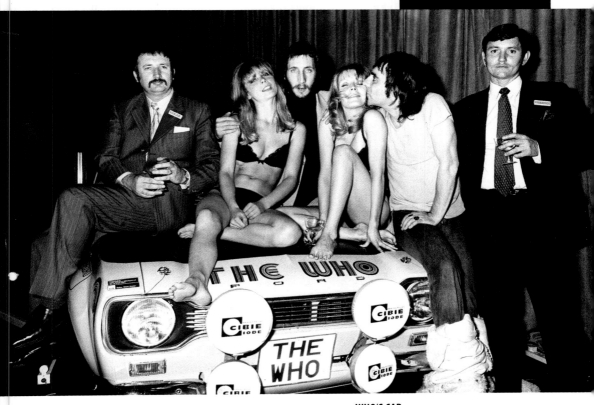

WHO'S CAR
PETE TOWNSHEND (C) AND KEITH MOON (SECOND R), OF
THE WHO, WITH RALLY DRIVERS STAN GRIFFIN
AND CHRIS DICKENSON, AT THE LAUNCH OF
THE BAND'S SPONSORED ENTRY IN THE *DAILY MIRROR*
RAC RALLY OF GREAT BRITAIN. THEY HAD ENTERED
A £10,000 PINK FORD ESCORT RS1600.
5th October, 1972

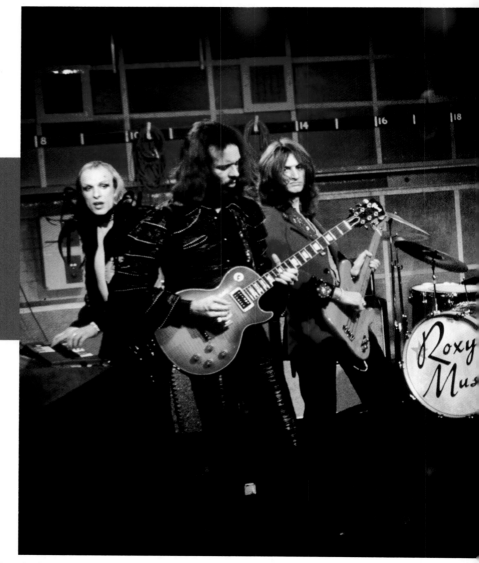

TREND SETTERS

ART ROCK BAND ROXY MUSIC,
WHO HAD A MAJOR INFLUENCE
ON THE ESTABLISHMENT OF GLAM
ROCK, AS WELL AS NEW WAVE
AND ELECTRONIC MUSIC.

1st April, 1973

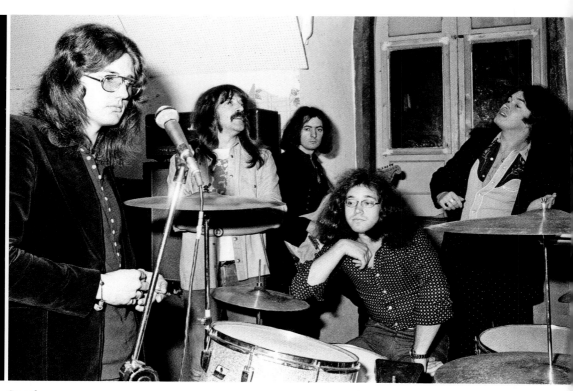

Purple pros
Pioneers of heavy metal and hard rock, Deep Purple prepare for a gig at The Lamb pub in Clearwell, Gloucestershire. They were once listed in the *Guinness Book of World Records* as the loudest rock band and have sold over 100 million albums worldwide.
23rd September, 1973

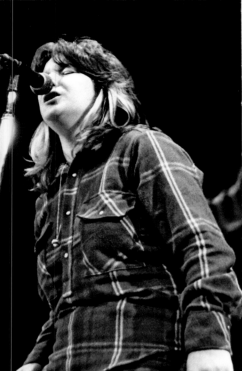

Clear as a bell
Scottish blues rock singer Maggie Bell, considered by some to be Britain's answer to Janis Joplin.
9th December, 1972

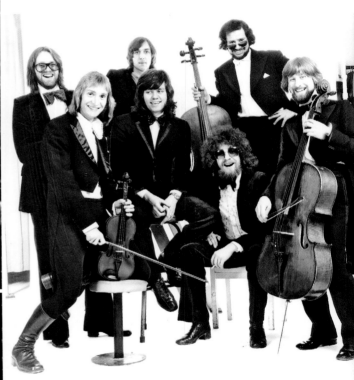

'Ello, ELO
Symphonic/progressive rock band Electric Light Orchestra, one of the biggest selling bands of the 1970s. The band had been formed by Jeff Lynne (seated) and Roy Wood, formerly of The Move, although the latter left after the release of their debut record and would go on to form Wizzard.
16th March, 1973

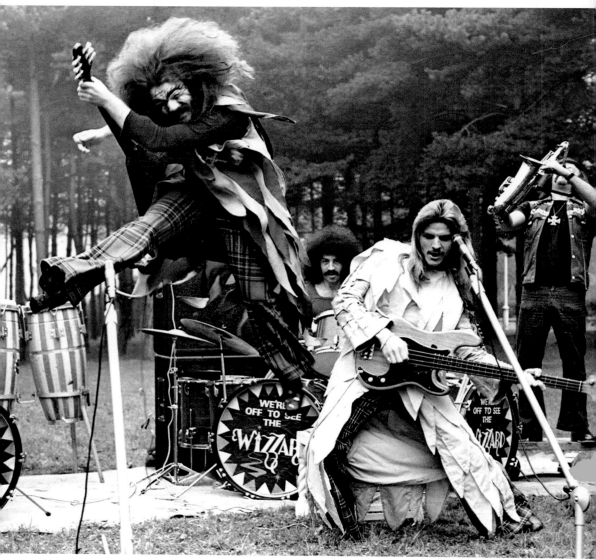

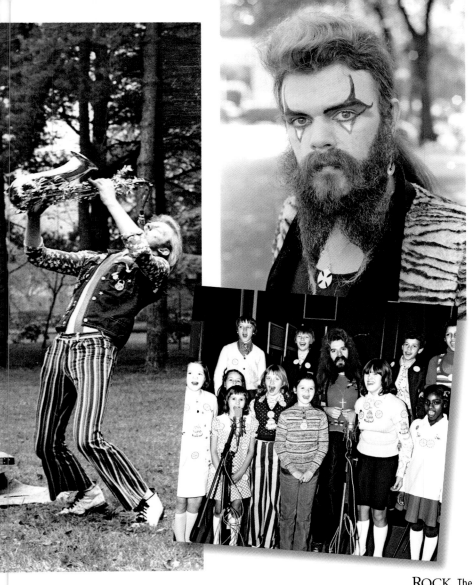

Playing in the park
Far left: Roy Wood of Wizzard leaps skyward in celebration of the band's first Top Ten hit, *Ball Park Incident*. The band was one of the most colourful of the glam rock era.
22nd January, 1973

What a face
Left: Roy Wood in trademark face paint and tiger-print drape coat at a photo call for the release of Wizzard's new single, *Angel Fingers*.
12th September, 1973

Christmas song
Roy Wood with children during re-recording of the popular Christmas song, *I Wish It Could Be Christmas Everyday*.
28th October, 1973

Playing with the Dolls

American glam rock band The New York Dolls at a Biba party in London. Their playing style had a major influence on early punk bands, while their visual style presaged later New Wave and glam metal bands.

25th November, 1973

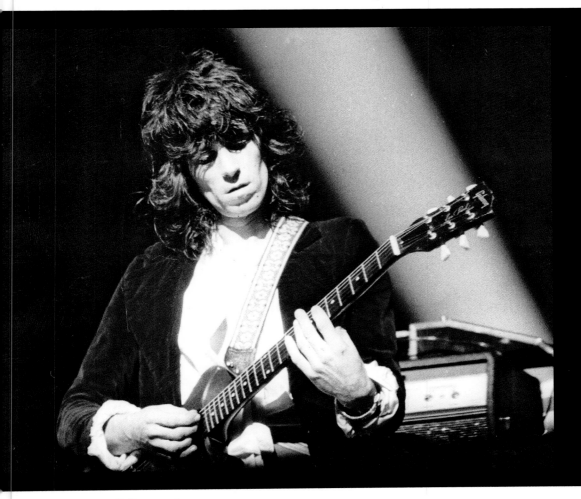

Guitar great
Rolling Stones co-founder and lead guitarist
Keith Richards, considered to be one of
the greatest guitarists of all time.
16th February, 1973

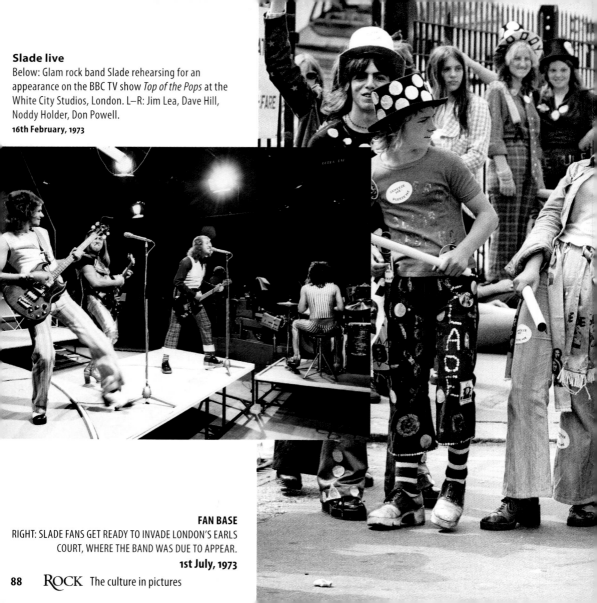

Slade live

Below: Glam rock band Slade rehearsing for an appearance on the BBC TV show *Top of the Pops* at the White City Studios, London. L–R: Jim Lea, Dave Hill, Noddy Holder, Don Powell.

16th February, 1973

FAN BASE

RIGHT: SLADE FANS GET READY TO INVADE LONDON'S EARLS COURT, WHERE THE BAND WAS DUE TO APPEAR.

1st July, 1973

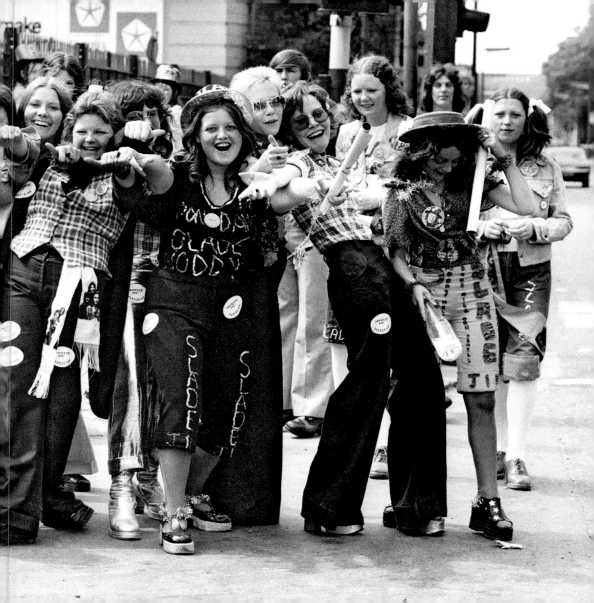

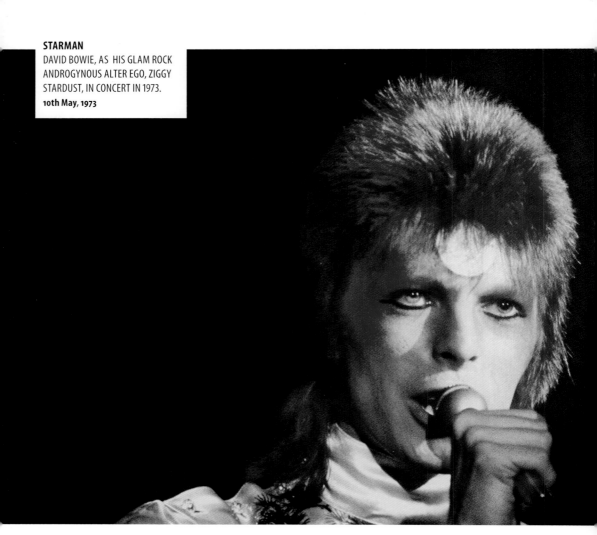

STARMAN
DAVID BOWIE, AS HIS GLAM ROCK
ANDROGYNOUS ALTER EGO, ZIGGY
STARDUST, IN CONCERT IN 1973.
10th May, 1973

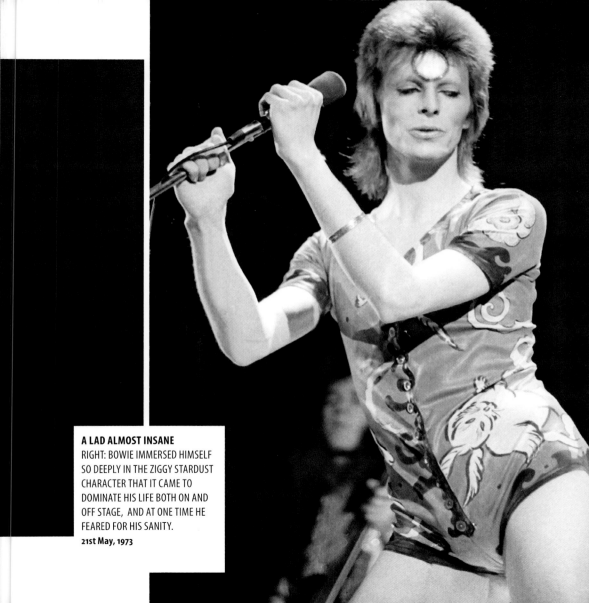

A LAD ALMOST INSANE
RIGHT: BOWIE IMMERSED HIMSELF
SO DEEPLY IN THE ZIGGY STARDUST
CHARACTER THAT IT CAME TO
DOMINATE HIS LIFE BOTH ON AND
OFF STAGE, AND AT ONE TIME HE
FEARED FOR HIS SANITY.
21st May, 1973

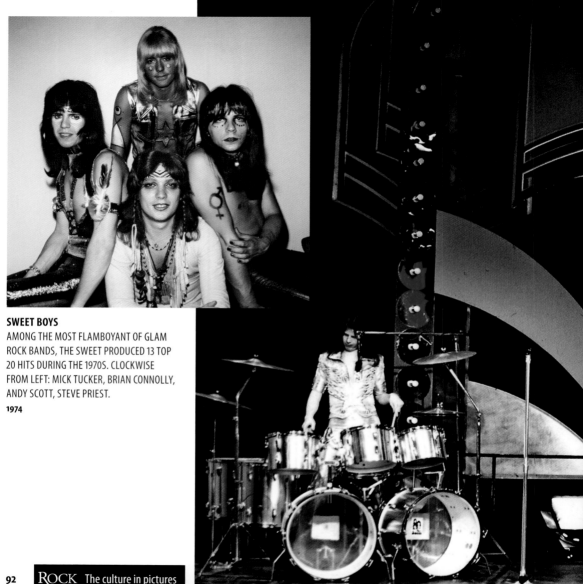

SWEET BOYS

AMONG THE MOST FLAMBOYANT OF GLAM
ROCK BANDS, THE SWEET PRODUCED 13 TOP
20 HITS DURING THE 1970S. CLOCKWISE
FROM LEFT: MICK TUCKER, BRIAN CONNOLLY,
ANDY SCOTT, STEVE PRIEST.

1974

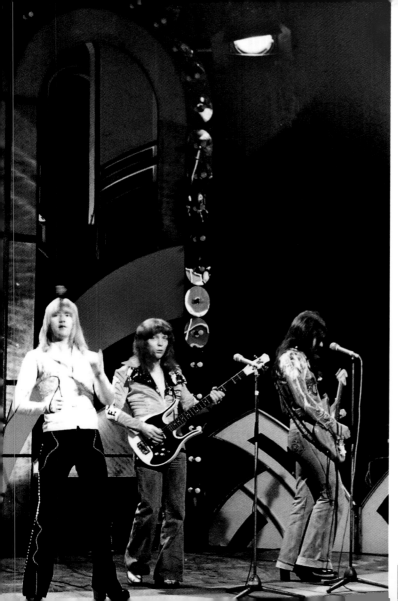

SWEET SINGING
THE SWEET REHEARSE FOR THEIR
APPEARANCE ON THE BBC SHOW *TOP OF THE
POPS*, AT THE WHITE CITY STUDIOS, LONDON.
16th February, 1973

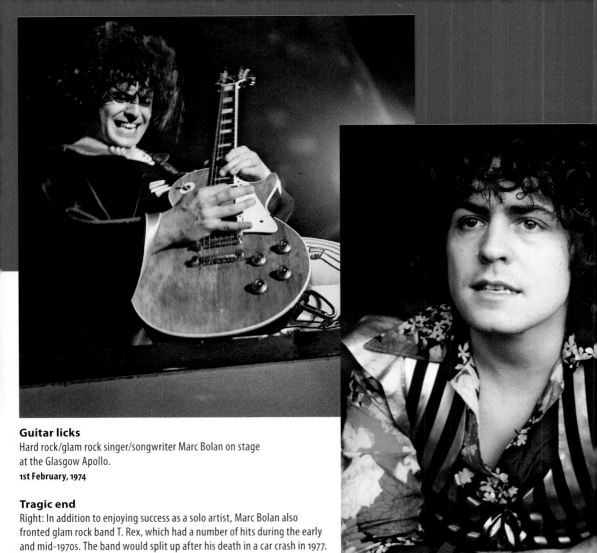

Guitar licks
Hard rock/glam rock singer/songwriter Marc Bolan on stage
at the Glasgow Apollo.
1st February, 1974

Tragic end
Right: In addition to enjoying success as a solo artist, Marc Bolan also
fronted glam rock band T. Rex, which had a number of hits during the early
and mid-1970s. The band would split up after his death in a car crash in 1977.
1974

Young dudes

Above: Mott The Hoople, a dominant band of the glam rock era. They enjoyed success with *All the Young Dudes*, written for them by David Bowie.

7th March, 1974

All a-glitter

Right: The Glitter Band was originally formed as a backing group for flamboyant glam rock singer Gary Glitter, but they went on to enjoy success in their own right, producing seven Top 20 hit singles and three hit albums in the mid-1970s.

18th March, 1974

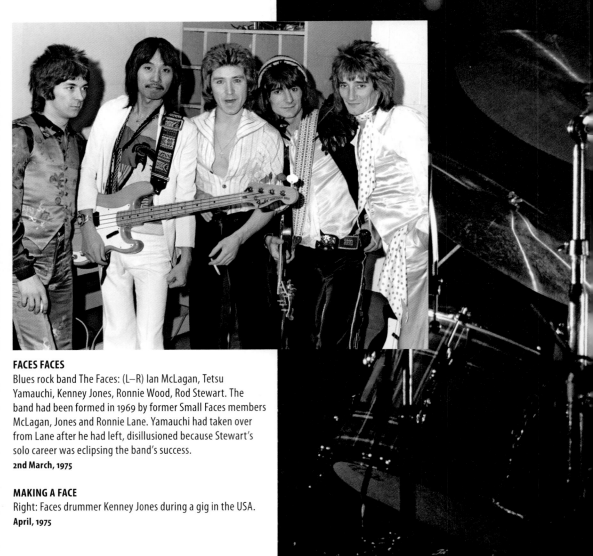

FACES FACES
Blues rock band The Faces: (L–R) Ian McLagan, Tetsu Yamauchi, Kenney Jones, Ronnie Wood, Rod Stewart. The band had been formed in 1969 by former Small Faces members McLagan, Jones and Ronnie Lane. Yamauchi had taken over from Lane after he had left, disillusioned because Stewart's solo career was eclipsing the band's success.
2nd March, 1975

MAKING A FACE
Right: Faces drummer Kenney Jones during a gig in the USA.
April, 1975

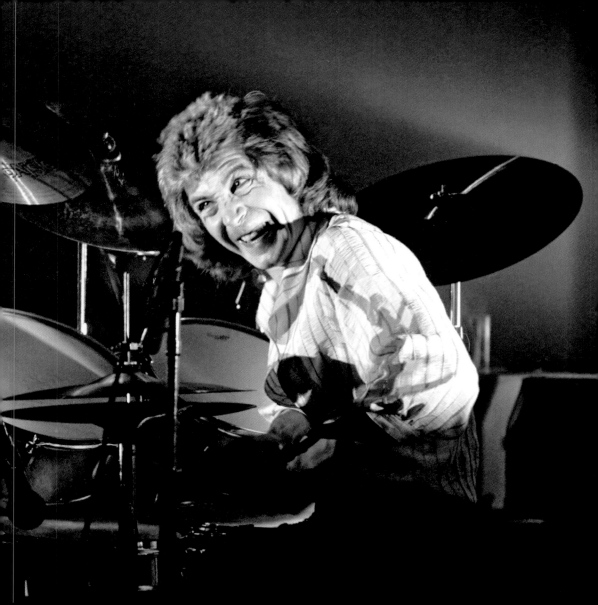

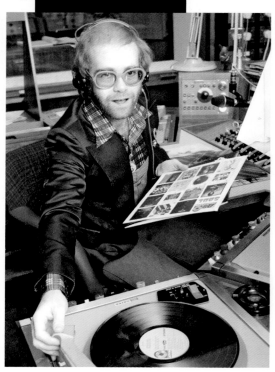

EJ as DJ

Elton John at the BBC, where he was recording his first radio programme as a disc jockey. His work spanned the gamut of glam rock, pop rock and soft rock.

2nd March, 1975

Talented group

Art rock band 10cc during filming for an appearance on the BBC chart show *Top of the Pops*. L–R: Lol Creme, Eric Stewart, Graham Gouldman, Kevin Godley. All four were multi-instrumentalists, singers, writers and producers.

24th April, 1975

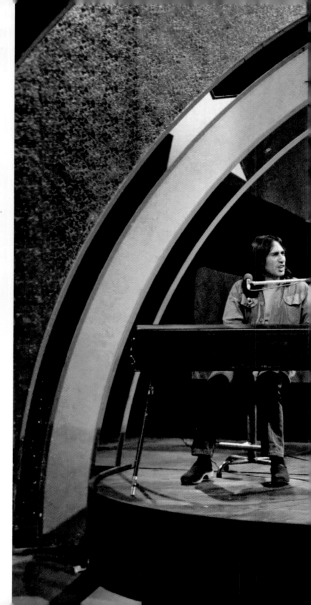

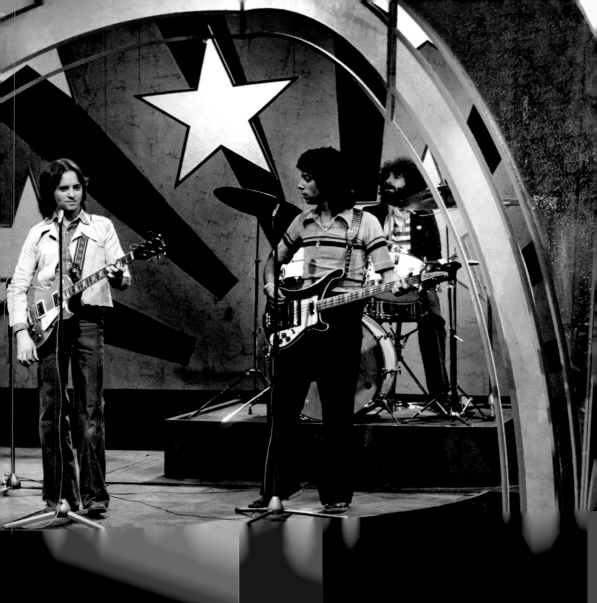

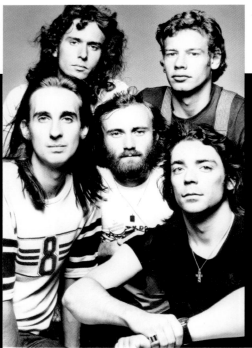

HARD ROCK/GLAM ROCK BAND SLADE, IN NEWCASTLE TO PUBLICISE THEIR FILM, *FLAME*, HAVE A CLOSE ENCOUNTER WITH FAN ELAINE EMBLETON.
1975

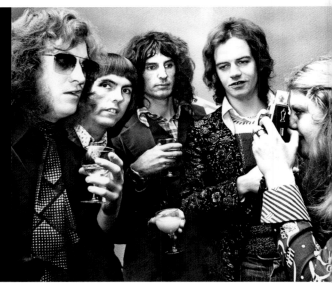

Progressive five

Progressive and symphonic rock band Genesis. Clockwise, from centre: Phil Collins, Mike Rutherford, Tony Banks, Bill Bruford, Steve Hackett. Formed originally in 1967, the band is one of the top 30 highest selling recording artists of all time, having sold around 150 million albums worldwide. Peter Gabriel was one of its founding members.

18th October, 1976

Kiss 'n' make-up

Right: American hard rock/heavy metal band Kiss at the Houses of Parliament in London to publicise their first European tour. They arrived in their trademark lurid costumes, high-heeled boots, and striking black-and-white make-up. Clockwise from top left: Paul Stanley, Gene Simmons, Ace Frehley, Peter Criss.

10th May, 1976

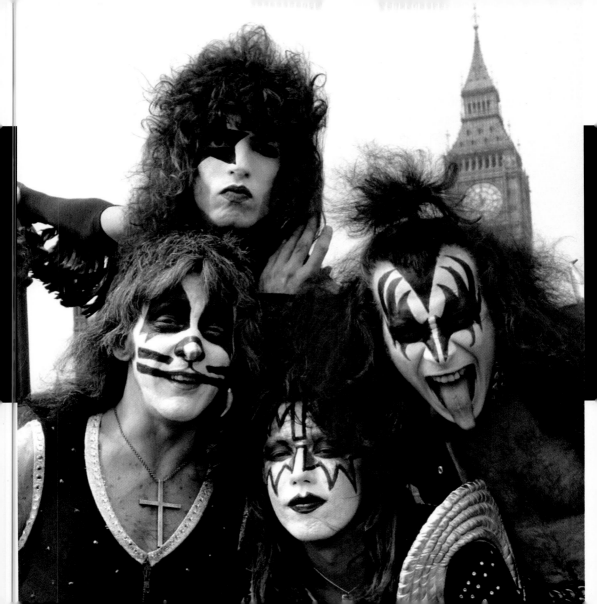

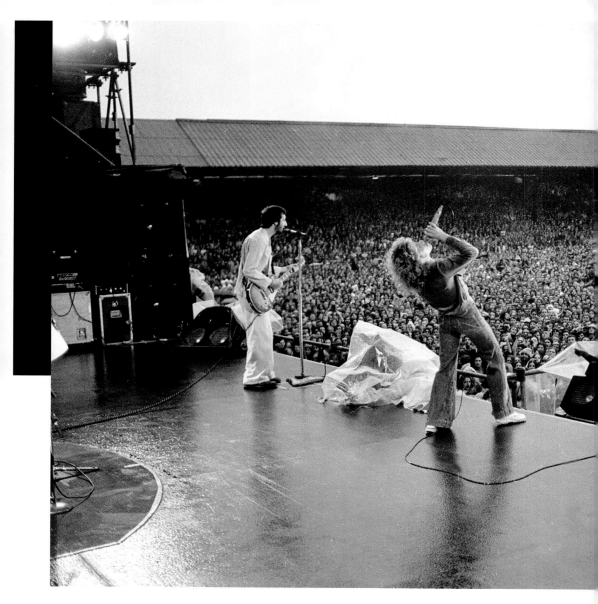

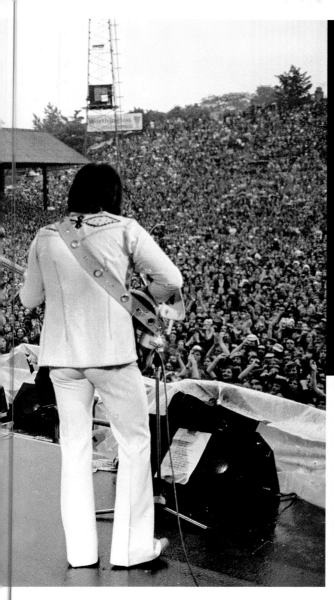

SINGING IN THE RAIN
Left: The Who play to a packed stadium during a rainy rock concert at Charlton Athletic Football Club's ground in south London.
31st May, 1976

DRUM ROLL
Madcap drummer Keith Moon of The Who gives an impromptu lesson to an Army Cadet Corps drummer in North London.
27th May, 1976

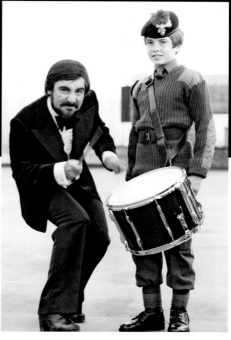

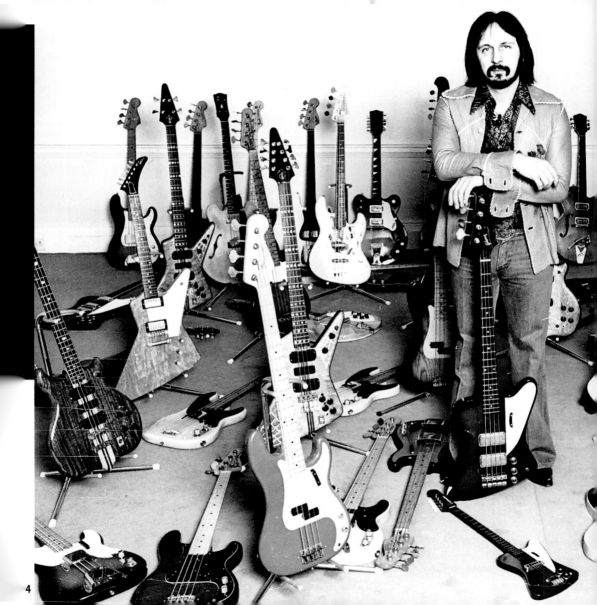

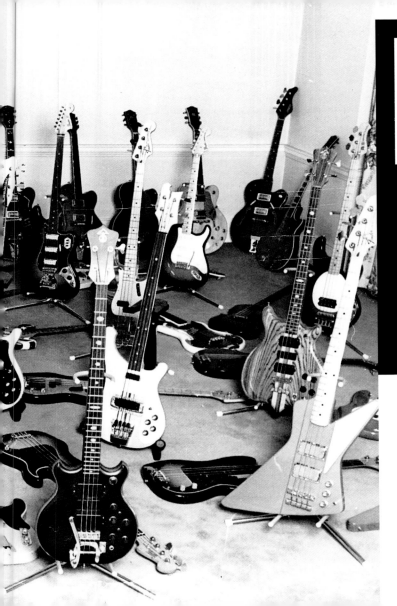

TV's Bill Grundy in rock outrage

Judge in 'murder' pardon shocker

By ARNOT McWHINNIE

A JUDGE made an astonishing attack yesterday on the way a man convicted of murder was given a royal pardon.

He told a jury: "You may well have come to the clear conclusion that he was rightly convicted."

The man at the centre of the storm is 48-year-old Patrick Meehan, who was freed from jail in May after serving nearly seven years.

The judge, Lord Robertson, said: "There is no legal justification whatsoever for saying that Meehan was wrongly convicted."

He went on to suggest that Meehan's conviction for killing elderly Mrs

Meehan yesterday

Rachel Ross still stood, despite the pardon.

The judge spoke out at the end of a second trial over the same murder.

This time, 38-year-old Ian Waddell was in the dock. He was a prosecution witness when Meehan got a life sentence in 1969.

Yesterday the jury acquitted Waddell of murder—and also cleared him of giving false evidence at Meehan's trial.

During the judge's summing up, Meehan stormed angrily from the public gallery at Edinburgh High Court.

He said outside: "I might as well tear up my royal pardon. It's a worthless piece of paper. It seems I am still convicted."

The judge said of the pardon: "In the ordinary use of language it you pardon someone you condemn them for something they have done—not for something they haven't done."

"It certainly doesn't quash the conviction."

○ Who killed Rachel Ross?—Centre Pages.

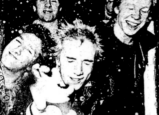

THE GROUP IN THE BIG TV RUMPUS

Johnny Rotten, leader of the Sex Pistols, opens a can of beer.
Last night their language made TV viewers froth.

THE FILTH AND THE FURY!

A POP group shocked millions of viewers last night with the filthiest language heard on British television.

The Sex Pistols, leaders of the new "punk rock" cult, hurled a string of four letter obscenities at interviewer Bill Grundy on Thames TV's family teatime programme "Today."

The Thames switchboard was flooded with protests.

Nearly 200 angry viewers telephoned the Mirror. One man was so furious that he kicked in the screen of his £380 colour TV.

Grundy was immediately carpeted by his boss and will apologise in tonight's programme

Shocker

A Thames spokesman said: "Because the programme was live, we could not foresee the language which would be used. We apologise to all viewers.

The show, screened at peak children's viewing time, turned into a shocker when Grundy asked about £40,000 that the Sex Pistols received

By STUART GREIG, MICHAEL McCARTHY and JOHN PEACOCK

from their record company.

One member of the group said: "F——ing spent it, didn't we?"

Then when Grundy asked about people who preferred Beethoven, Mozart and Bach, another Sex Pistol remarked: "That's just their tough s——."

Later Grundy told the group: "Say something outrageous."

A punk rocker replied: "You dirty sod. You dirty bastard."

"Go on. Again," said Grundy.

"You dirty f——er."

"What?"

"What a f——ing rotter." As the Thames switchboard became jammed, viewers rang the Mirror to voice their complaints.

Lorry driver James Holmes, 47, was outraged that his eight-year-old son Lee heard the swearing — and kicked in the screen of his TV.

"It blew up and I was knocked backwards," he said. "But I was so angry and disgusted with this film that I took a swing with my boot.

"I can swear as well as anyone, but I don't want this sort of muck coming into my home at teatime.

Mr. Holmes, of Beechfield Walk, Waltham Abbey, Essex, added: "I am not a violent person, but I would like to have got hold of Grundy. He should be sacked for encouraging this sort of disgusting behaviour."

Uproar as viewers jam phones

When the air turned blue ..

INTERVIEWER Bill Grundy introduced the Sex Pistols to viewers with the comment: "Words actually fail me about the next guests on tonight's show."

The group sang a number — and the amazing interview got under way.

GRUNDY: I am told you have received £40,000 from a record company. Doesn't that seem to be slightly opposed to an anti-materialistic way of life.

PISTOL: The more the merrier.

GRUNDY: Really.

PISTOL: Yea, yea.

GRUNDY: Tell me more then.

PISTOL: F——ing spent it, didn't we.

GRUNDY: You are serious?

PISTOL: Mmmm.

GRUNDY: Beethoven, Mozart, Bach?

PISTOL: They're wonderful people.

GRUNDY: Are they?

PISTOL: Yes they really turn us on. They do.

GRUNDY: Suppose they turn other people on?

PISTOL: (in a whisper) : That's just their tough s——.

GRUNDY: It's what?

PISTOL: Nothing—a rude word. Next question.

GRUNDY: No, no. What was the rude word?

PISTOL: S——.

GRUNDY: Was it really? Good heavens. What about you girls behind? Are you married or just enjoying yourself?

GIRL: I've always wanted to meet you.

GRUNDY: Did you really? We'll meet afterwards, shall we?

PISTOL: You dirty old man. You dirty old man.

GRUNDY: Go on, you've got a long time yet. You've got another five seconds. Say something outrageous.

PISTOL: You dirty sod. You dirty bastard.

GRUNDY: Go on. Again.

PISTOL: You dirty f——er.

GRUNDY: What?

PISTOL: What a f——ing rotter.

GRUNDY: Well, that's it for tonight... I'll be seeing you soon. I hope I'm not seeing YOU again. Goodnight.

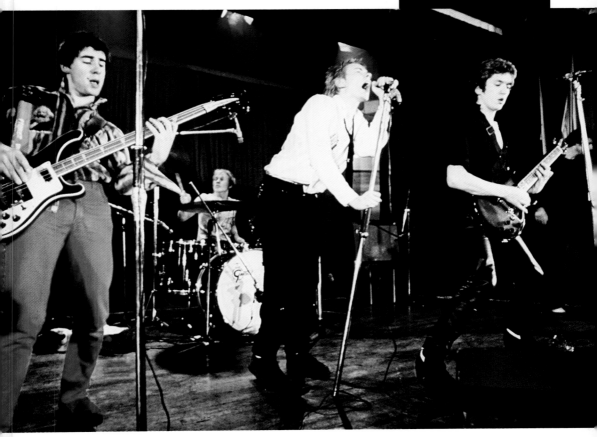

PRIMARY PUNKS

SEMINAL PUNK ROCK BAND THE SEX PISTOLS: (L–R) GLEN MATLOCK (BASS),
PAUL COOK (DRUMS), JOHNNY ROTTEN (JOHN LYDON – VOCALS), STEVE JONES (GUITAR).
THE BAND WAS INSTRUMENTAL IN THE FORMATION OF THE PUNK MOVEMENT IN THE UK.

1st December, 1976

The defence

Sex Pistols manager Malcolm McLaren at a press conference in Manchester to defend the band against growing criticism following their television appearance with Bill Grundy.

2nd December, 1976

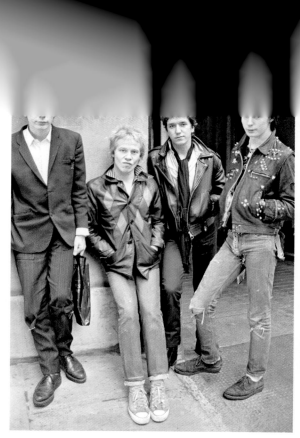

New pistol

When bass player Glen Matlock left the Sex Pistols in 1977, his place was taken by John Richie (R), who assumed the stage name Sid Vicious. He had been chosen by manager Malcolm McLaren more for his look and attitude than his ability to play bass, which at first was vitually non-existent.

1977

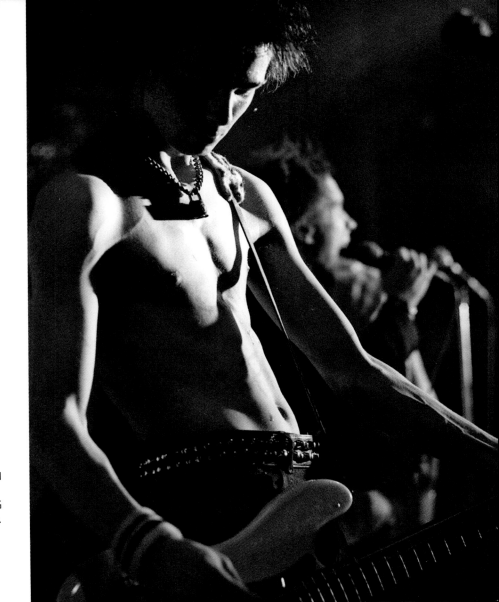

BARELY THERE
RIGHT: SID VICIOUS ON
STAGE WITH THE SEX
PISTOLS DURING A GIG
IN THE NETHERLANDS.
11th December, 1977

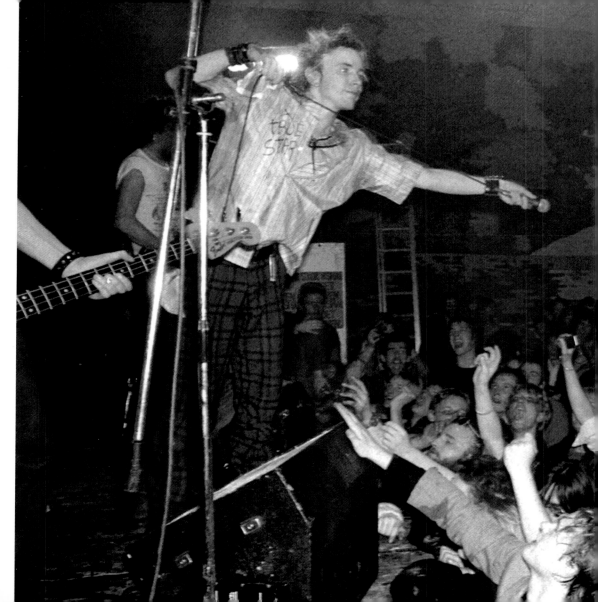

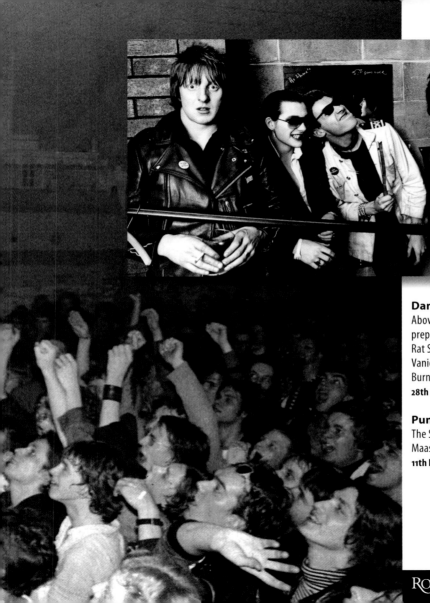

Damned punks
Above: Punk rock band The Damned prepare for a gig in Newcastle. L—R: Rat Scabies (Christopher Millar), Dave Vanion, Captain Sensible (Raymond Burns), Brian James.
28th March, 1977

Punks' chorus
The Sex Pistols on stage at Maasbree in the Netherlands.
11th December, 1977

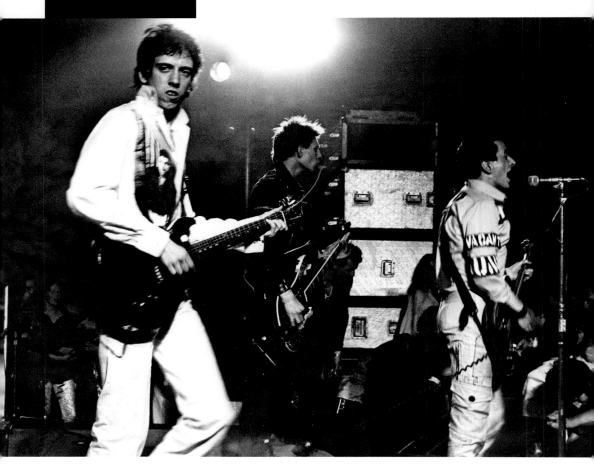

Student gig
Punk rock band The Clash play a gig at the Students' Union, Newcastle Upon Tyne. L–R: Mick
Jones (guitar), Paul Simonon (bass), Joe Strummer (guitar/vocals), Nicky 'Topper' Headon
(drums). The Clash were one of the originating bands of the British punk scene.
20th May, 1977

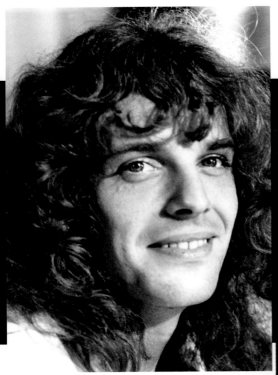

Soloist
Rock guitarist and vocalist Peter Frampton, who came to prominence initially with rock bands The Herd and Humble Pie. Since then, he has carved out a successful solo career.
21st October, 1976

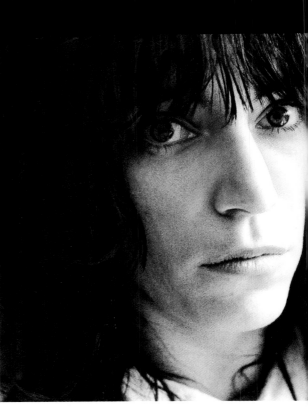

The Godmother
American singer and poet Patti Smith, who played a major role in the birth of the punk movement in the USA. She is often referred to as 'The Godmother of Punk'.
11th May, 1976

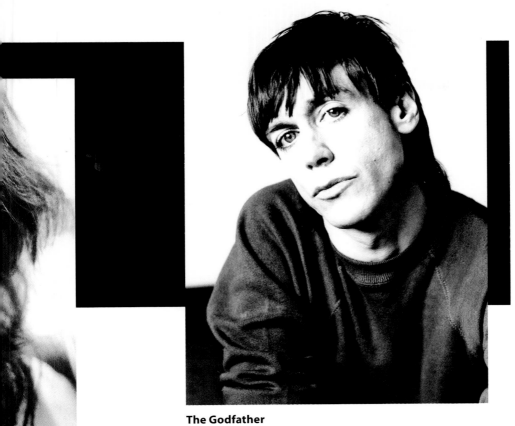

The Godfather

American singer Iggy Pop (real name James Osterburg, Jr) had a major influence on the burgeoning punk movement through his work with garage rock band The Stooges in the early 1970s. He is sometimes known as the 'Godfather of Punk'.

1st March, 1977

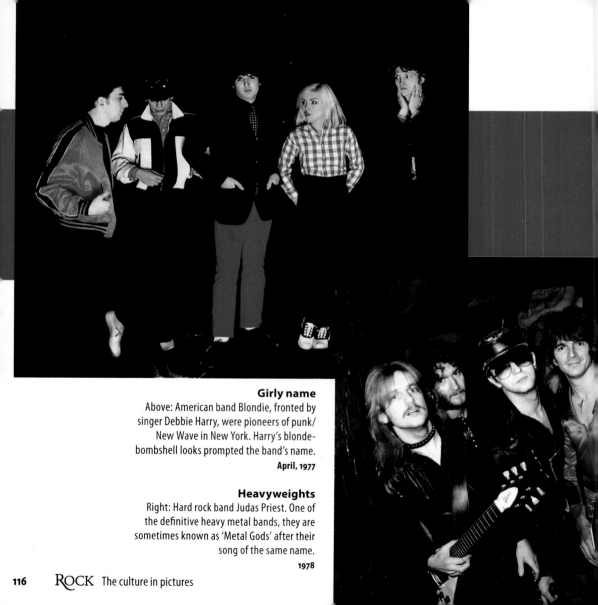

Girly name
Above: American band Blondie, fronted by singer Debbie Harry, were pioneers of punk/ New Wave in New York. Harry's blonde-bombshell looks prompted the band's name.
April, 1977

Heavyweights
Right: Hard rock band Judas Priest. One of the definitive heavy metal bands, they are sometimes known as 'Metal Gods' after their song of the same name.
1978

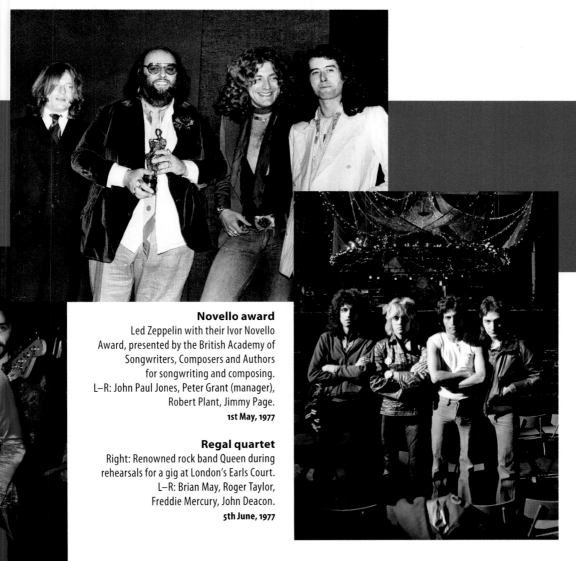

Novello award
Led Zeppelin with their Ivor Novello
Award, presented by the British Academy of
Songwriters, Composers and Authors
for songwriting and composing.
L–R: John Paul Jones, Peter Grant (manager),
Robert Plant, Jimmy Page.
1st May, 1977

Regal quartet
Right: Renowned rock band Queen during
rehearsals for a gig at London's Earls Court.
L–R: Brian May, Roger Taylor,
Freddie Mercury, John Deacon.
5th June, 1977

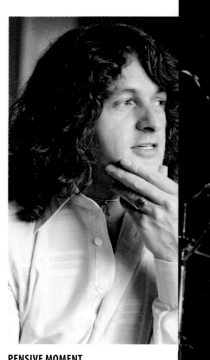

PENSIVE MOMENT
VOCALIST JON ANDERSON, CO-FOUNDER
OF PROGRESSIVE ROCK BAND YES,
DURING A THOUGHTFUL MOMENT.
1st July, 1977

YES MEN
YES ON STAGE AT WEMBLEY: (L–R) STEVE
HOWE, JON ANDERSON, CHRIS SQUIRE,
RICK WAKEMAN. THE BAND WAS A
PIONEER OF THE PROGRESSIVE
ROCK GENRE.
November, 1977

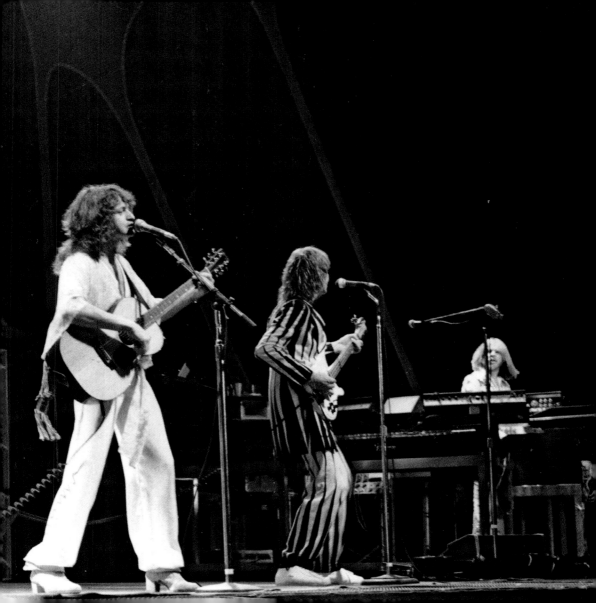

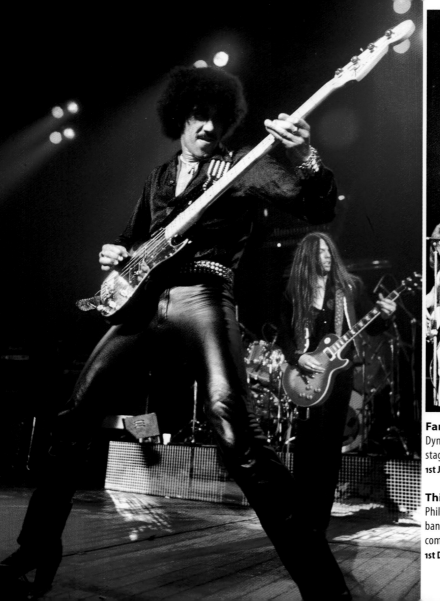

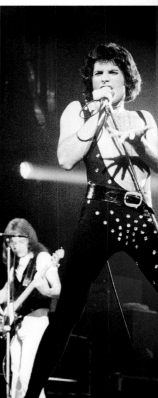

Fantastic Freddie
Dynamic singer Freddie Mercury on stage during a Queen gig.
1st June, 1977

Thin man
Phil Lynott, front man of Irish hard rock band Thin Lizzy. Lynott composed or co-composed almost all of the band's songs
1st December, 1977

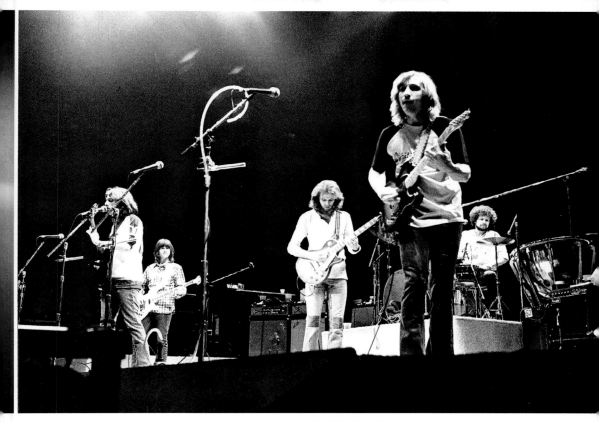

EAGLES IN THE GARDEN

AMERICAN COUNTRY/FOLK ROCK BAND THE EAGLES PLAY A GIG
AT MADISON SQUARE GARDEN, NEW YORK. THE BAND WAS
ONE OF THE MOST SUCCESSFUL MUSICAL ACTS OF THE 1970S,
WITH FIVE NUMBER-ONE SINGLES, SIX NUMBER-ONE ALBUMS
AND A NUMBER OF AWARDS.

18th March, 1977

New album
Above: Keyboard player Ken Hensley (L) and vocalist John Lawton, of seminal hard rock band Uriah Heep, pictured outside their record company's offices in Chalk Farm, London. The band was celebrating the release of its 11th album, *Innocent Victim*.
15th November, 1977

Saying goodbye
Below: Fans pay tribute to singer Marc Bolan after his cremation at Golders Green in London. Bolan had died in a car crash a few days before.
20th September, 1977

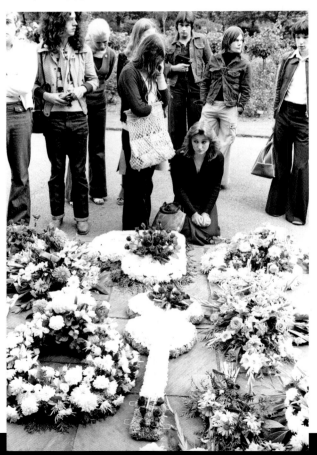

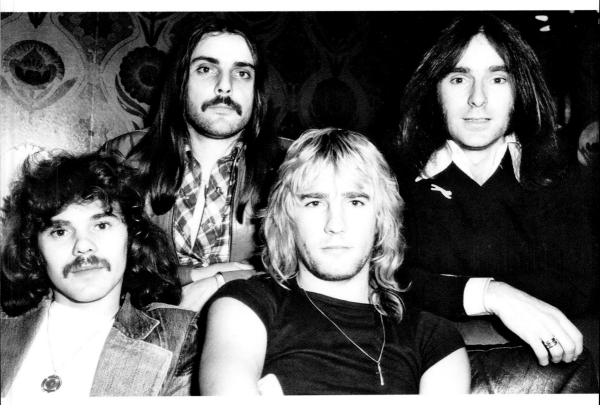

The Quo
Hard rock/boogie rock band Status Quo celebrate 10 years in the business. Their style of playing brought them countless accolades and a legion of dedicated fans, known as the 'Quo Army'. To date, they have sold over 120 million albums worldwide. L–R: Alan Lancaster, John Coghlan, Rick Parfitt, Francis Rossi.
15th February, 1977

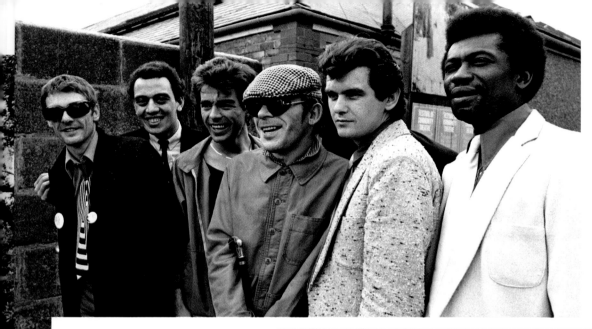

Talented man
Above: Protopunk/New Wave band Ian Dury and The Blockheads. Dury (third R) was a lyricist as well as a singer and actor.
June, 1979

Leading from the front
Left: Bob Geldof (C) was front man for the Irish punk band The Boom Town Rats.
13th June, 1978

Police band
Right: New Wave/reggae rock band The Police: (L–R) Andy Summers (guitar), Sting (real name Gordon Sumner – guitar/vocals), Stewart Copeland (drums).
1st December, 1979

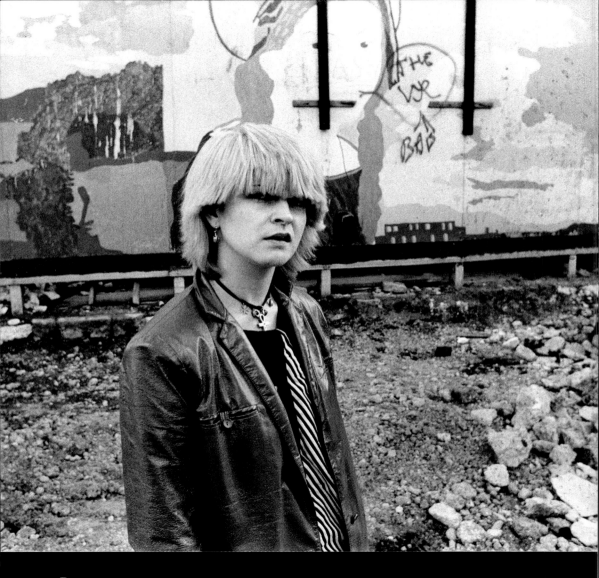

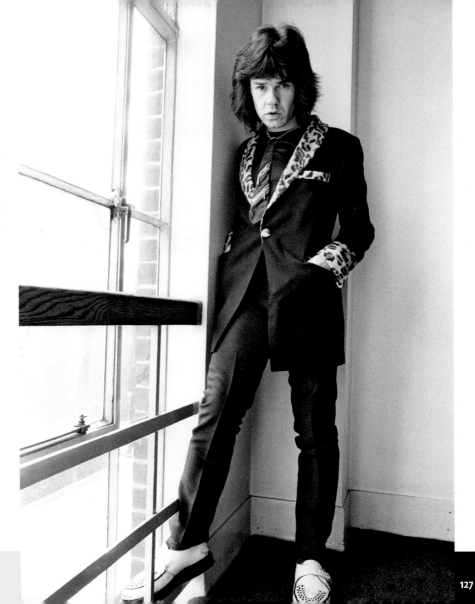

ROCK GARDEN
LEFT: PUNK ACTRESS
AND SINGER
TOYAH WILLCOX
PHOTOGRAPHED IN
COVENT GARDEN.
22nd August, 1979

BLUES MAN
RIGHT: IRISH BLUES
ROCK GUITARIST AND
SINGER GARY MOORE,
WHO ENJOYED A
SUCCESSFUL SOLO
CAREER AS WELL AS
TIME WITH THIN LIZZY.
27th March, 1979

ROD IN RED

ROD STEWART REHEARSES WITH HIS BAND PRIOR TO EMBARKING ON A EUROPEAN TOUR.

27th October, 1980

BOOMTOWN BOB

BOB GELDOF OF THE BOOMTOWN RATS. AFTER LEAVING THE BAND, GELDOF CARVED OUT A SOLO CAREER. IN 1984, HE CO-WROTE THE ENDURING HIT *DO THEY KNOW IT'S CHRISTMAS?* WITH MIDGE URE OF ULTRAVOX. THE SONG WAS WRITTEN TO RAISE MONEY FOR FAMINE VICTIMS IN ETHIOPIA. AS WELL AS CONTINUING TO FOCUS ON THE PLIGHT OF THE THIRD WORLD, GELDOF HAS BECOME A SUCCESSFUL BUSINESSMAN AND SELF-PUBLICIST.

12th May, 1980

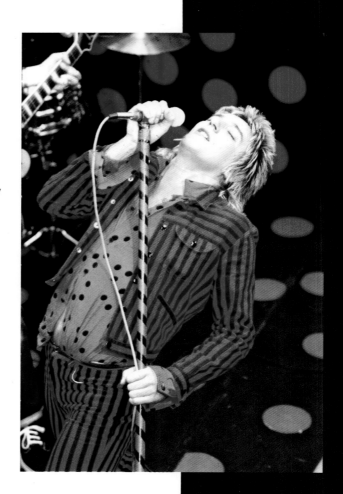

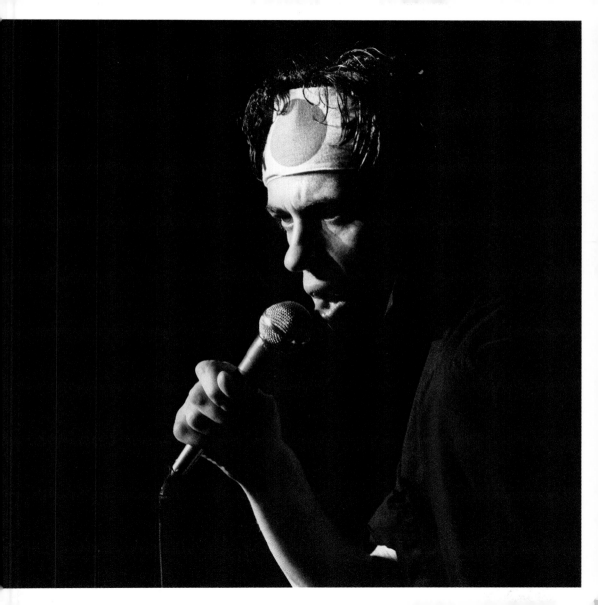

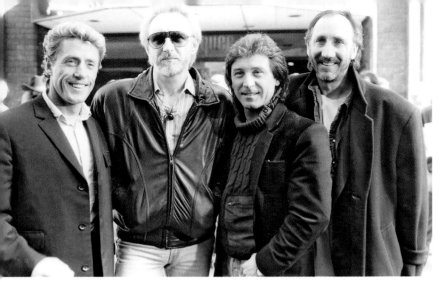

Who are they

Left: The Who, (L–R) Roger Daltrey, John Entwistle, Kenney Jones, Pete Townshend. Jones, formerly of The Faces, had replaced drummer Keith Moon after his death in 1978.

1980

Stage presence

Right: The Police on stage.

1st October, 1981

New mods

Right: Punk/ New Wave/mod revival band The Jam, (L–R) Bruce Foxton, Rick Buckler, Paul Weller. The band had 18 consecutive Top 40 singles, including four number ones.

22nd April, 1980

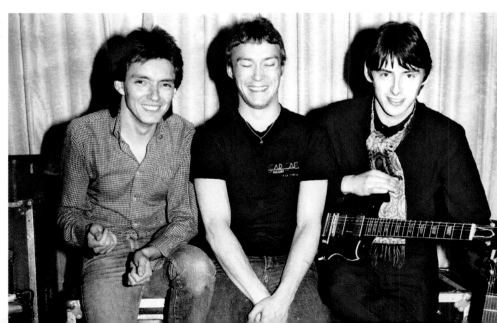

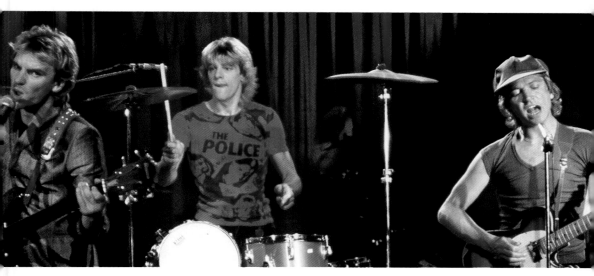

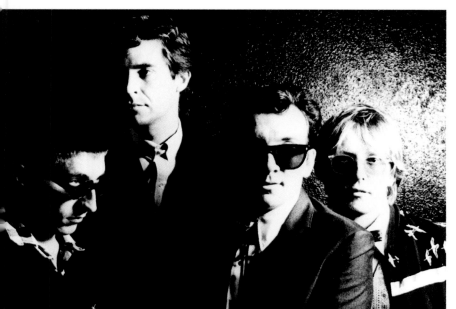

Pop star

Left: Pub rock/New Wave band Elvis Costello and The Attractions. Singer/ songwriter Costello (second R) was the son of jazz trumpeter Ross MacManus. His first broadcast was as backing for his father, who wrote and sang the song *I'm a Secret Lemonade Drinker* for a TV commercial.

1981

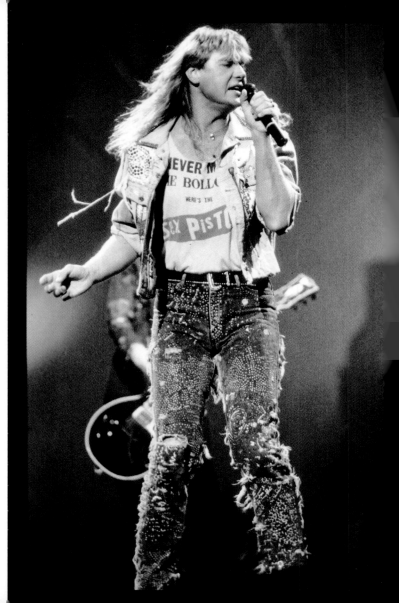

METAL MAN

RIGHT: JOE ELLIOTT, VOCALIST WITH HARD ROCK/HEAVY METAL BAND DEF LEPPARD. THE BAND'S MOST SUCCESSFUL PERIOD WAS BETWEEN THE EARLY 1980S AND EARLY 1990S, AND THEY HAVE SOLD OVER 65 MILLION ALBUMS WORLDWIDE.

1980

IN THE SPOTLIGHT

FAR RIGHT: ART/PROGRESSIVE ROCK SINGER/SONGWRITER KATE BUSH. NOTABLE FOR HER UNUSUAL VOCAL STYLE, BUSH IS ALSO A MULTI-INSTRUMENTALIST AND ONE OF THE MOST SUCCESSFUL UK FEMALE SOLO ARTISTS OF THE LAST 30 YEARS. SHE WAS THE FIRST WOMAN TO HAVE A SELF-WRITTEN NUMBER-ONE SINGLE, *WUTHERING HEIGHTS*, AND THE FIRST FEMALE ARTIST EVER TO ENTER THE ALBUM CHART AT NUMBER ONE.

1980

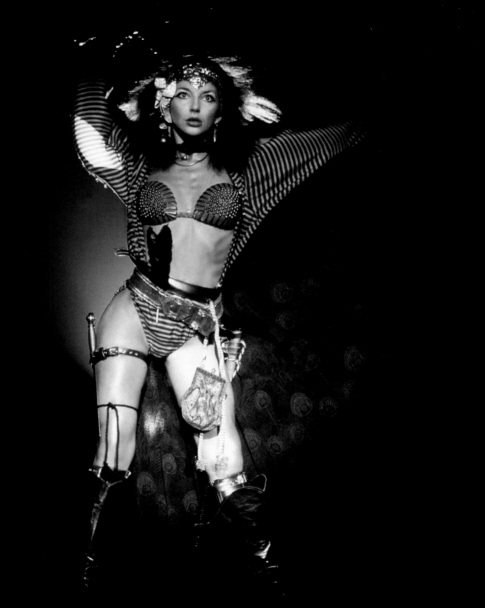

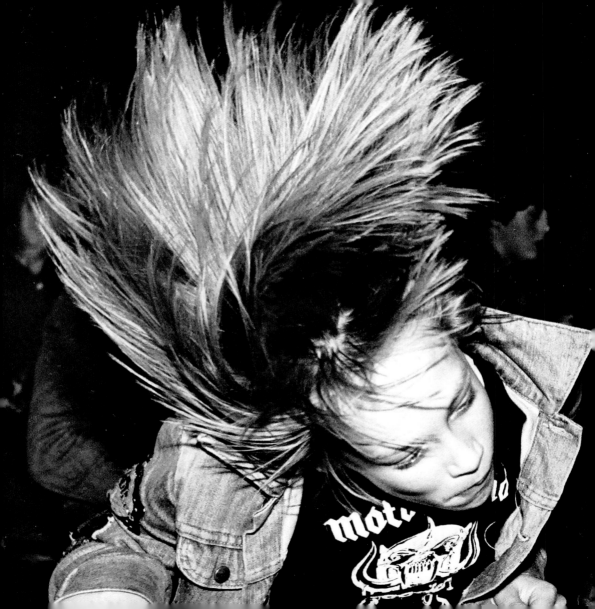

Headbanger
Left: A fan of heavy metal rock band Motorhead demonstrates headbanging – violently shaking the head in time with the music. It is not without its risks, however, and has been known to cause stiff necks and whiplash. One heavy metal guitarist, Terry Balsamo, even suffered a stroke from it.
9th April, 1981

Wallbanger?
Right: Brian Johnson, vocalist with Australian hard rock band AC/DC, contemplates the excesses of a rock 'n' roll lifestyle. The band has sold over 200 million albums worldwide.
4th February, 1982

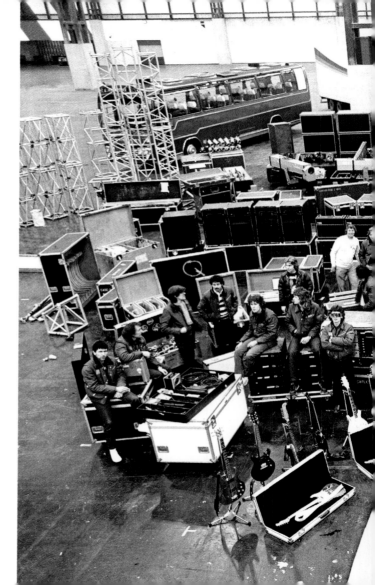

EQUIPMENT CHECK

STATUS QUO STAND IN FRONT OF THEIR
SUPPORT CREW, AND ALL THE EQUIPMENT
AND VEHICLES NEEDED FOR THEM TO TOUR.
THE PHOTOGRAPH WAS TAKEN AT THE
NEC, BIRMINGHAM, WHERE THEY HAD
JUST PLAYED A GIG AS PART OF THEIR
'NEVER TOO LATE' TOUR.

23rd March, 1981

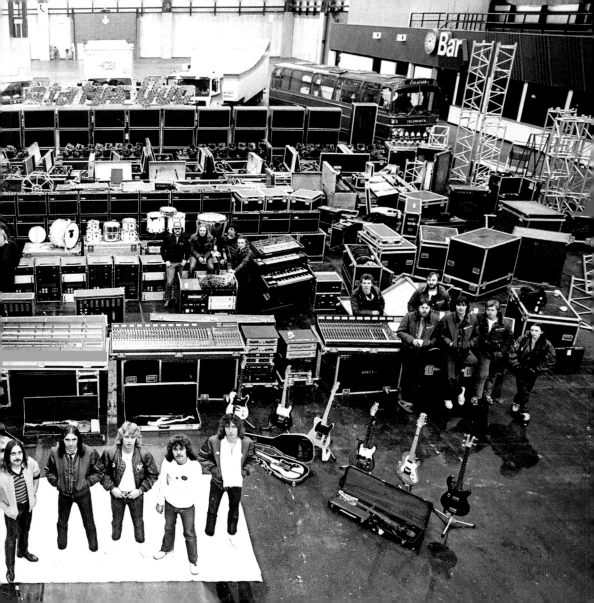

Dr in the house
Lee Brilleaux of pub/blues rock band Dr Feelgood, on stage at the Rock
on the Tyne Festival at Gateshead International Stadium.
30th August, 1981

JAMMING
Above: Paul Weller (L) of The Jam rehearses a number.
1982

Go girls, go!

American all-female group The Go-Go's started out as a punk band, but their work evolved into New Wave and pop rock. Belinda Carlisle (top R) was a long-term member before embarking on a solo career.

August, 1982

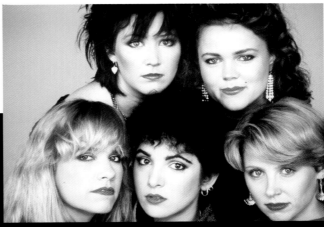

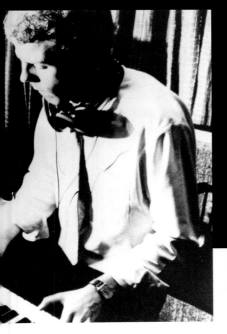

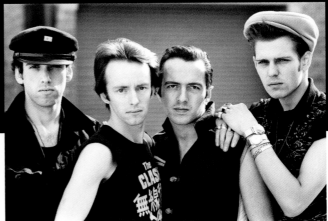

BEST ALBUM

THE CLASH. THEIR THIRD ALBUM, *LONDON CALLING*, WAS DECLARED THE BEST ALBUM OF THE 1980S BY AMERICAN MAGAZINE *ROLLING STONE*.

21st April, 1982

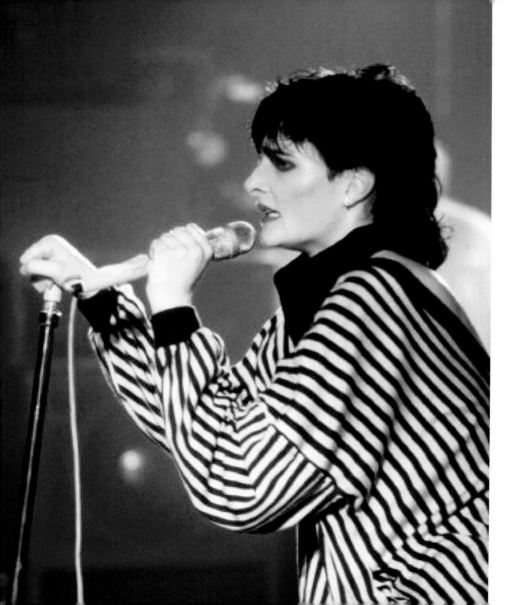

MUSICAL AUDACITY
SIOUXSIE SIOUX ON STAGE DURING A GIG WITH THE BANSHEES. *THE TIMES* DESCRIBED THE BAND AS "ONE OF THE MOST AUDACIOUS AND UNCOMPROMISING MUSICAL ADVENTURERS OF THE POST-PUNK ERA."
1978

AT THE MIKE
IRISH BLUES/HARD ROCK MUSICIAN AND SINGER RORY GALLAGHER ON STAGE DURING A EUROPEAN TOUR. THE CHARISMATIC GALLAGHER SOLD OVER 30 MILLION ALBUMS WORLDWIDE. HE DIED IN 1995 FROM COMPLICATIONS AFTER A LIVER TRANSPLANT.
April, 1982

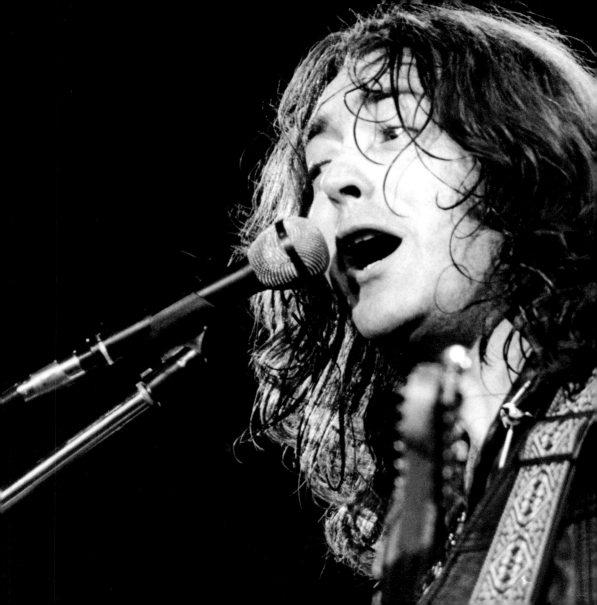

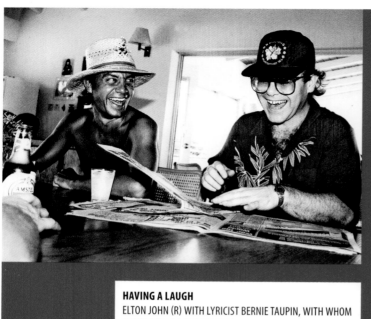

HAVING A LAUGH
ELTON JOHN (R) WITH LYRICIST BERNIE TAUPIN, WITH WHOM
HE ENJOYED A LONG-TERM COLLABORATION.
24th October, 1982

MOUSCAPADE
RIGHT: ELTON JOHN ON STAGE IN A MINNIE MOUSE COSTUME.
THE SINGER HAS ALWAYS BEEN RENOWNED FOR HIS
FLAMBOYANT DRESS SENSE.
1983

HAPPY COUPLE
FAR RIGHT: ELTON JOHN CELEBRATES HIS MARRIAGE TO
GERMAN RECORDING ENGINEER RENATE BLAUEL AT DARLING
POINT, SYDNEY, AUSTRALIA. THE MARRIAGE WAS DISSOLVED
SEVEN YEARS LATER WHEN THE COUPLE COULD NO LONGER
DENY HIS TRUE SEXUALITY.
14th February, 1984

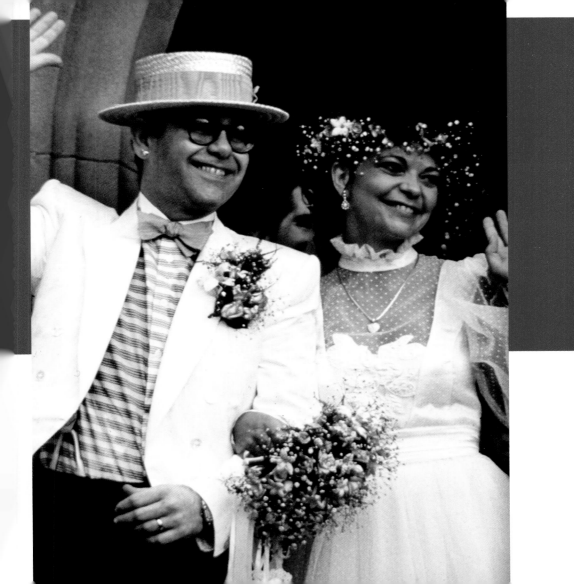

Launch party

Right: Co-founders of American New Wave band Blondie, Debbie Harry and Chris Stein, at a party to celebrate the publication of the book *Making Tracks – The Rise of Blondie*.

21st May, 1982

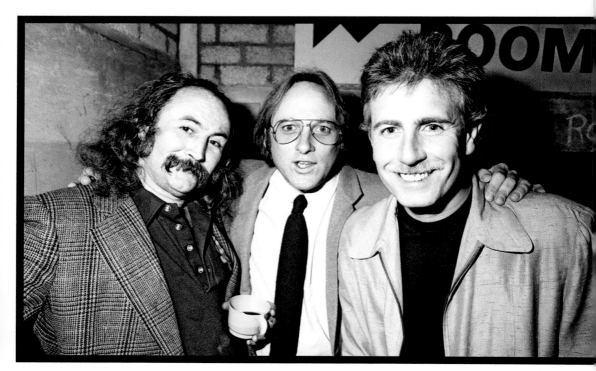

HARMONIC TRIO

FOLK ROCK SUPERGROUP CROSBY, STILLS AND NASH: (L–R) DAVID CROSBY, STEVEN STILLS, GRAHAM NASH. AMERICANS CROSBY AND STILLS WERE FORMERLY WITH THE BYRDS AND BUFFALO SPRINGFIELD RESPECTIVELY, WHILE NASH IS ENGLISH AND CAME TO PROMINENCE WITH BEAT GROUP THE HOLLIES. THE BAND IS NOTED FOR THEIR INTRICATE VOCAL HARMONIES.

15th June, 1983

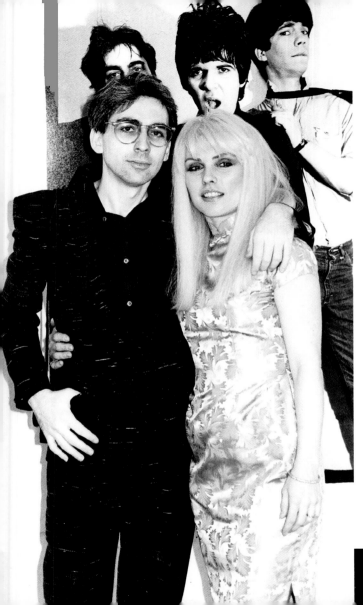

Rock royalty

Below: American country/pop rock singer Linda Ronstadt, known variously as 'The Queen of Rock' and the 'First Lady of Rock'. Ronstadt is one of the most versatile and commercially successful female singers in US history, and once was the highest paid woman in rock.

18th January, 1983

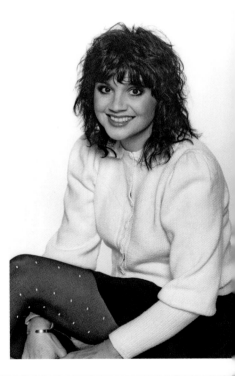

Black Prince

Ozzy Osbourne, the 'Prince of Darkness', on stage during a gig at Hammersmith Odeon in London. Osbourne had been co-founder of heavy metal band Black Sabbath, but had been fired from the band in 1979 because of his alcohol and drug abuse. He established a successful solo career, however, earning a number of platinum discs in a career that has spanned over 40 years.

November, 1983

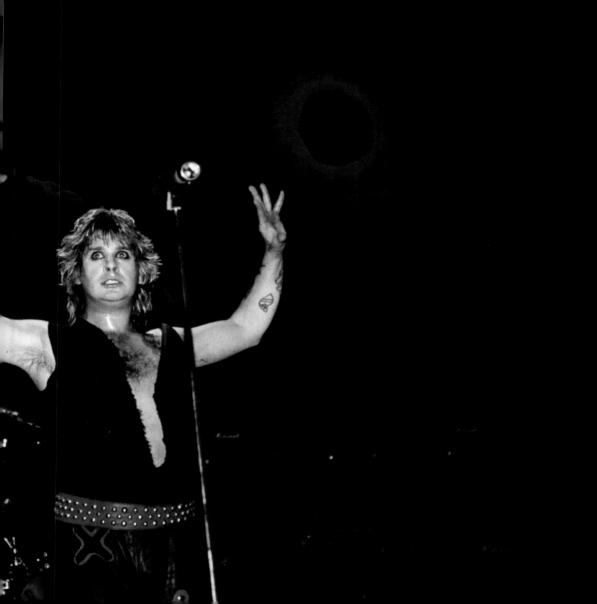

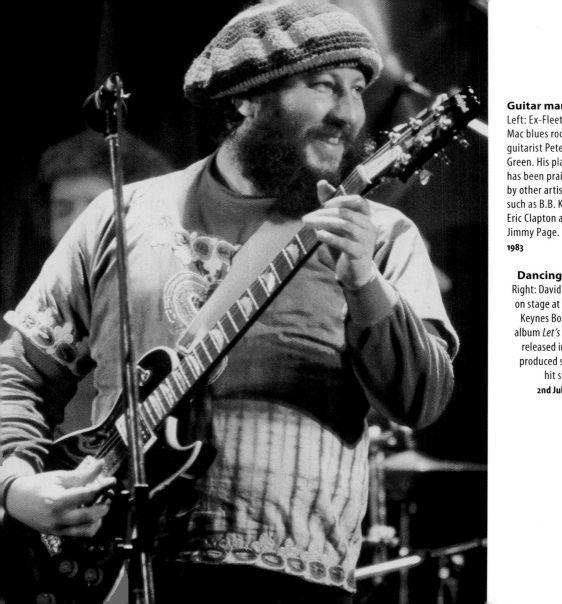

Guitar man
Left: Ex-Fleetwood
Mac blues rock
guitarist Peter
Green. His playing
has been praised
by other artists
such as B.B. King,
Eric Clapton and
Jimmy Page.
1983

Dancing man
Right: David Bowie
on stage at Milton
Keynes Bowl. His
album *Let's Dance*,
released in 1983,
produced several
hit singles.
2nd July, 1983

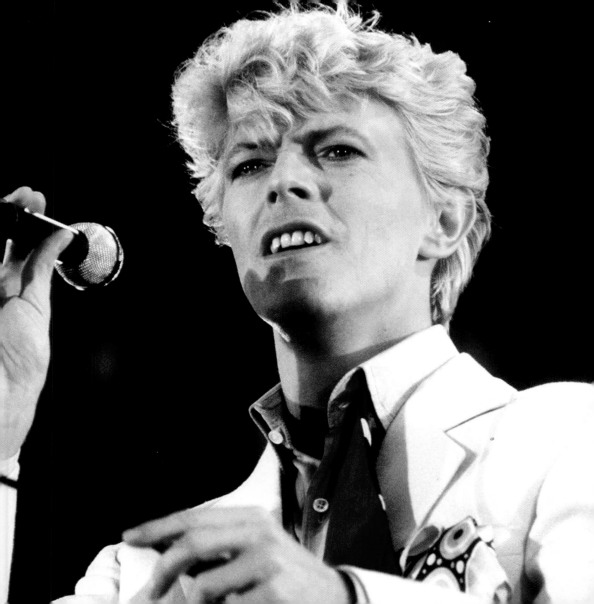

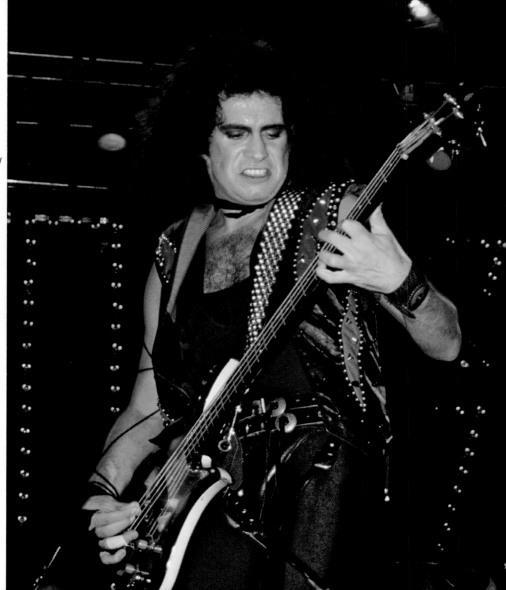

Bare Faced
American rock band Kiss play a gig at Wembley Arena. This was said to be the first time that they had been seen without their dramatic stage make-up. L–R: Gene Simmons, Paul Stanley.
23rd October, 1983

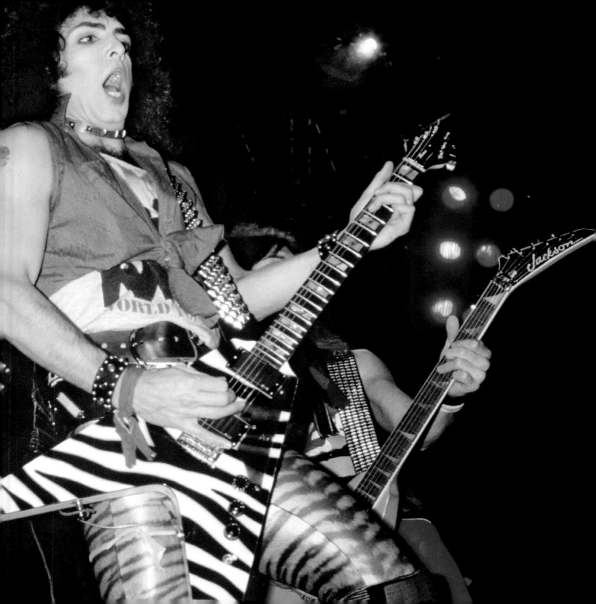

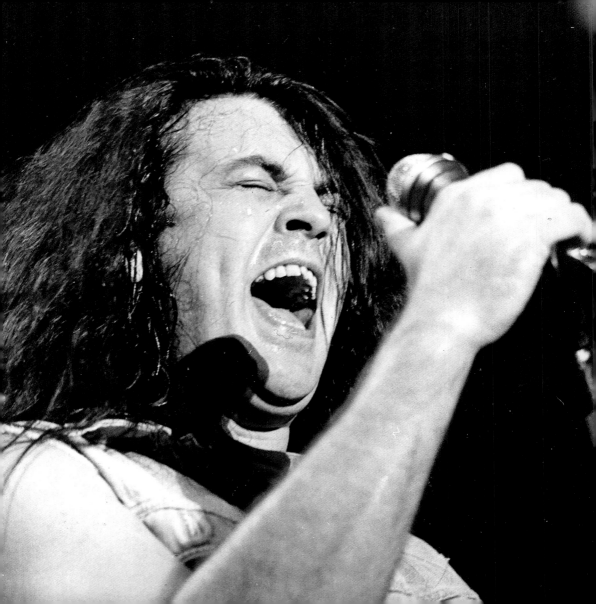

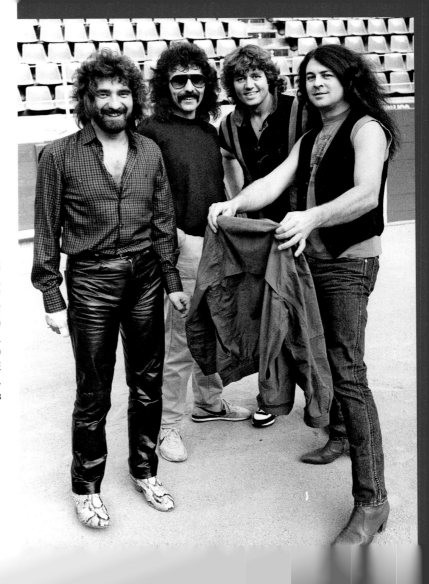

SABBATH SABBATICAL
LEFT: IAN GILLAN, SINGER WITH HEAVY METAL BAND BLACK SABBATH. KNOWN FOR HIS WIDE VOCAL RANGE, GILLAN CAME TO PROMINENCE WITH HARD ROCK BAND DEEP PURPLE AND SPENT A YEAR WITH BLACK SABBATH BETWEEN 1983 AND 1984.

1983

METAL PIONEERS
RIGHT: PIONEERING HEAVY METAL BAND BLACK SABBATH: (L–R) TERRY 'GEEZER' BUTLER, TONY IOMMI, BEV BEVAN, IAN GILLAN. BEVAN HAD REPLACED ORIGINAL DRUMMER BILL WARD, WHILE GILLAN HAD STOOD IN FOR PREVIOUS VOCALIST RONNIE JAMES DIO.

1983

FLAMBOYANT FREDDIE
POWERFUL VOCALIST
FREDDIE MERCURY OF QUEEN,
ON STAGE DURING A GIG AT
WEMBLEY ARENA. IT WAS HIS
38TH BIRTHDAY. MERCURY
ALSO COMPOSED MANY OF
THE BAND'S HITS, INCLUDING
WE ARE THE CHAMPIONS. HE
IS CONSIDERED ONE OF THE
GREATEST MALE SINGERS OF
ALL TIME. HE DIED IN 1991
OF BRONCHOPNEUMONIA
BROUGHT ON BY THE
CONTRACTION OF AIDS.
5th September, 1984

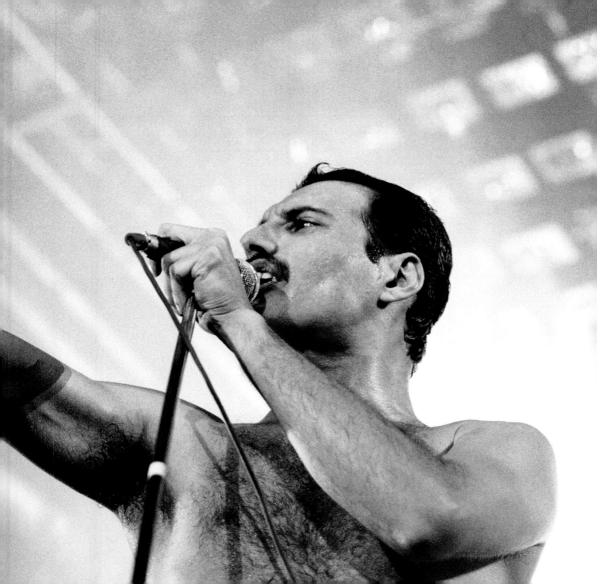

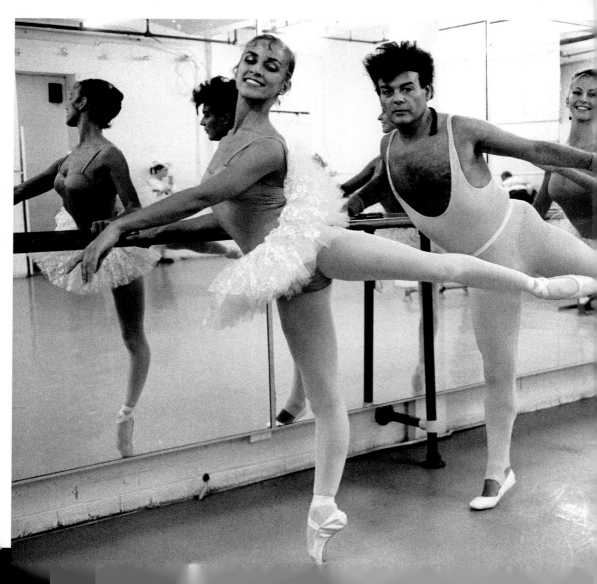

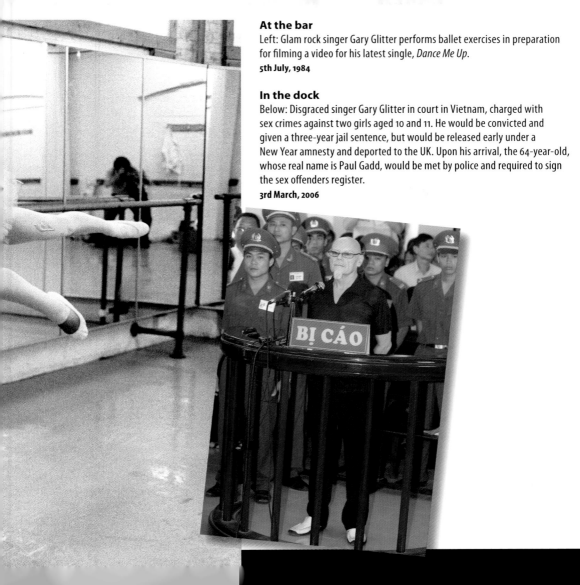

At the bar
Left: Glam rock singer Gary Glitter performs ballet exercises in preparation for filming a video for his latest single, *Dance Me Up*.
5th July, 1984

In the dock
Below: Disgraced singer Gary Glitter in court in Vietnam, charged with sex crimes against two girls aged 10 and 11. He would be convicted and given a three-year jail sentence, but would be released early under a New Year amnesty and deported to the UK. Upon his arrival, the 64-year-old, whose real name is Paul Gadd, would be met by police and required to sign the sex offenders register.
3rd March, 2006

BỊ CÁO

WAVE OF SUCCESS

MANCHESTER BAND THE SMITHS: (L–R) ANDY ROUKE (BASS), STEVEN MORRISSEY (VOCALS), MIKE JOYCE (DRUMS),
JOHNNY MARR (GUITAR). THE SMITHS ARE CONSIDERED BY MANY TO BE THE MOST IMPORTANT ALTERNATIVE ROCK BAND
TO EMERGE FROM THE INDEPENDENT MUSIC SCENE IN THE 1980S.

12th March, 1984

Bedding down
Status Quo demonstrate the sleeping accommodation on their new, £150,000 tour bus, which would be used for their final world tour.
4th April, 1984

159

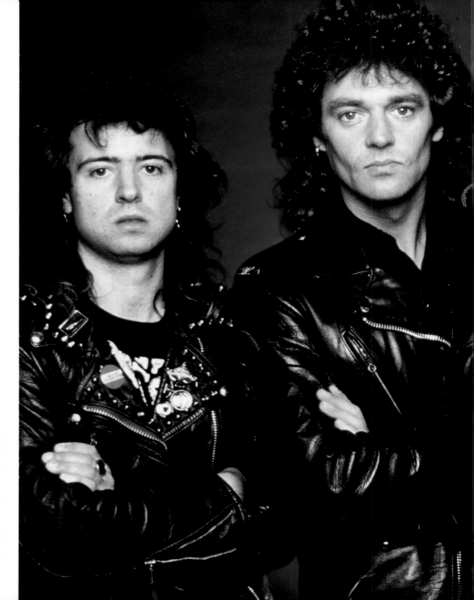

Making a point
Hard rock/heavy metal band Motorhead: (L–R) Phil Campbell, Pete Gill, Ian 'Lemmy' Kilmister, Michael 'Würzel' Burston. Formed by Lemmy in 1975, Motorhead is considered one of the UK's foremost rock bands.
1st October, 1984

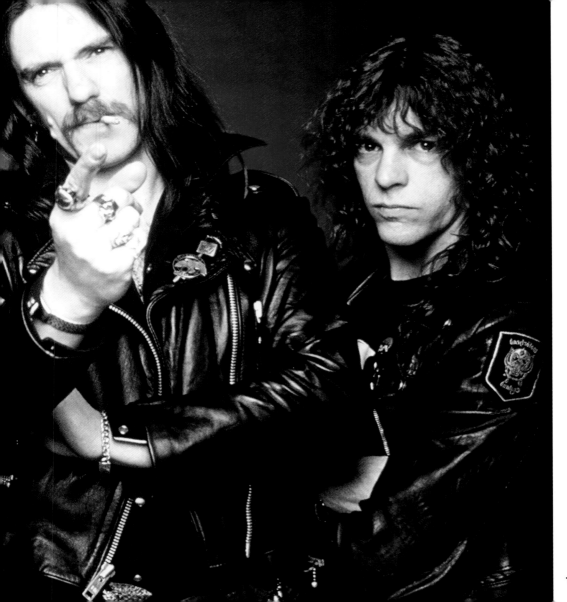

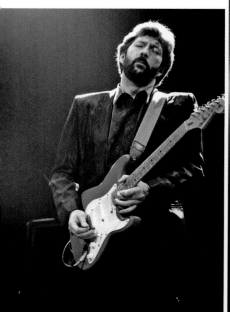

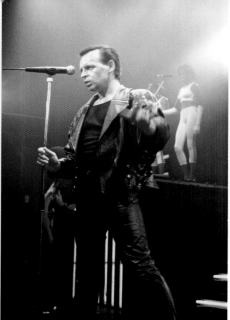

ELECTRONIC PIONEER
LEFT: NEW WAVE/
SYNTHPOP/INDUSTRIAL
ROCK SINGER GARY NUMAN.
A PIONEER OF COMMERCIAL
ELECTRONIC MUSIC, NUMAN
IS BEST KNOWN FOR HIS
1979 HITS *ARE 'FRIENDS'
ELECTRIC?* (AS FRONT MAN
OF PUNK BAND TUBEWAY
ARMY) AND *CARS*.
1985

Feeling the music
Above: Eric Clapton in concert at the Royal
Albert Hall, London. Clapton is considered
one of the most important and influential
guitarists of all time.
6th January, 1984

Not so simple
Right: New Wave/alternative rock band
Simple Minds, (L–R) Mel Gaynor, Charlie
Burchill, Derek Forbes, Jim Kerr, Mick MacNeill.
The band produced a number of acclaimed
albums in the early 1980s.
6th March, 1984

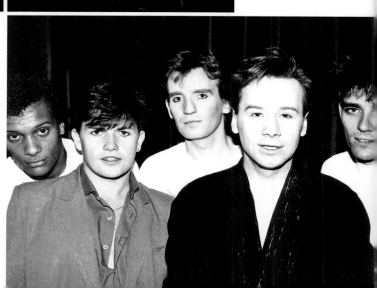

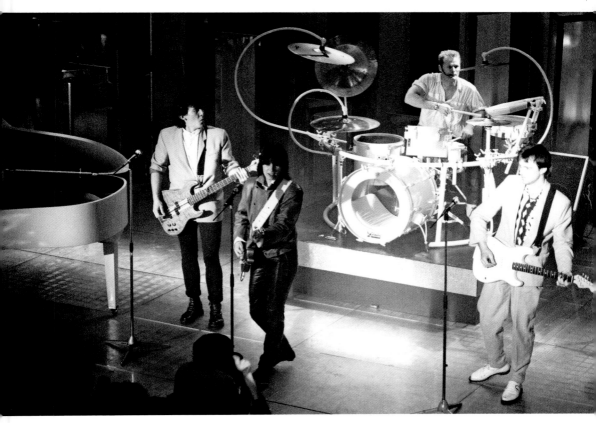

Not pretending
New Wave/alternative rock band
The Pretenders, fronted by Chrissie
Hynde (second L), on stage during
the Montreaux Golden Rose
television festival. Hynde is the only
continuous member of the band.
18th May, 1984

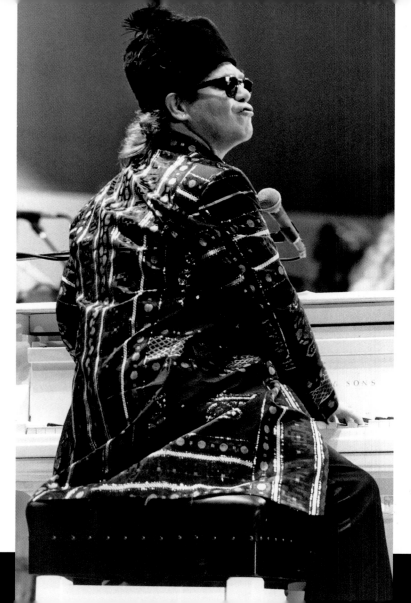

PIANO MAN
LEFT: ELTON JOHN ON
STAGE DURING THE LIVE
AID CONCERT HELD AT
WEMBLEY STADIUM.
13th July, 1985

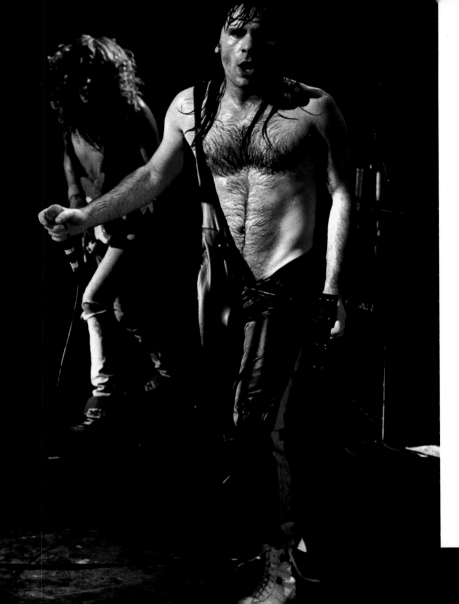

Heated performance
Bruce Dickinson, lead singer
of Iron Maiden, one of the
most successful heavy
metal bands in history.
They have sold over 85
million albums worldwide.
1985

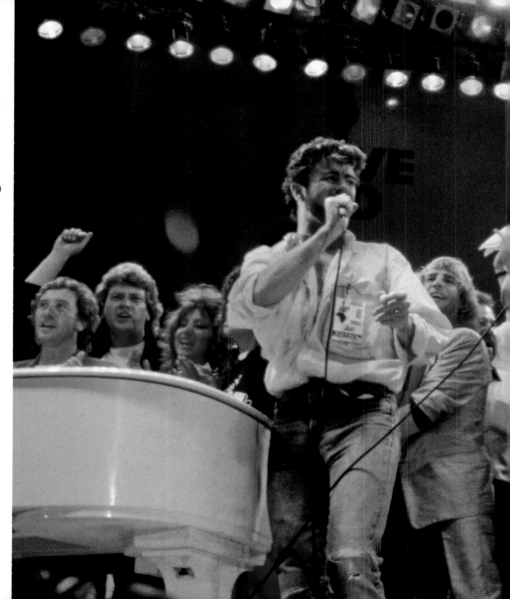

CHARITABLE ACT
THE FINALE OF THE LIVE AID CONCERT AT WEMBLEY STADIUM. AMONG THE STARS ON STAGE ARE GEORGE MICHAEL (L), U2 LEAD SINGER BONO (C) AND QUEEN FRONTMAN FREDDIE MERCURY (R). THE EVENT HAD BEEN ORGANISED BY BOB GELDOF AND MIDGE URE TO AID FAMINE VICTIMS IN ETHIOPIA.
13th July, 1985

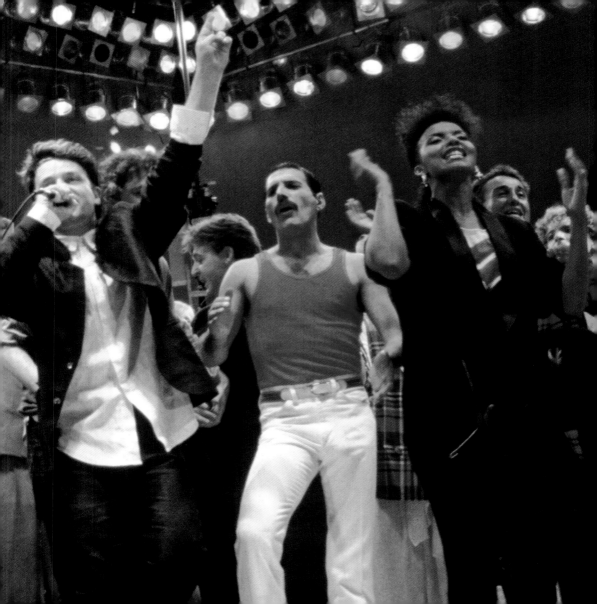

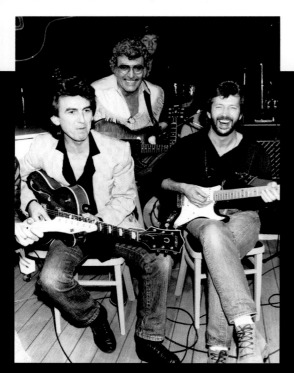

Legendary trio

Above: Former Beatles guitarist George Harrison (L) with American rock 'n' roll legend Carl Perkins (C) and Eric Clapton. Harrison and Clapton were among a number of rock musicians appearing on a televised tribute to Perkins.

1985

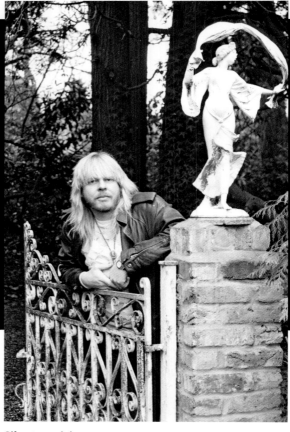

Silent musician

Above: Progressive rock musician Rick Wakeman contemplates his recently released album, *Silent Nights*, and a forthcoming British tour.

21st March, 1985

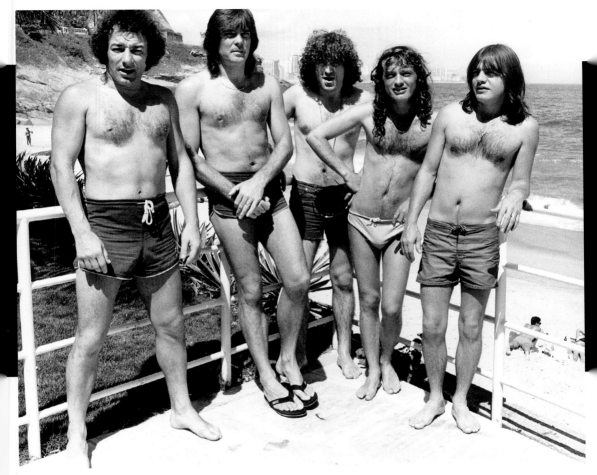

BOYS IN BRAZIL
AC/DC AT THE BEACH AFTER PLAYING GIGS IN RIO DE JANEIRO, BRAZIL, AS
PART OF THEIR 'FLICK OF THE SWITCH' WORLD TOUR.
24th January, 1985

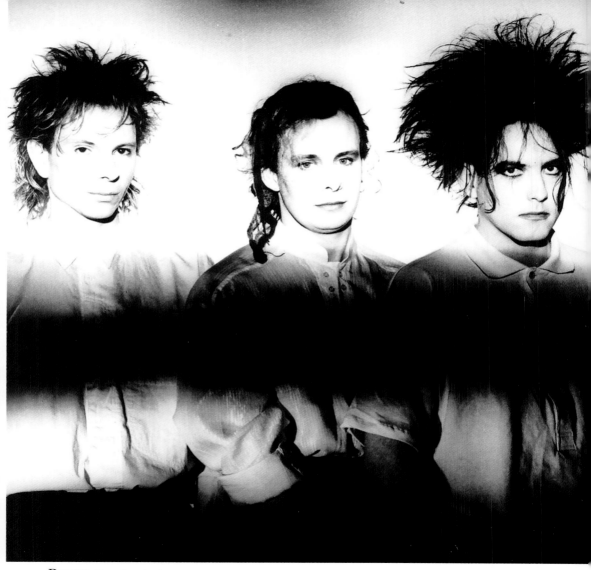

ROCK The culture in pictures

BAD HAIR DAY
ALTERNATIVE/GOTHIC
ROCK BAND THE CURE.
THE BAND WAS FOUNDED
BY FRONT MAN ROBERT
SMITH (C) AND WAS ONE
OF THE WORLD'S MOST
POPULAR ALTERNATIVE
ROCK BANDS OF THE
EARLY 1990S.
10th September, 1986

ONE FOR THE KIDS
THE ELECTRIC LIGHT ORCHESTRA WAS ONE OF MANY BANDS WHO PERFORMED
FOR FREE AT THE 1986 HEARTBEAT CONCERT AT THE NEC, TO RAISE MONEY FOR
BIRMINGHAM CHILDREN'S HOSPITAL.
15th March, 1986

Face net
Martin Degville, singer with glam
punk band Sigue Sigue Sputnik.
1st April, 1986

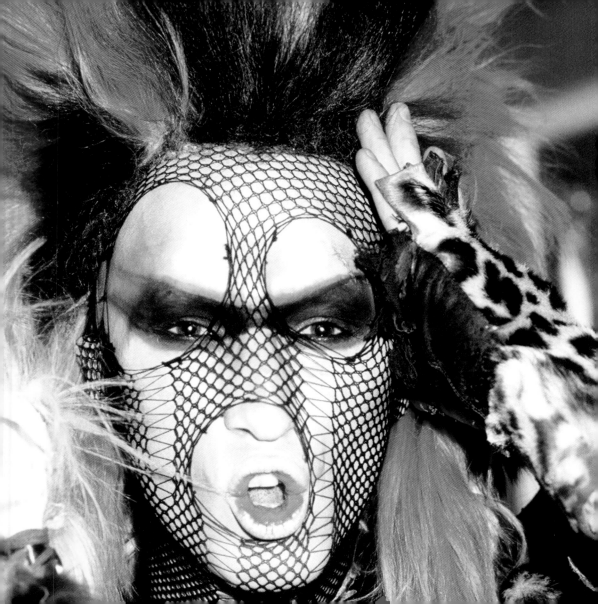

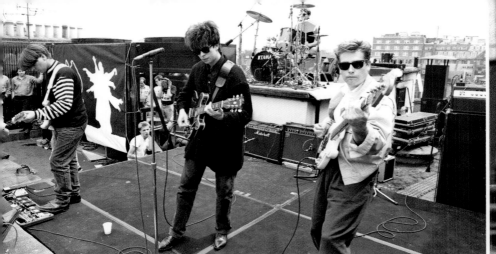

Echoing The Beatles

Above: Post-punk/ alternative rock band Echo and The Bunnymen play a gig on a London rooftop.
6th July, 1987

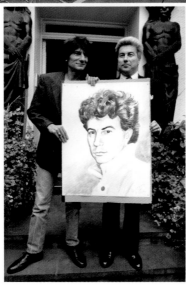

What a picture

Right: Ronnie Wood of the Rolling Stones, an amateur artist, presents his painting of Ken Follett to the renowned author.
September, 1987

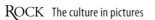

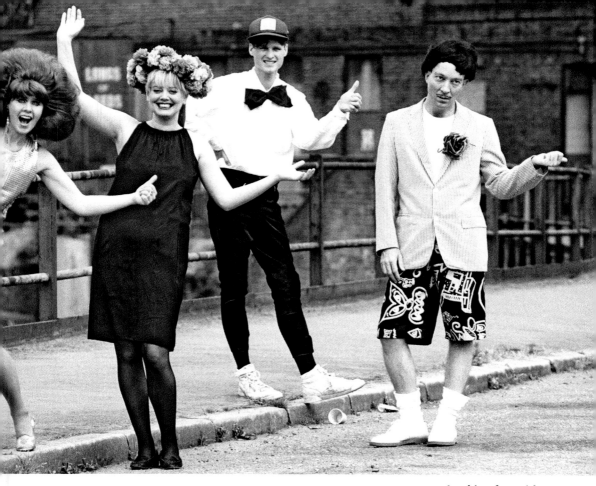

On the stage

Left: In addition to singing, Ian Dury also acted on the stage and in a number of films. He is shown here with Kate Lock in the play *Talk of the Devil*, at the Palace Theatre, Watford.

7th March, 1986

Looking for a ride

American New Wave/pop rock band The B-52s on tour in the UK. L–R: Kate Pierson, Cindy Wilson, Keith Strickland, Fred Schneider.

7th July, 1987

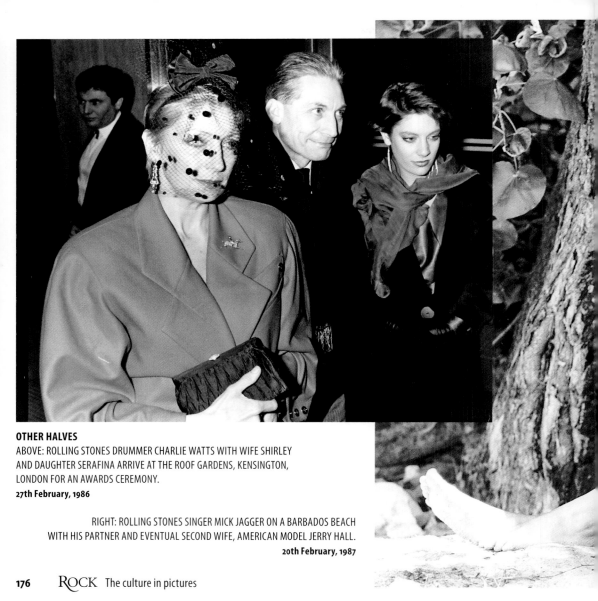

OTHER HALVES

ABOVE: ROLLING STONES DRUMMER CHARLIE WATTS WITH WIFE SHIRLEY
AND DAUGHTER SERAFINA ARRIVE AT THE ROOF GARDENS, KENSINGTON,
LONDON FOR AN AWARDS CEREMONY.

27th February, 1986

RIGHT: ROLLING STONES SINGER MICK JAGGER ON A BARBADOS BEACH
WITH HIS PARTNER AND EVENTUAL SECOND WIFE, AMERICAN MODEL JERRY HALL.

20th February, 1987

Amnesty benefit

Right: American singer/songwriter Lou Reed during a benefit concert for Amnesty International at the London Palladium. Reed came to prominence with The Velvet Underground in the late 1960s; his career has encompassed experimental, art, psychedelic, folk and glam rock.

31st March, 1987

Career man

Below: Former Genesis front man Peter Gabriel during a concert in Clapham, London in aid of the anti-apartheid movement. Gabriel had left the band in 1975, going on to carve out a successful solo career.

8th July, 1986

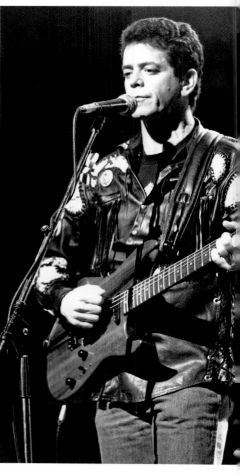

Playing for U2
Right: David 'The Edge' Evans on stage with U2 at the NEC, Birmingham.
3rd June, 1987

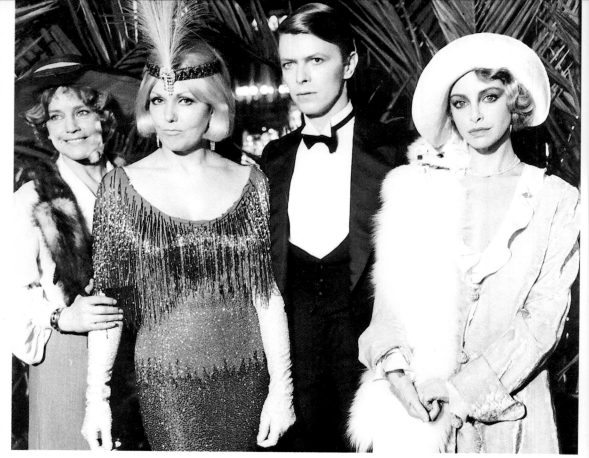

Star man's stars
Above: David Bowie with co-stars from the film *Just a Gigolo*. L–R:
Maria Schell, Kim Novak, Sydne Rome. The film was a flop, prompting
Bowie to call it his "32 Elvis Presley movies rolled into one."
6th February, 1987

Head case
Right: American heavy metal/shock rock singer Alice Cooper
(real name Vincent Furnier). Cooper's stage act draws heavily
on the horror movie genre.
September, 1987

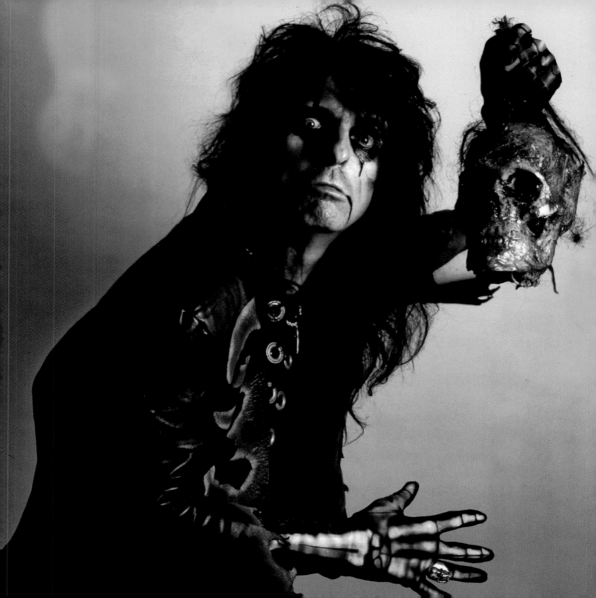

The name's the same

Right and centre: American punk band The Ramones play the Reading Rock Festival. All the members of the band adopted the name Ramone. Joey (L) was lead singer, while Dee Dee (C) played bass.

August, 1988

Taking a dive

Far right: Fans of The Ramones dive from the stage during a gig at The Ritz in New York.

11th September, 1987

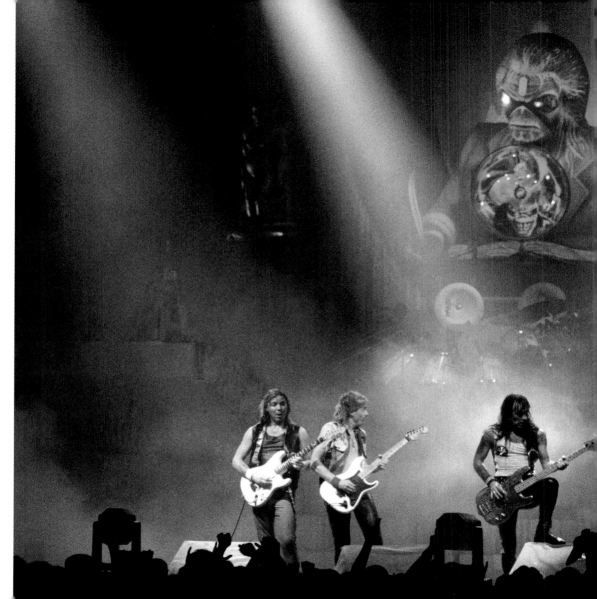

Green menace

Left: Heavy metal band Iron Maiden on stage. Behind them looms their giant mascot 'Eddie', who assumes a different form for every tour. The figure also appears on most of their album and singles covers.

18th July, 1988

Multi-skilled

Below: Iron Maiden's Bruce Dickinson prepares for a fencing match. The accomplished singer/songwriter is also a qualified airline pilot, actor, author, broadcaster and marketing manager.

27th March, 1988

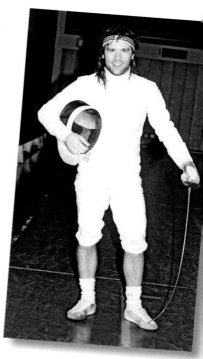

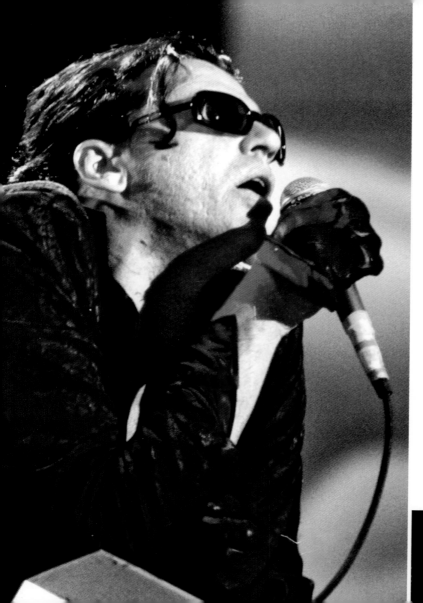

TAKING THE LEAD
LEFT: MICHAEL HUTCHENCE, LEAD SINGER WITH AUSTRALIAN NEW WAVE/ ALTERNATIVE ROCK BAND INXS, ON STAGE DURING THE MUSIC IN THE BAY FESTIVAL IN CARDIFF. HUTCHENCE WOULD COMMIT SUICIDE IN 1997 WHILE SUFFERING FROM DEPRESSION.
14th June, 1988

GADD ABOUT
RIGHT: GLAM ROCK SINGER GARY GLITTER (REAL NAME PAUL GADD) IN FULL VOICE.
20th December, 1988

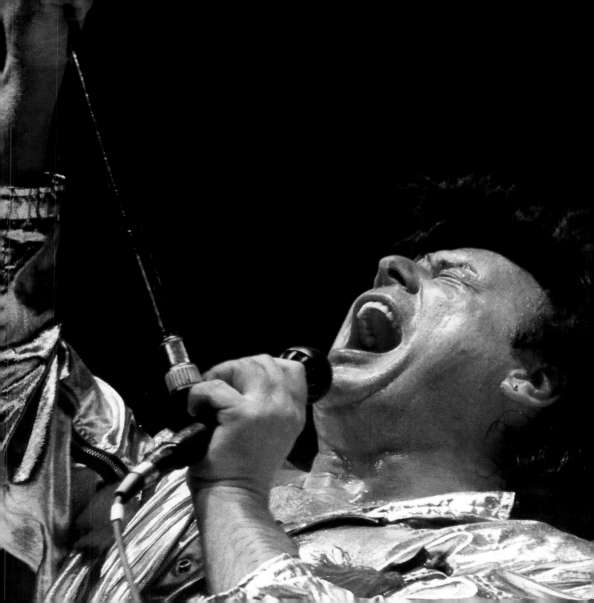

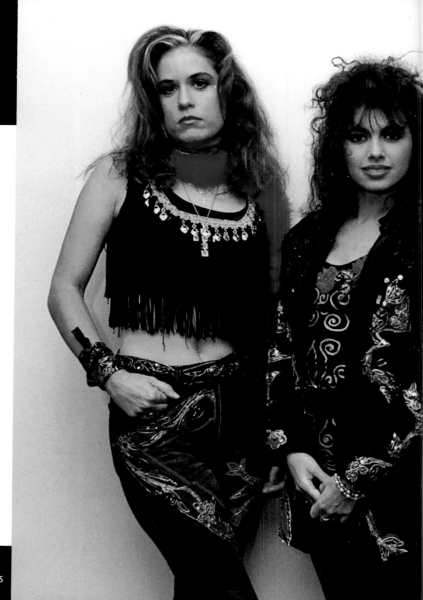

Baubles and bangles

American pop rock band The Bangles, who had a worldwide number one hit with *Walk Like an Egyptian*. L–R: Vicki Peterson, Susanna Hoffs, Debbi Peterson, Michael Steele.

20th October, 1988

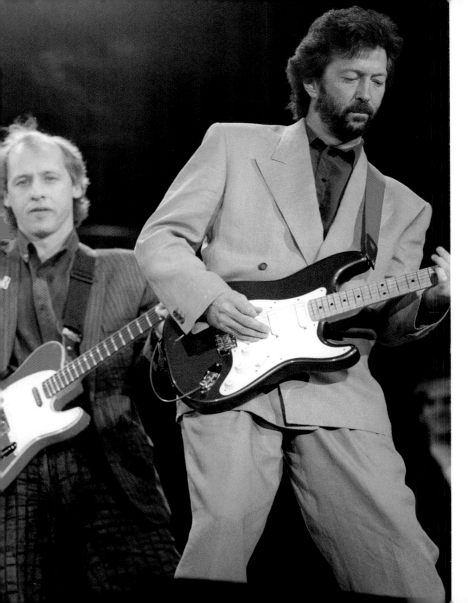

BIRTHDAY BASH
RENOWNED GUITARISTS
ERIC CLAPTON AND MARK
KNOPFLER ON STAGE AT THE
WEMBLEY ARENA DURING
A CONCERT TO CELEBRATE
THE 70TH BIRTHDAY OF
SOUTH AFRICAN PRESIDENT
NELSON MANDELA.
11th June, 1988

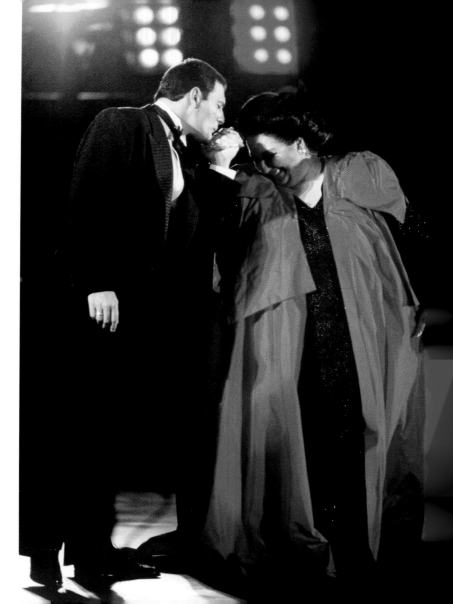

ROCK OPERA
FREDDIE MERCURY AND SPANISH
SOPRANO MONTSERRAT CABALLÉ
IN CONCERT AT THE OFFICIAL
LAUNCH OF SPAIN'S CULTURAL
OLYMPIAD. THE PAIR HAD
RECORDED AN ALBUM, *BARCELONA*,
WHICH COMBINED ELEMENTS OF
POP MUSIC AND OPERA.
8th October, 1988

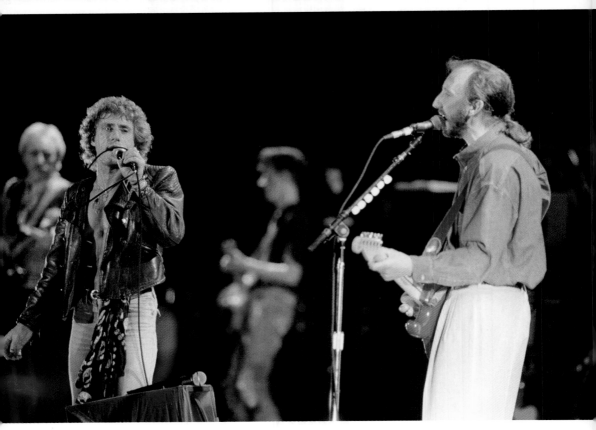

Who's there?
Above: The Who in concert at the NEC, Birmingham, Roger Daltry (L), Pete Townshend (R), John Entwistle (background L).
The band toured a number of cities in the USA as well as playing the NEC, Wembley Arena and the Royal Albert Hall in London in 1989 to celebrate their 25th anniversary.
7th October, 1989

Who's jumping?
Left: Pete Townshend of The Who performs his trademark leap during a concert at the Royal Albert Hall, London.
2nd November, 1989

ROCK The culture in pictures

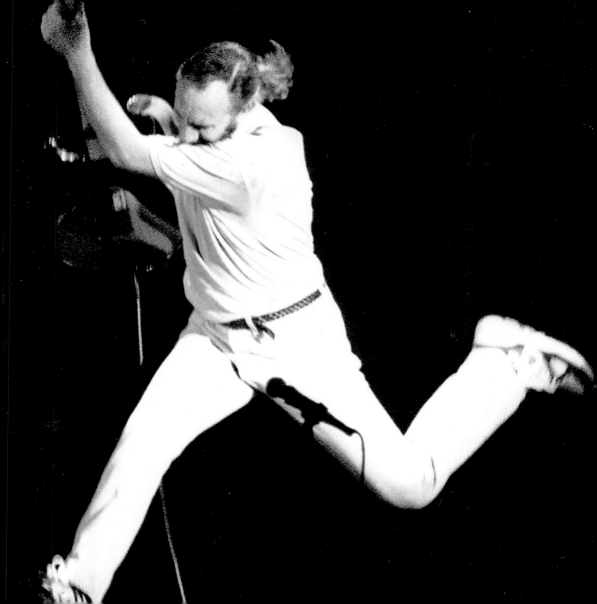

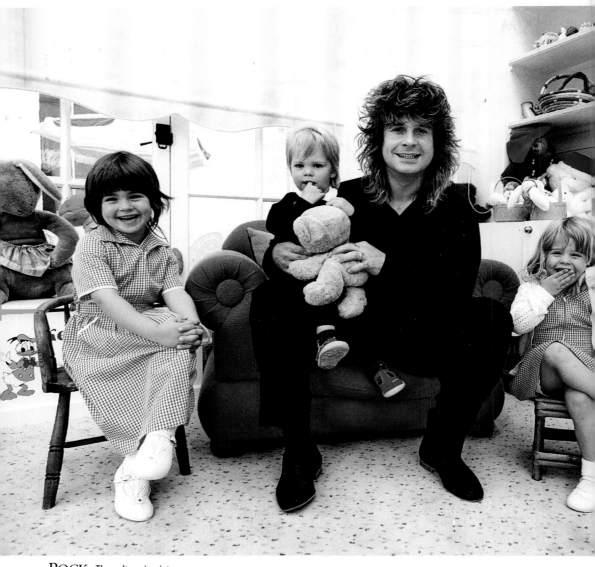

Family man

Far left: Heavy metal singer Ozzy Osbourne displays a less dark side at home with his children.
3rd July, 1988

Mayfair gig

Left: Mark Knopfler on stage with Dire Straits, during a concert at the Mayfair Ballroom, Newcastle in support of young cancer victim Joanne Gillespie.
10th October, 1989

Support band

Below left: Mark Knopfler and Dire Straits after playing a gig in support of North East Personality of the Year 12-year-old Joanne Gillespie, who had written a book about her fight against cancer. L–R: Alan Clark, Terry Williams, John Illsley, Sarah Gillespie, Mark Knopfler, Joanne Gillespie, Chris White, Guy Fletcher, Brendan Croker.
10th October, 1989

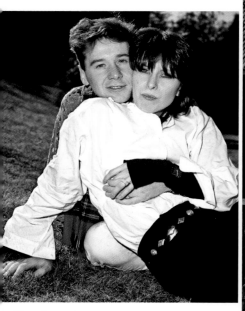

Vocal couple
Above: Chrissie Hynde, lead singer with The Pretenders, and her husband, Jim Kerr, lead singer of New Wave/pop rock band Simple Minds. The couple had married in 1984, but would divorce six years later.
July, 1989

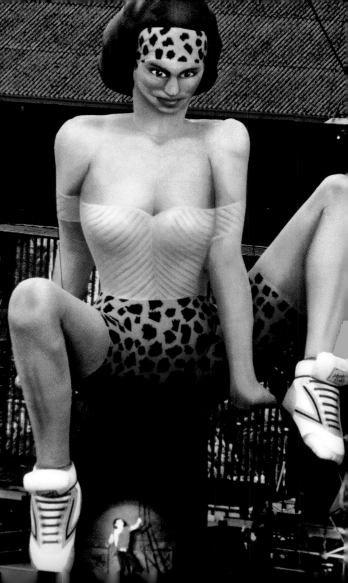

Farewell tour
Left: Mick Jagger of the Rolling Stones is dwarfed by a huge figure of a woman, part of the stage dressing for the band's gig at Hampden Park, Glasgow. The concert was part of their 'Urban Jungle' tour, the last tour in which bassist Bill Wyman would participate.
9th July, 1990

Below: Bill Wyman of the Rolling Stones waits for his bride-to-be, 18-year-old Mandy Smith, on their wedding day. The couple were the subject of much newspaper coverage, not only because of their age difference (he was 53), but also because their relationship had begun when she was only 14.

5th June, 1989

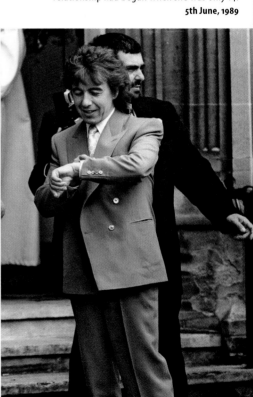

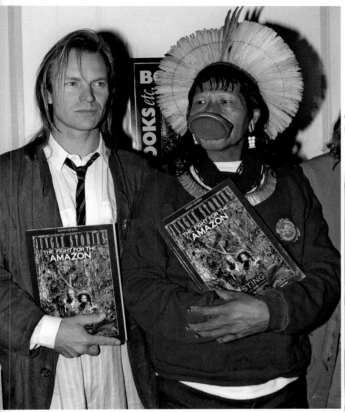

New book

Above: Singer/songwriter Sting with Raoni, an Amazonian Kayapo Indian chief, at the launch of *Jungle Stories – The Fight For The Amazon*, the book he had co-written with film-maker Jean-Pierre Dutilleux detailing the plight of the Amazonian Indians.

28th April, 1989

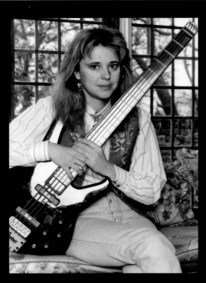

ROCK CHICK
AMERICAN HARD ROCK/POP ROCK SINGER
AND BASSIST SUZI QUATRO. SHE FOUND
SUCCESS ON THE OTHER SIDE OF THE
ATLANTIC IN THE UK AND EUROPE.
14th December, 1990

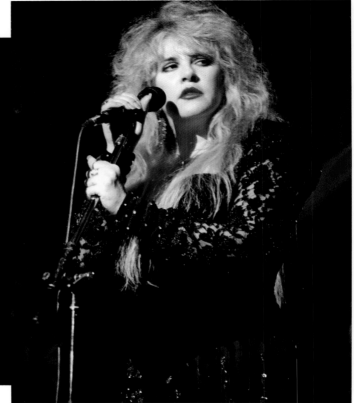

THE QUEEN
AMERICAN SINGER/SONGWRITER STEVIE NICKS, FORMER VOCALIST WITH FLEETWOOD
MAC AND VERY SUCCESSFUL SOLO ARTIST. SHE WAS DUBBED THE 'REIGNING QUEEN OF
ROCK AND ROLL' BY *ROLLING STONE* MAGAZINE.
24th August, 1990

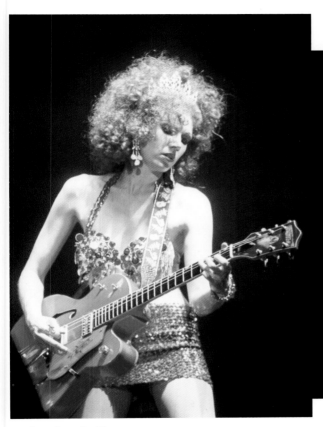

Husband-and-wife act
Poison Ivy (real name Kristy Wallace), lead guitarist of American punk band The Cramps. She had co-founded the band with Lux Interior (real name Erick Purkhiser), her husband.
28th August, 1990

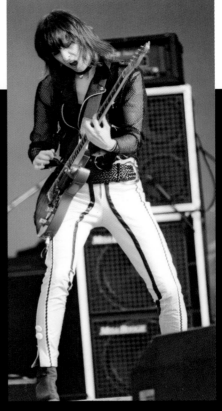

CONSTANT CHRISSIE
CHRISSIE HYNDE OF THE PRETENDERS DURING A GIG AT THE GATESHEAD STADIUM. SHE HAS BEEN THE ONLY CONSTANT MEMBER OF THE BAND THROUGHOUT ITS HISTORY.
1990

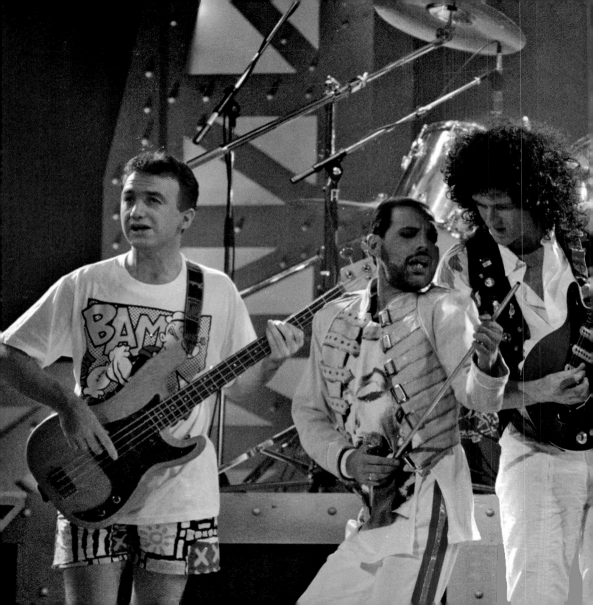

Best sellers

Above: Steve Tyler, lead singer of hard rock/blues rock band Aerosmith. They are the best selling American rock band of all time, having sold over 150 million albums worldwide.

20th August, 1990

The champions

Left: Queen in concert at Wembley Stadium. L–R: John Deacon, Freddie Mercury, Brian May; Roger Taylor on drums.

10th July, 1989

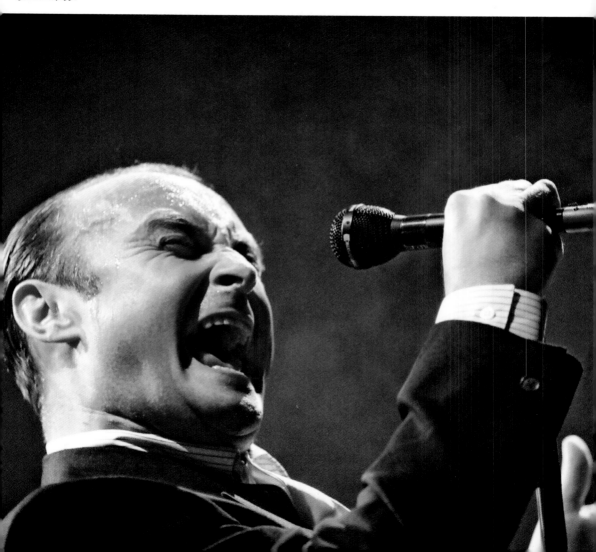

High note
Former Genesis drummer and singer Phil Collins, who established a very successful solo career after leaving the band.
13th March, 1990

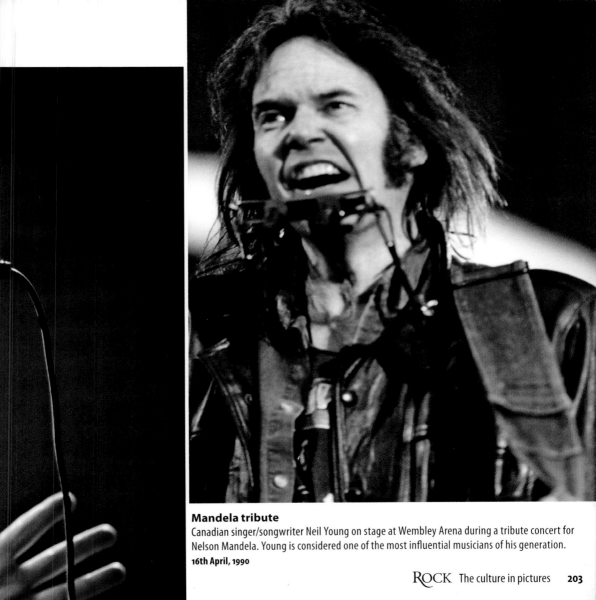

Mandela tribute
Canadian singer/songwriter Neil Young on stage at Wembley Arena during a tribute concert for
Nelson Mandela. Young is considered one of the most influential musicians of his generation.
16th April, 1990

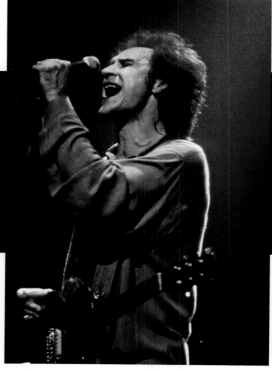

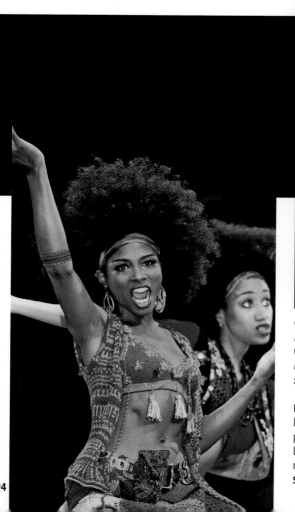

Grand night
Above: Ray Davies of The Kinks during a gig at the Clapham Grand, south London. They had released their final studio album, *Phobia*, on the same day.
29th March, 1993

Hair piece
Left: American singer Sinitta stars in the 25th-anniversary production of the rock musical *Hair* at the Old Vic theatre in London. Sinitta, who lived in the UK for most of her career, had a number of hits in the 1980s.
September, 1993

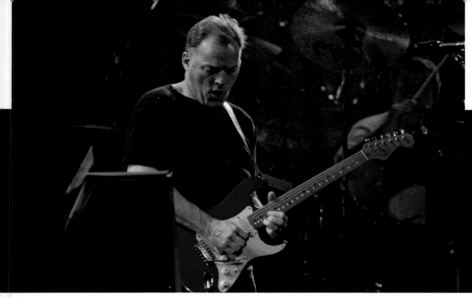

IN THE PINK
DAVE GILMOUR OF PINK FLOYD
DURING A CONCERT AT EARLS
COURT, LONDON.
13th October, 1994

FISH SHOP
FISH (REAL NAME DEREK DICK),
FORMER VOCALIST WITH
PROGRESSIVE ROCK BAND
MARILLION, PERFORMS AT THE
HMV SHOP IN NEWCASTLE.
6th April, 1994

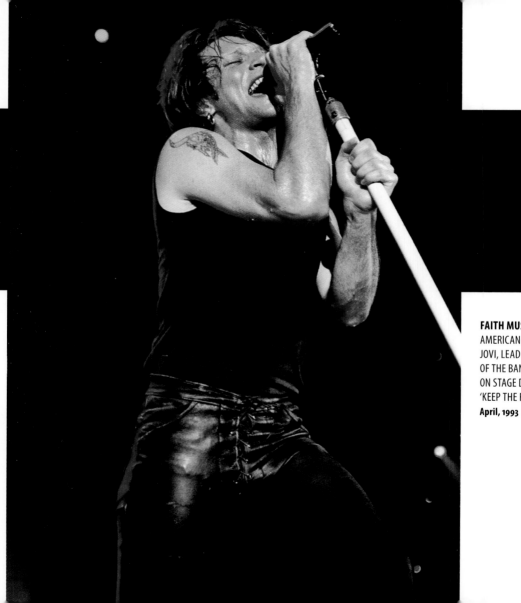

FAITH MUSIC
AMERICAN JON BON
JOVI, LEAD SINGER
OF THE BAND BON JOVI,
ON STAGE DURING THEIR
'KEEP THE FAITH' TOUR.
April, 1993

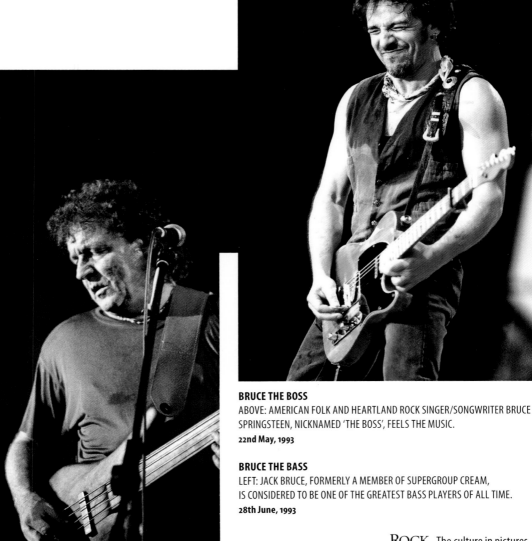

BRUCE THE BOSS
ABOVE: AMERICAN FOLK AND HEARTLAND ROCK SINGER/SONGWRITER BRUCE
SPRINGSTEEN, NICKNAMED 'THE BOSS', FEELS THE MUSIC.
22nd May, 1993

BRUCE THE BASS
LEFT: JACK BRUCE, FORMERLY A MEMBER OF SUPERGROUP CREAM,
IS CONSIDERED TO BE ONE OF THE GREATEST BASS PLAYERS OF ALL TIME.
28th June, 1993

Animals too

Left: Over time, various 'Animals' bands have been formed by previous members of the original group. Animals II included original drummer John Steel (front row, R) and guitarist Hilton Valentine (back row, L).

1990

Construction project
Former Animals bassist Chas Chandler (R),
with business partner and fellow musician
Nigel Stanger, discusses the building of the
Newcastle Arena, which they had helped develop.
20th November, 1995

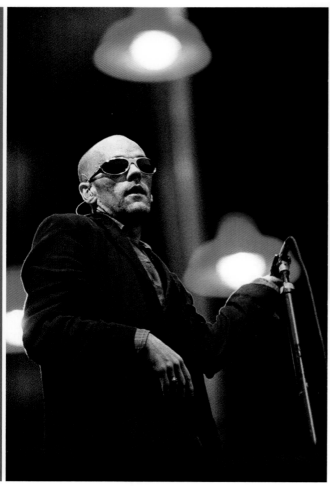

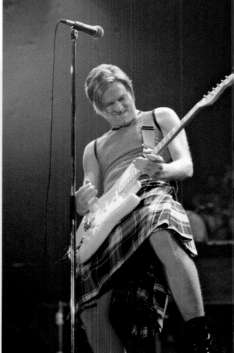

Scot rock

Above: Canadian hard rock musician Bryan Adams dons a kilt for a gig at the Scottish Exhibition Centre, Glasgow. He has won many awards for his compositions and is known for his philanthropic work in helping to improve education around the world.

22nd July, 1996

Album tour

Left: Michael Stipe, lead singer with American band R.E.M., on stage at Murrayfield Stadium, Edinburgh during the band's world tour to promote their *Monster* album.

27th July, 1995

Solo success
Former Jam and Style Council front man Paul Weller established a successful solo career after the latter band split in 1989.
1995

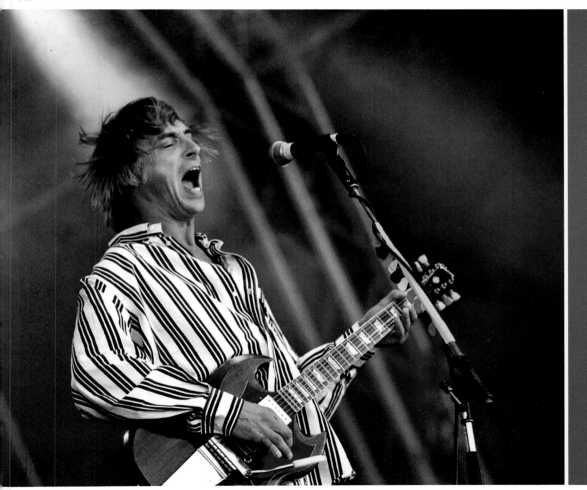

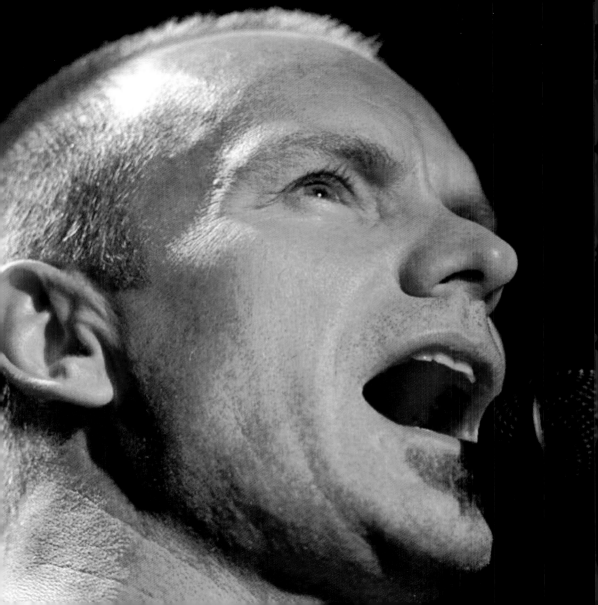

ABERDEEN ROCK

LEFT: SINGER/
SONGWRITER STING
ON STAGE DURING A
CONCERT IN ABERDEEN.
HIS AWARD WINNING
MUSIC INCORPORATES
ELEMENTS OF JAZZ,
REGGAE, CLASSICAL,
NEW AGE AND
WORLDBEAT.

22nd November, 1996

BIRTHDAY BOY

RIGHT: ELTON JOHN,
COSTUMED AS LOUIS
XIV (L), ON HIS WAY
WITH PARTNER DAVID
FURNISH TO HIS 50TH
BIRTHDAY PARTY AT
THE HAMMERSMITH
PALAIS, LONDON.

6th April, 1997

AFTER THE MONEY

RIGHT: THE ORIGINAL
MEMBERS OF THE
SEX PISTOLS WERE
REUNITED IN 1996 FOR
THE SIX-MONTH 'FILTHY
LUCRE' TOUR. THEY ARE
SHOWN IN PRAGUE,
CZECH REPUBLIC. L–R:
GLEN MATLOCK, JOHN
LYDON, STEVE JONES,
PAUL COOK.

9th July, 1996

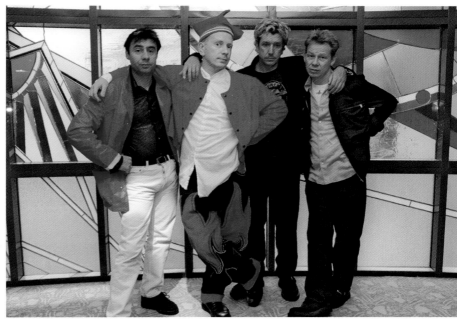

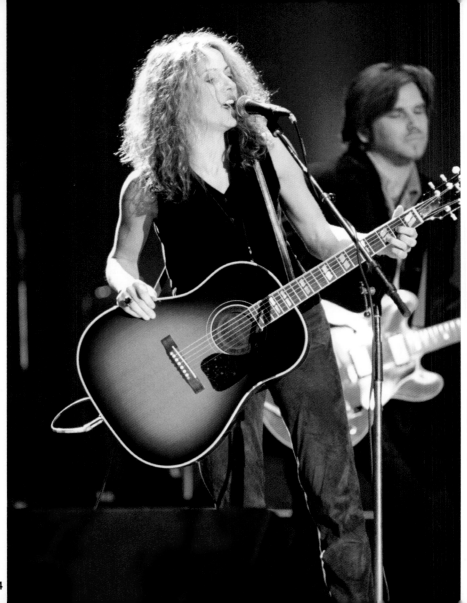

COLLABORATOR
AMERICAN SINGER/
SONGWRITER SHERYL
CROW AT THE BRIT
AWARDS. HER MUSIC
ENCOMPASSES POP,
COUNTRY AND ROOTS
ROCK, AND SHE HAS
COLLABORATED
WITH A NUMBER OF
WELL-KNOWN ARTISTS,
INCLUDING MICK
JAGGER, ERIC CLAPTON,
PAVAROTTI AND STING.
24th February, 1997

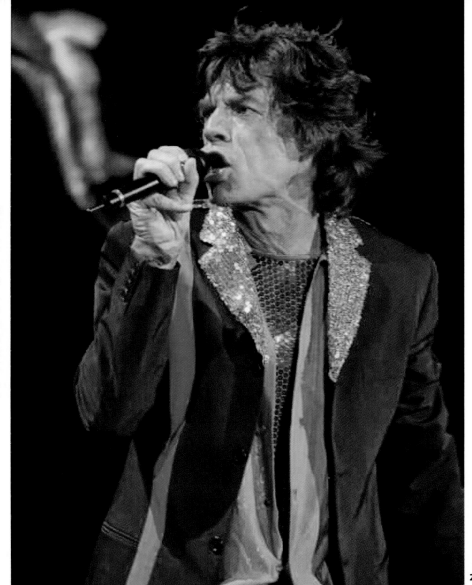

MAJOR TOUR
MICK JAGGER ON STAGE
IN CHICAGO, USA,
DURING THE FIRST
LEG OF THE ROLLING
STONES' 'BRIDGES TO
BABYLON' WORLD TOUR.
THE TOUR ATTRACTED
4,577,000 PEOPLE OVER
THE COURSE OF ITS 108
SHOWS AND WAS THE
SECOND LARGEST US
TOUR OF ALL TIME.
September, 1997

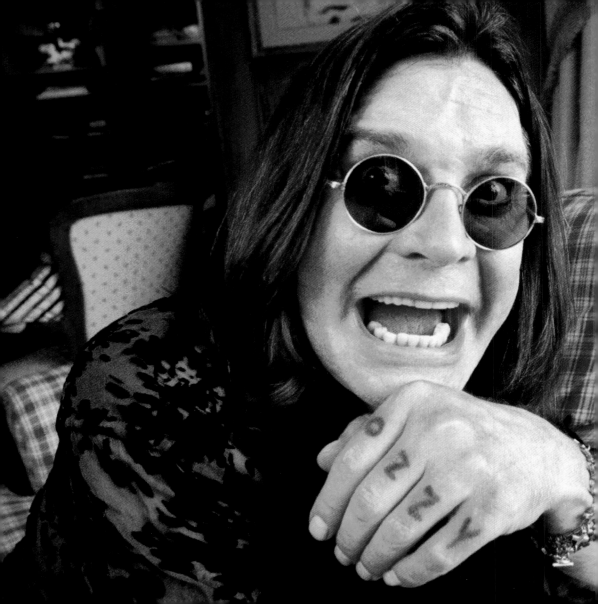

Tattooed prince
Left: Ozzy Osbourne shows his famous finger tattoos. The heavy metal singer has 15 tattoos in total.
27th September, 1998

MIRROR IMAGE
RIGHT: SCOTTISH ALTERNATIVE/INDIE ROCK BAND TRAVIS: (TOP TO BOTTOM) NEIL PRIMROSE, DOUGIE PAYNE, ANDY DUNLOP, FRAN HEALY.
26th March, 1998

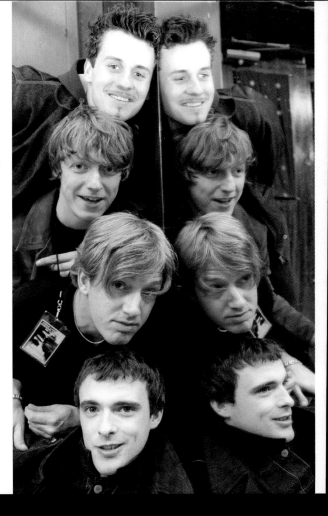

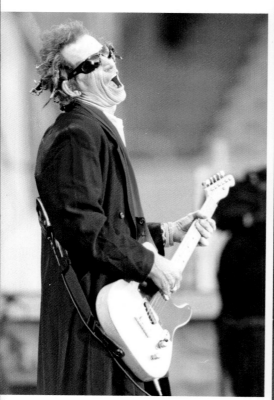

Dangerous?
Above: Keith Richards, lead guitarist of the Rolling Stones,
performing at Murrayfield Stadium, Edinburgh. Richards
was once described as "mad, bad and dangerous to know."
4th June, 1999.

Rocking and rolling
Right: Mick Jagger and Keith Richards on stage
at Wembley Stadium.
12th June, 1999

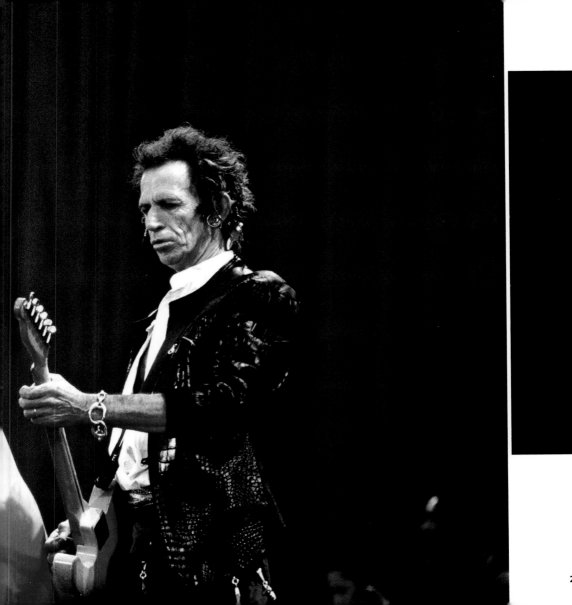

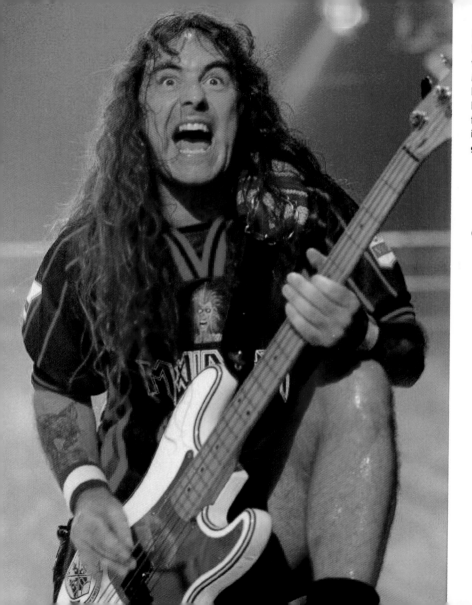

Iron man
Left: Steve Harris, bassist with heavy metal band Iron Maiden, on stage at the Palais Omnisports de Paris-Bercy in Paris. Harris, who founded the band in 1975, is its primary songwriter.
9th September, 1999

Festival funk
Right: American funk/ hard rock singer/ songwriter Lenny Kravitz on stage at the Glastonbury Festival. Kravitz is known for elaborate stage performances and music videos. He won a Grammy for Best Male Rock Vocal Performance for four years running between 1999 and 2002.
June, 1999

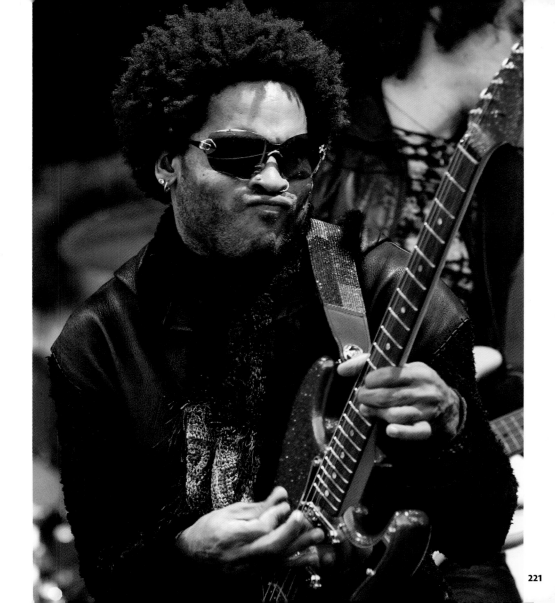

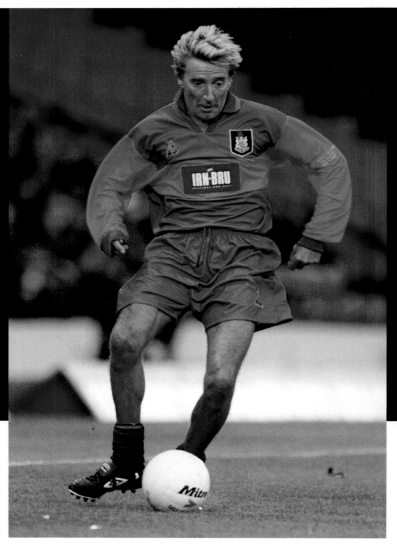

Making a pass

Well known for his love of
football, Rod Stewart takes
part in a Celebrity All Stars vs
Queen's Park match, the first to
be played at the new Hampden
Park ground in Glasgow.
21st May, 1999

ROCK The culture in pictures

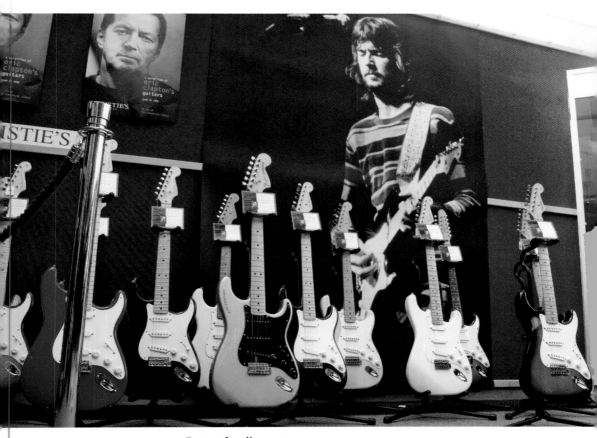

Future funding

Some of the 100 guitars belonging to Eric Clapton that were auctioned by Christie's in New York. The proceeds from the auction, over $4m, went to fund the Crossroads Centre in Antigua, a drug rehabilitation facility founded by Clapton in 1997.

24th June, 1999

Fleetwood fun

Fleetwood Mac drummer Mick Fleetwood
enjoys himself during a gig at the
Telewest Arena, Newcastle Upon Tyne,
part of the reunited band's 'Say You Will'
tour: singer Stevie Nicks (L), guitarist
Lindsay Buckingham (R).
22nd November, 2003

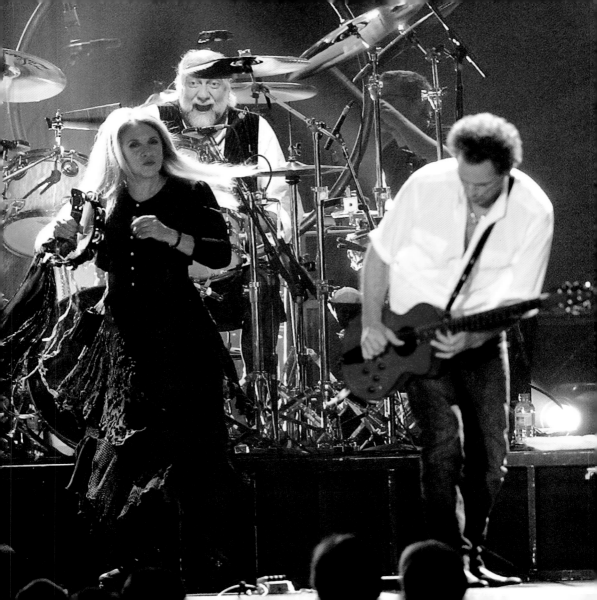

New man
INXS, with vocalist Jon Stephens (L), who had joined the band after Michael Hutchence's death.
They were playing the Cardiff International Arena in support of a re-formed Blondie.
11th December, 2002

Aerial act
Right: Dave Grohl of American alternative rock band Foo Fighters on stage during the Gig on the Green, Glasgow Green. The band's name came from the term used by Allied pilots during the Second World War to describe UFOs and other aerial phenomena.
26th August, 2000

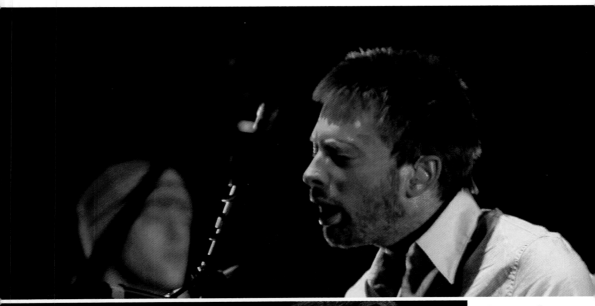
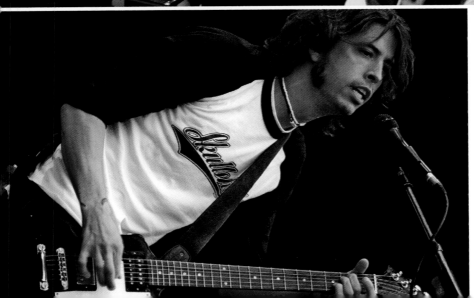

Arena rock

Above: Vocalist Thom Yorke of alternative rock band Radiohead during a concert at The Odyssey Arena, Belfast.
14th September, 2001

Tour date

Right: Bryan Ferry (L) and saxophonist Andy Mackay of the glam/art rock band Roxy Music at the start of a world tour in Glasgow. The band was co-founded by Ferry with bass player Graham Simpson in 1970.

12th June, 2001

Ferry man

Far right: Bryan Ferry at the City Hall, Newcastle Upon Tyne. While continuing as lead singer and principal songwriter for Roxy Music, he also developed a successful solo career.

22nd October, 2002

Press attention

Below: Roxy Music with music journalist Billy Sloan. L–R: Phil Manzanera, Bryan Ferry, Sloan, Andy Mackay.

13th February, 2001

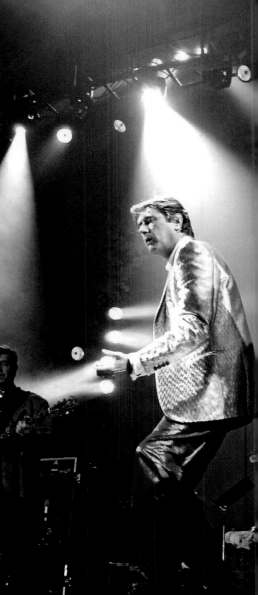

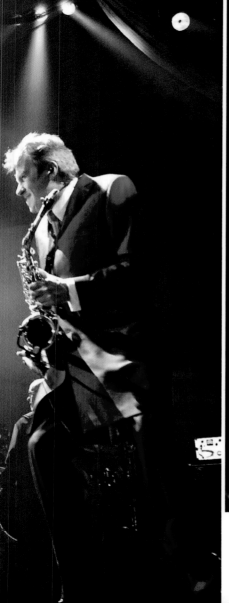

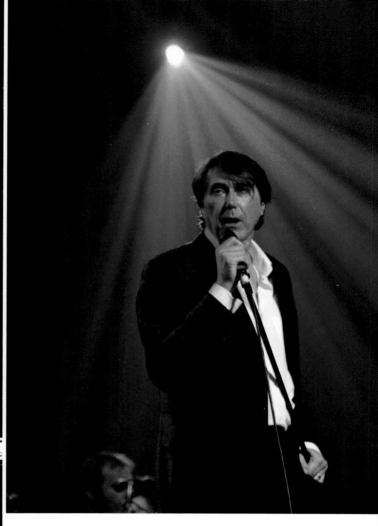

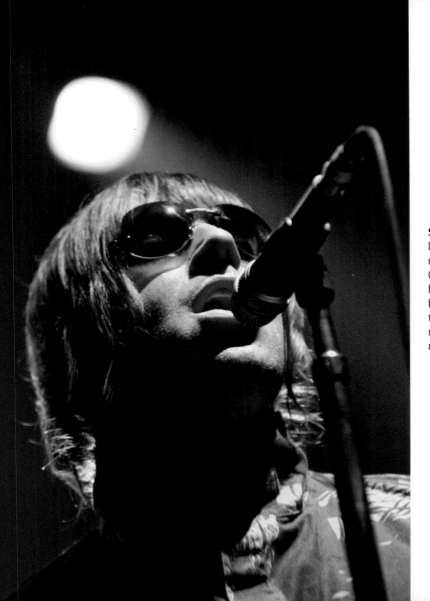

Sibling rivalry
Liam Gallagher, singer and founding member of alternative rock band Oasis. He was soon joined in the band by older brother Noel, but disputes between them and their wild lifestyles kept their names in the headlines.
8th December, 2002

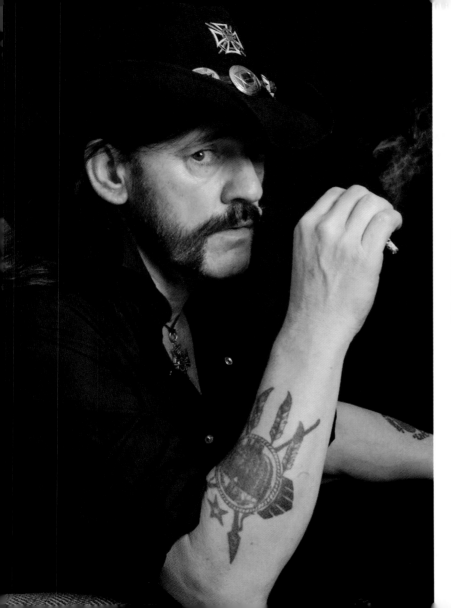

Metal bass
Lemmy, singer and bassist
for heavy metal/hard rock
band Motorhead. He is
the sole constant member
of the band.
13th October, 2002

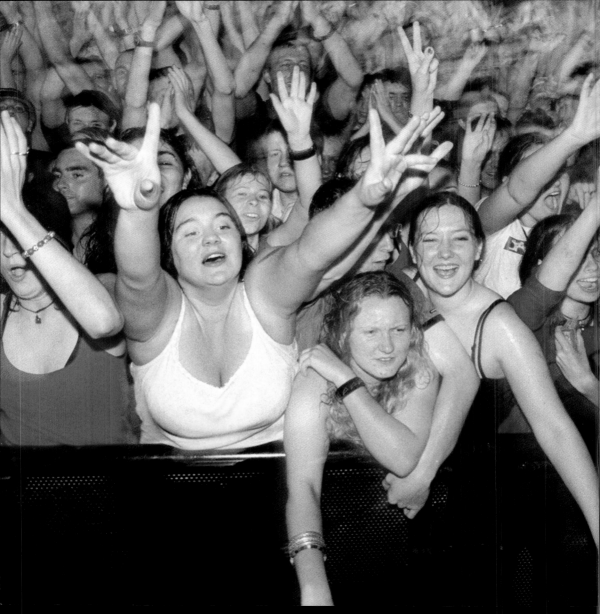

Undampened spirits

Left: Seemingly oblivious to the rain, Stereophonics fans sing along with the band during the Gig on the Green, Glasgow, Scotland.

25th August, 2000

Green eyed

Right: Stereophonics fans show their allegiance during the Gig on the Green, Glasgow.

25th August, 2000

Stereo sound

Below: Javier Weyler, drummer with alternative/ indie rock band the Stereophonics, during a gig at the Cardiff International Arena, Wales.

September, 2005

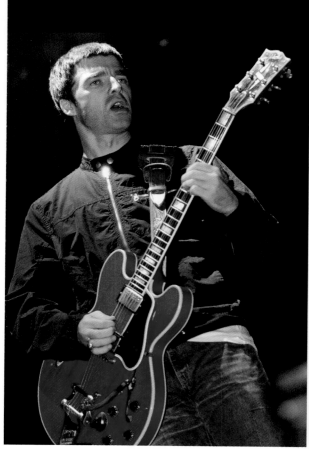

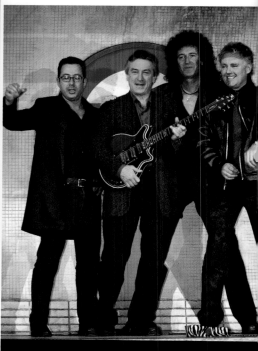

MUSICAL MEN

BELOW: THE FORTHCOMING STAGE MUSICAL *WE WILL ROCK YOU*, BASED ON THE SONGS OF QUEEN AND DUE TO OPEN AT LONDON'S DOMINION THEATRE ON 14TH MAY, 2002, IS CELEBRATED BY (L–R) BEN ELTON, ROBERT DE NIRO, BRIAN MAY AND ROGER TAYLOR. THE MUSICAL WAS WRITTEN BY ELTON IN COLLABORATION WITH MAY AND TAYLOR, WHILE DE NIRO WAS THE PRODUCER.

26th March, 2002

Oasis at the Springs

Above: Noel Gallagher, of Oasis, at the Coachella Music Festival in Palm Springs, California, USA. Gallagher would leave the band after a fight with his brother, Liam, in 2009.

27th April, 2002

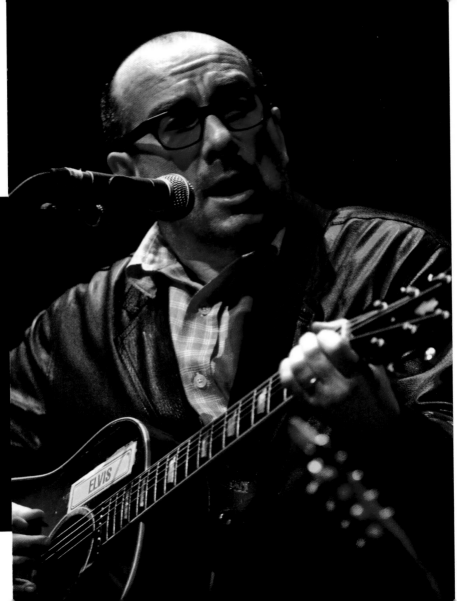

Board member
Elvis Costello during a benefit concert for landmine victims at the Clyde Auditorium, Glasgow. Costello is an Advisory Board member of the Jazz Foundation of America.
15th January, 2002

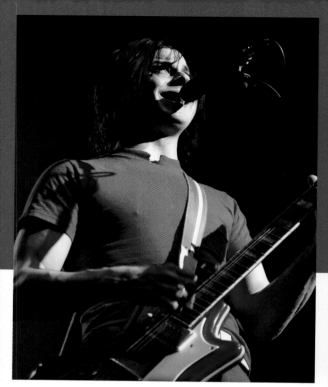
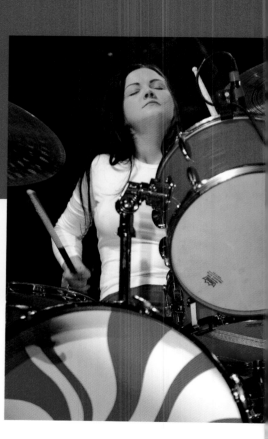

Striped duo

Above and right: American alternative rock band The White Stripes on stage at the Carling Academy, Glasgow. The band was formed by husband and wife Jack White (guitar) and Meg White (drums). The couple divorced just before the band came to prominence in 2002 as part of the garage rock revival scene.

10th April, 2003

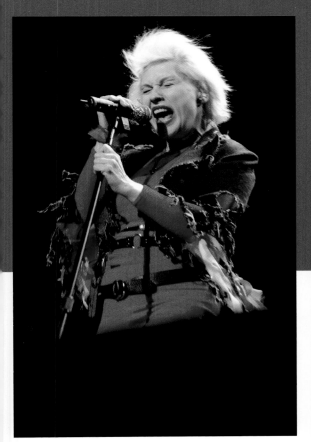

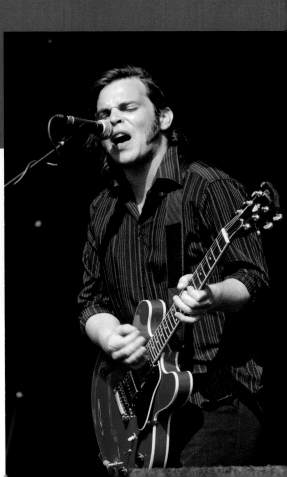

At the waterfront
Above: Debbie Harry in concert with a re-formed Blondie
at the Waterfront Hall, Belfast
10th November, 2003

T Party
Right: Gaz Coombes, lead singer and guitarist
with alternative rock band Supergrass, on stage at
the T In The Park music festival, Balado, Kinross-shire, Scotland.
13th July, 2003

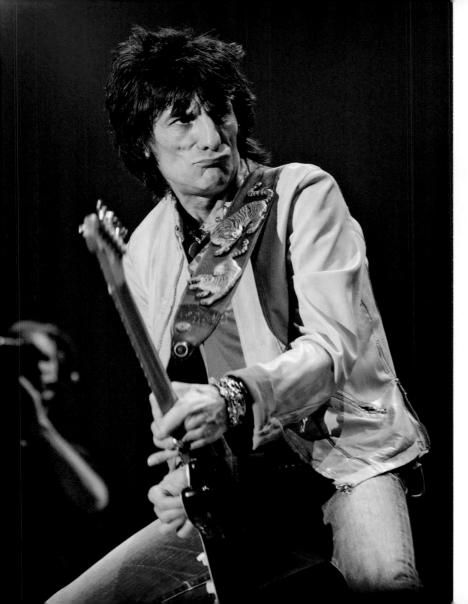

WOOD 'N' STONES
LEFT: RONNIE WOOD ON STAGE WITH THE ROLLING STONES AT THE SCOTTISH EXHIBITION AND CONFERENCE CENTRE, GLASGOW. THE BAND SET A PRICING RECORD AT THE VENUE AT A HEFTY £150 PER TICKET.
1st September, 2003

Bare bass
Right: Bass player Nick Oliveri, of Queens of the Stone Age, strips off during the Big Day Out festival at Glasgow Green.
24th August, 2003

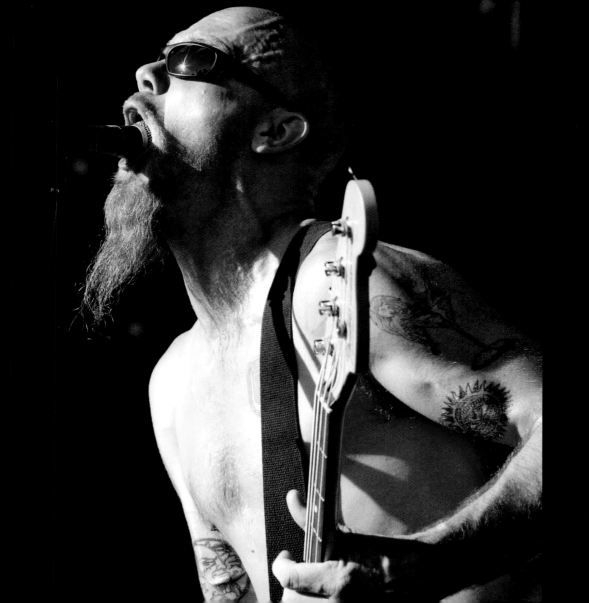

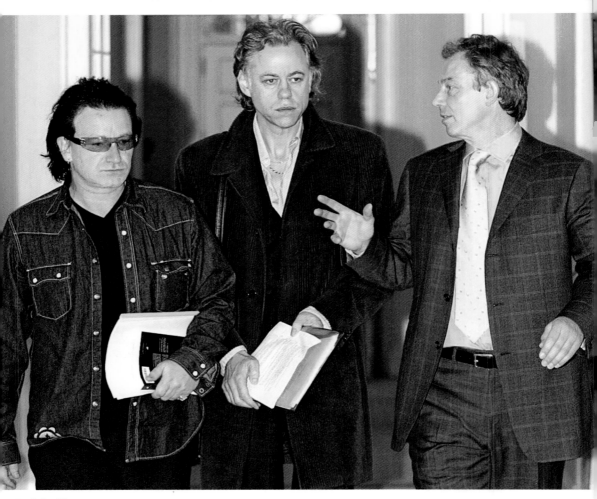

Political issue
Britain's Prime Minister, Tony Blair (R), with Bob Geldof (C) and U2 frontman Bono inside 10 Downing Street, London.
The rock stars were there as part of their campaign to urge world leaders to unite in the fight against AIDS.
22nd May, 2003

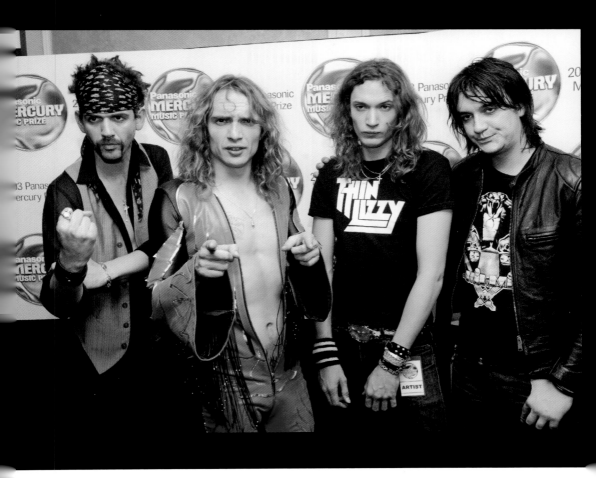

Dark stars
Glam/hard rock band The Darkness at the Grosvenor Hotel, London for the Mercury Music Awards.
L—R: Frankie Poullain, Justin Hawkins, Dan Hawkins, Ed Graham.
9th September, 2003

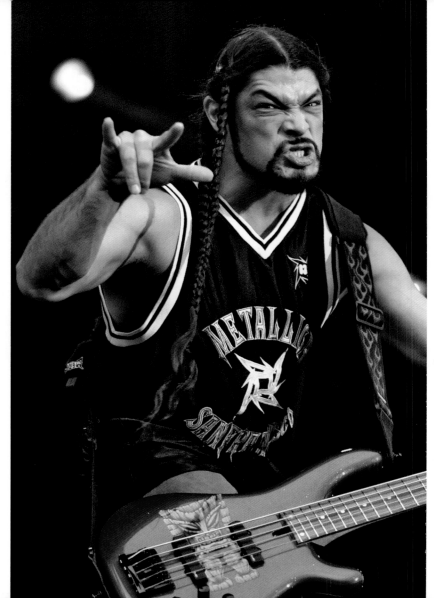

Metal plaits
Robert Trujillo of American heavy metal/ hard rock band Metallica on stage at Green's Playhouse, Glasgow. The band was instrumental in pioneering the genre known as thrash metal.
2nd June, 2004

Food for thought
Right: American hard rock musician and actor Meatloaf (real name Marvin Aday) at the Odyssey Arena, Belfast. The singer's album *Bat Out of Hell* is one of the best selling albums of all time.
7th December, 2003

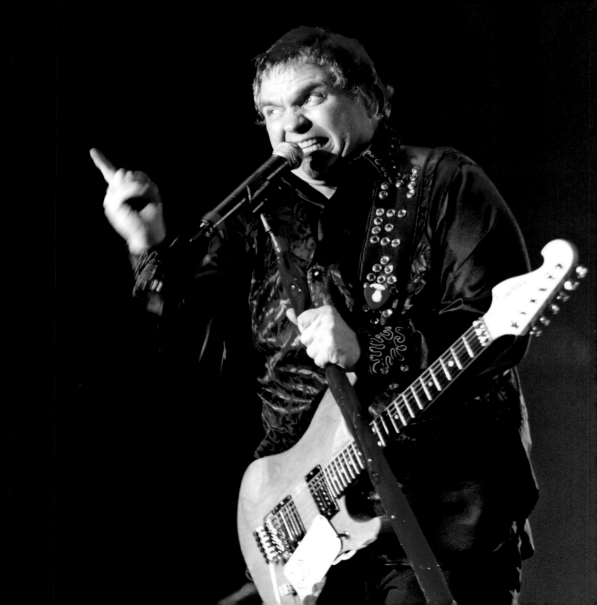

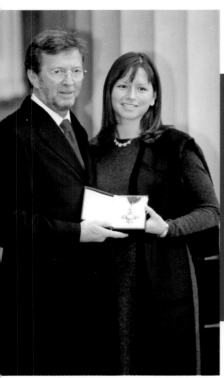

EC CBE
Legendary guitarist Eric Clapton with
his pregnant wife, Melia, after receiving his
CBE for services to music from the Princess
Royal at Buckingham Palace, London.
4th November, 2004

Bill's book
Former Rolling Stone bassist Bill
Wyman launches his new book,
Bill Wyman's Treasure Islands.
Wyman is a keen archaeological
explorer – he has designed and
sells his own metal detector –
and the book details treasure
hunts across the British Isles.
2005

 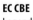

THREE FOR TWO
STING AT A BOOK SIGNING SESSION
FOR HIS AUTOBIOGRAPHY,
BROKEN MUSIC, AT THE BORDERS
BOOKSHOP, NORTH TYNESIDE.
19th November, 2004

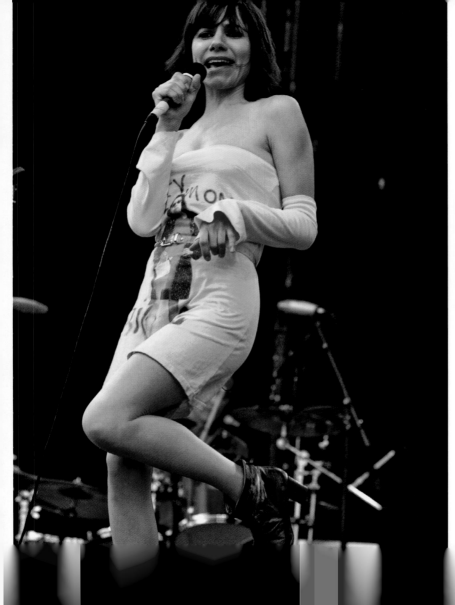

Multi-instrumentalist
Alternative/indie rock singer/songwriter P.J. Harvey at the T in the Park festival, Balado, Kinross-shire. Although known primarily as a vocalist and guitarist, Harvey is proficient with a wide range of instruments.
11th July, 2004

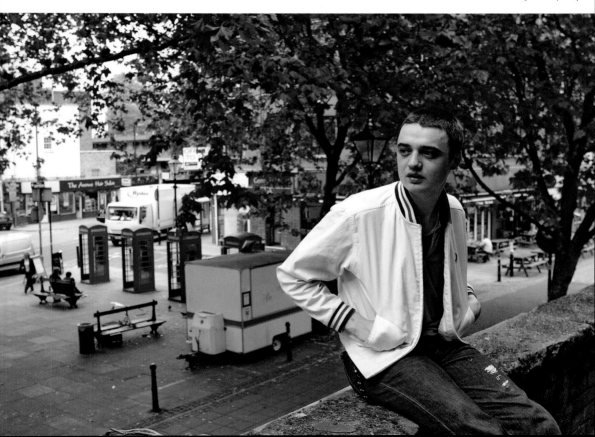

SELF-DESTRUCTIVE

PETE DOHERTY, GUITARIST/VOCALIST AND FOUNDING MEMBER OF GARAGE/INDIE ROCK BAND THE LIBERTINES.
HIS DRUG ADDICTION PROBLEMS, HOWEVER, WOULD LEAD TO THE BREAK-UP OF THE BAND AT THE END OF 2004.

29th June, 2004

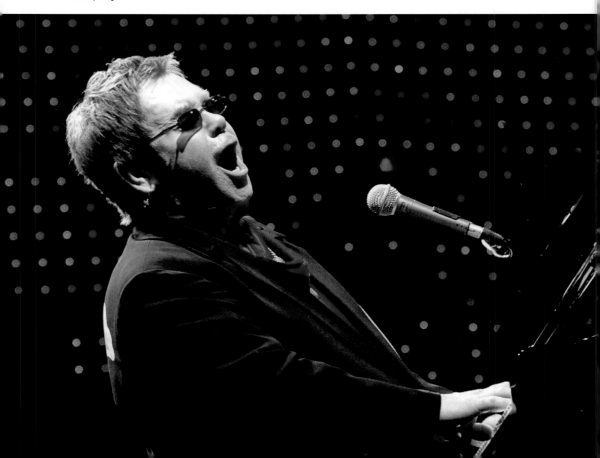

PIANO MAN
ELTON JOHN IN CONCERT AT THE CARDIFF INTERNATIONAL
ARENA. OVER THE COURSE OF FOUR DECADES, HE HAS SOLD
OVER 250 MILLION RECORDS, MAKING HIM ONE OF THE
MOST SUCCESSFUL ARTISTS OF ALL TIME.
June, 2005

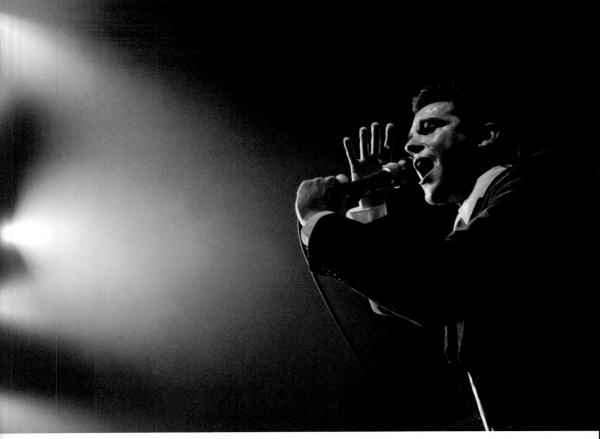

IN THE SPOTLIGHT
BRANDON FLOWERS, CO-FOUNDER, SINGER AND KEYBOARD
PLAYER WITH AMERICAN ALTERNATIVE/INDIE ROCK
BAND THE KILLERS, DURING THE NME TOUR AT CARDIFF
UNIVERSITY. FLOWERS RELEASED A SOLO ALBUM IN 2010,
FLAMINGO, WHICH REACHED NO. 1 IN THE UK.
6th February, 2005

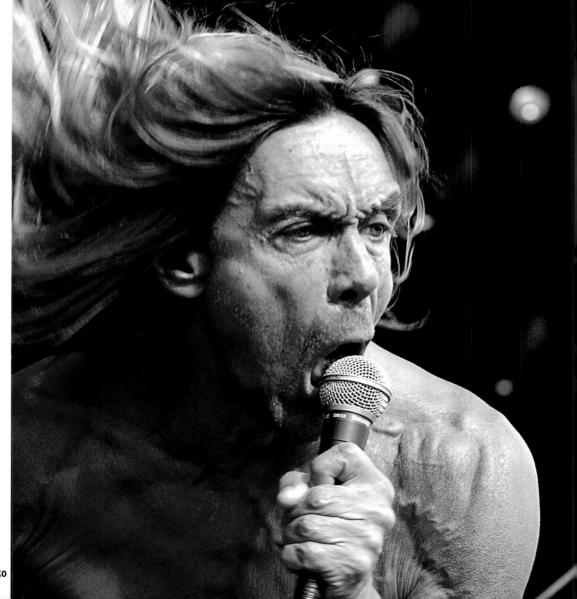

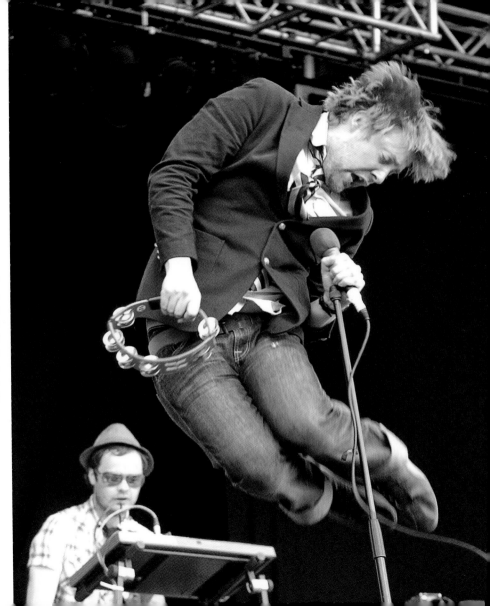

Pop on the green
Left: Veteran rock star Iggy Pop on stage during the Download Festival at Glasgow Green. He was backed by The Stooges, the band with whom he had come to prominence in the late 1960s/early 1970s.
June, 2004

Air play
Right: Ricky Wilson, lead singer of indie rock band Kaiser Chiefs, takes to the air during the T in the Park concert at Balado, Kinross-shire.
10th July, 2005

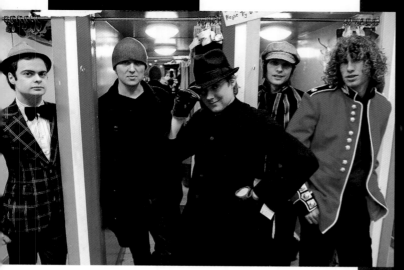

Chief outfits

The Kaiser Chiefs in Edinburgh to kit themselves out with new outfits for forthcoming Scottish gigs. L–R: Nick 'Peanut' Baines, Andrew 'Whitey' White, Ricky Wilson, Nick Hodgson, Simon Rix.

12th April, 2005

Radio stars

Alternative rock band Radiohead: (L–R) Phil Selway, Colin Greenwood, Jonny Greenwood, Ed O'Brien, Thom Yorke. The band has sold over 30 million albums worldwide.

May, 2005

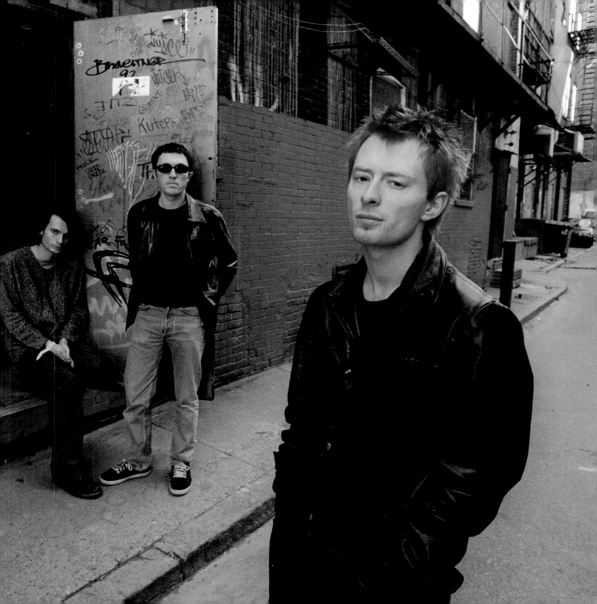

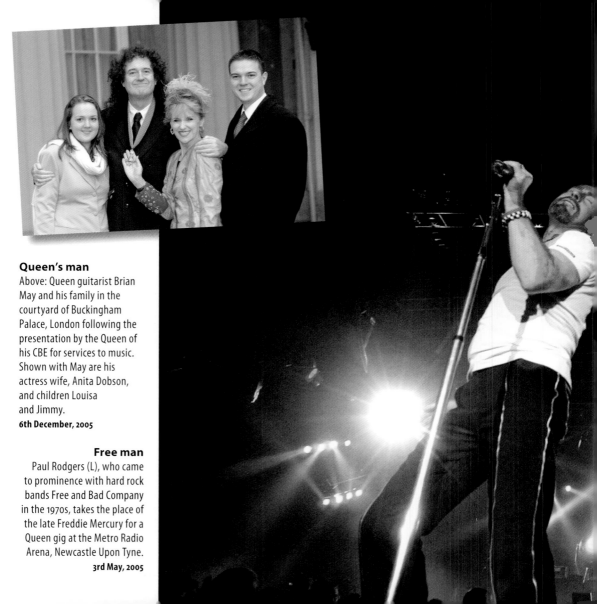

Queen's man

Above: Queen guitarist Brian May and his family in the courtyard of Buckingham Palace, London following the presentation by the Queen of his CBE for services to music. Shown with May are his actress wife, Anita Dobson, and children Louisa and Jimmy.

6th December, 2005

Free man

Paul Rodgers (L), who came to prominence with hard rock bands Free and Bad Company in the 1970s, takes the place of the late Freddie Mercury for a Queen gig at the Metro Radio Arena, Newcastle Upon Tyne.

3rd May, 2005

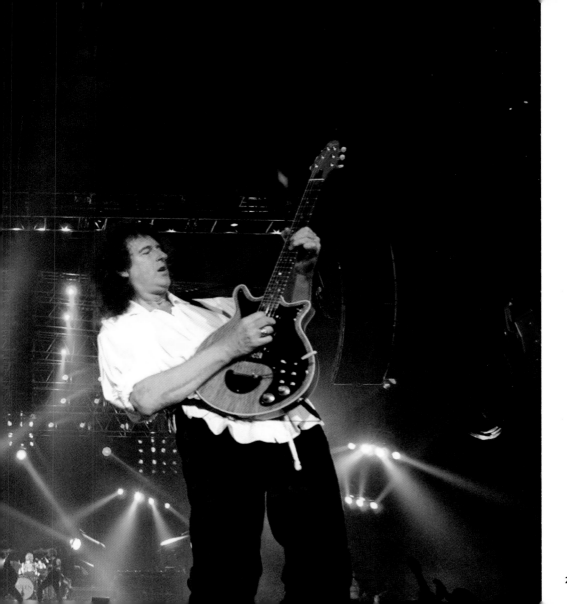

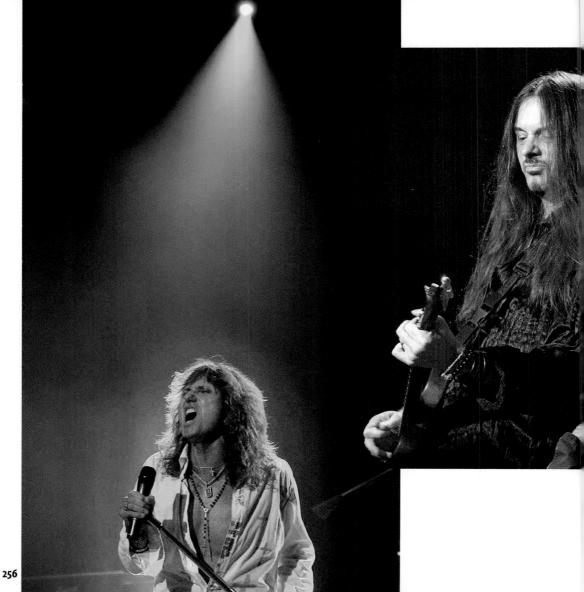

Snake charmers
Above and left: Hard rock/heavy metal band Whitesnake at the City Hall, Newcastle Upon Tyne: lead singer David Coverdale (L), guitarist Reb Beach (above L), bassist Uriah Duffy (above R).
26th June, 2006

Moody men
Progressive/symphonic rock band The Moody Blues play the NEC, Birmingham: (L–R) John Lodge, Justin Hayward.
13th October, 2006

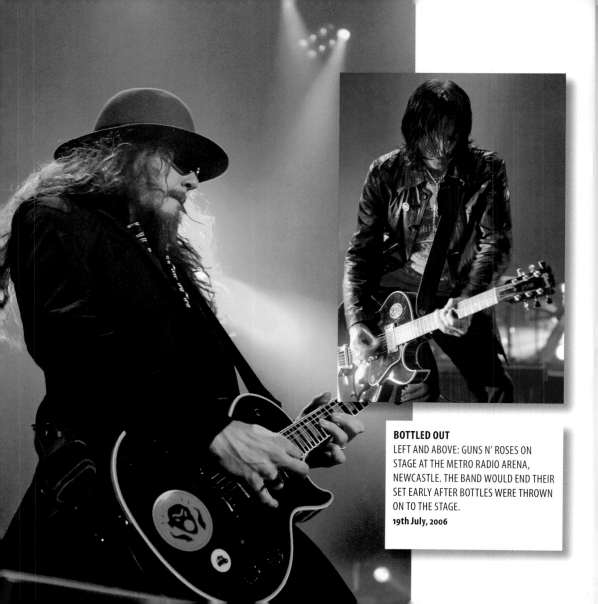

BOTTLED OUT
LEFT AND ABOVE: GUNS N' ROSES ON STAGE AT THE METRO RADIO ARENA, NEWCASTLE. THE BAND WOULD END THEIR SET EARLY AFTER BOTTLES WERE THROWN ON TO THE STAGE.
19th July, 2006

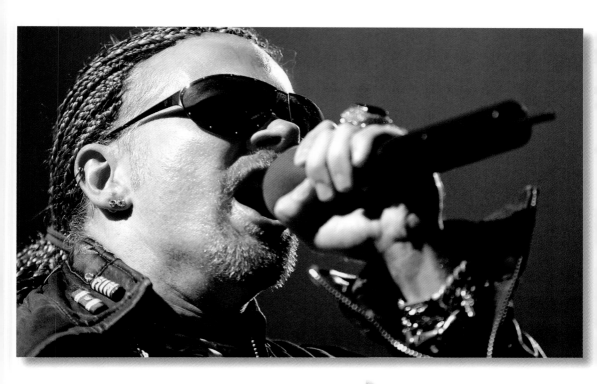

ROCK ROSE
AXL ROSE LEAD SINGER AND
CO-FOUNDER OF AMERICAN HARD
ROCK/HEAVY METAL BAND GUNS N'
ROSES. THE BAND HAS SOLD OVER
100 MILLION ALBUMS WORLDWIDE.
19th July, 2006

MANIC JUMP

NICKY WIRE, BASS PLAYER WITH WELSH
ALTERNATIVE ROCK BAND MANIC STREET
PREACHERS, AT THE GLASTONBURY
FESTIVAL, SOMERSET.

June, 2007

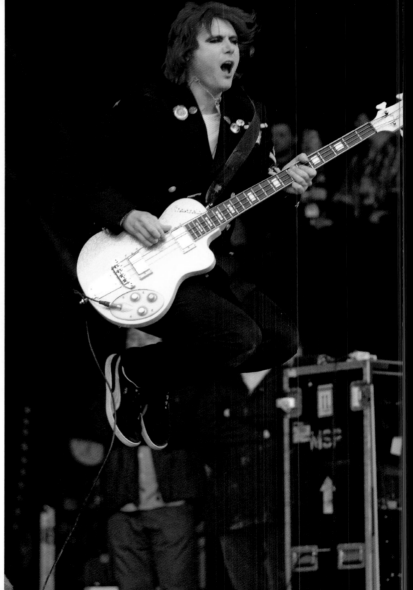

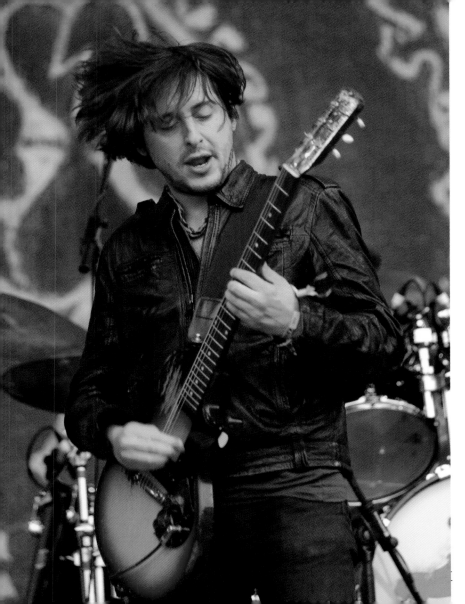

Break-up band
Carl Barât, front man of
indie rock band The Dirty
Pretty Things, at the
Glastonbury Festival.
Barât had formed the band
after the break-up of
The Libertines, following
a dispute between him
and Pete Doherty.
June, 2007

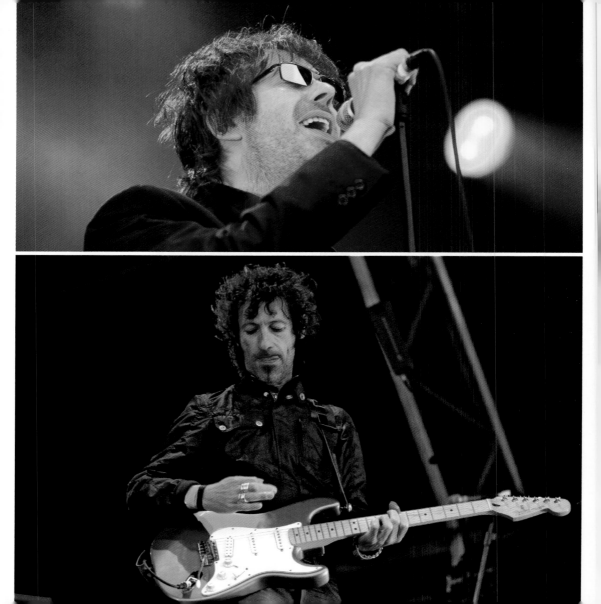

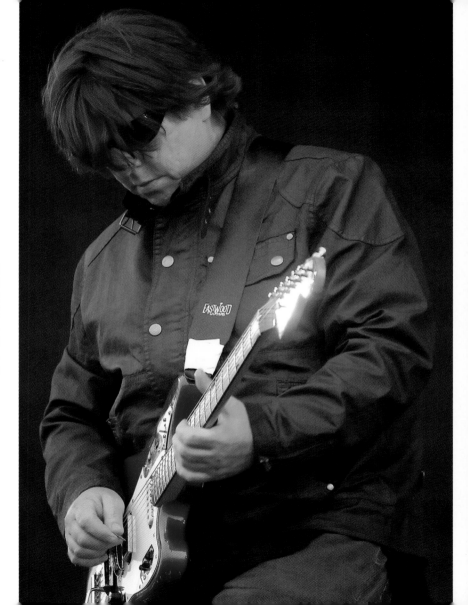

WHARF MEN
LEFT AND BELOW LEFT: ALTERNATIVE ROCK BAND ECHO AND THE BUNNYMEN, ON STAGE AT SPILLER'S WHARF, NEWCASTLE DURING THE EVOLUTION FESTIVAL. SHOWN ARE VOCALIST IAN MCCULLOCH AND GUITARIST GORDY GOUDIE.
May, 2007

BUNNYMAN
WILL SERGEANT, GUITARIST WITH ECHO AND THE BUNNYMEN, ON STAGE AT THE ISLE OF WIGHT FESTIVAL. SERGEANT IS THE BAND'S ONLY CONSTANT MEMBER.
June, 2007

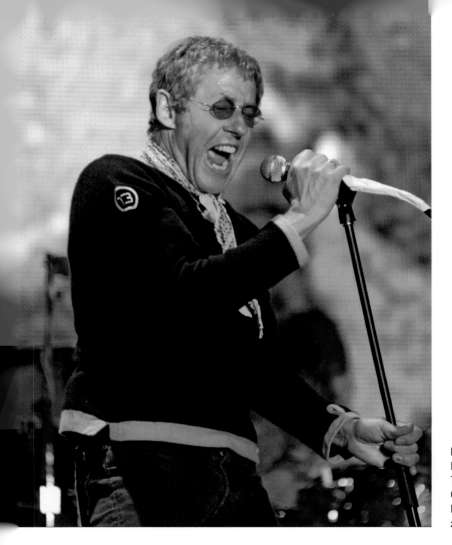

FESTIVAL FINALE
LEGENDARY BAND THE WHO ON
THE PYRAMID STAGE TO CLOSE THE
GLASTONBURY FESTIVAL: ROGER
DALTREY (L), PETE TOWNSHEND (R).
25th June, 2007

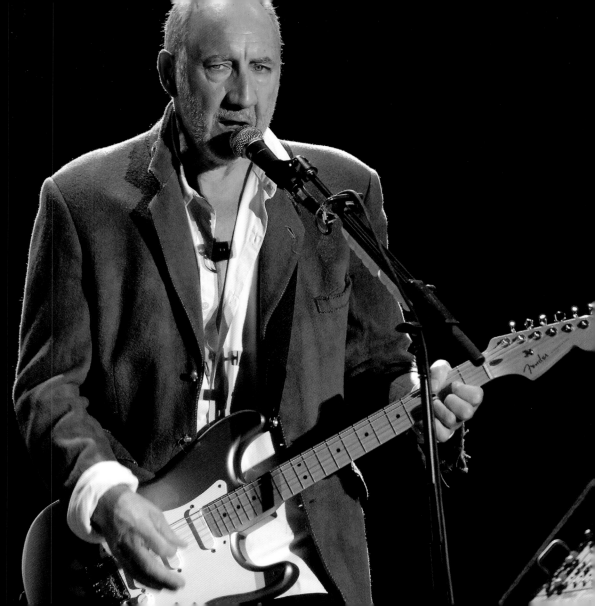

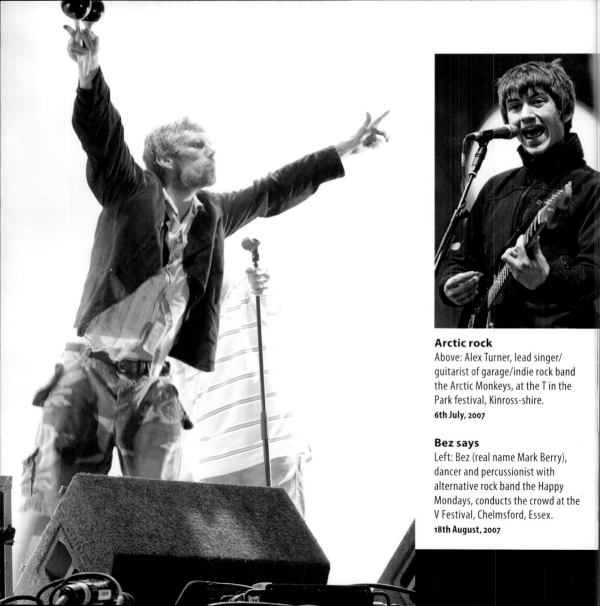

Arctic rock
Above: Alex Turner, lead singer/
guitarist of garage/indie rock band
the Arctic Monkeys, at the T in the
Park festival, Kinross-shire.
6th July, 2007

Bez says
Left: Bez (real name Mark Berry),
dancer and percussionist with
alternative rock band the Happy
Mondays, conducts the crowd at the
V Festival, Chelmsford, Essex.
18th August, 2007

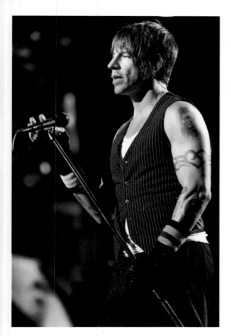

Red hot at Reading
Above: Anthony Kiedis, vocalist with American alternative/funk rock band the Red Hot Chilli Peppers, on stage at the Reading Festival.
22nd August, 2007

Jumping Flea
Right: Flea (real name Michael Balzary), bassist and co-founder of the Red Hot Chilli Peppers, at the Reading Festival. He is considered one of the best rock bass players of all time.
22nd August, 2007

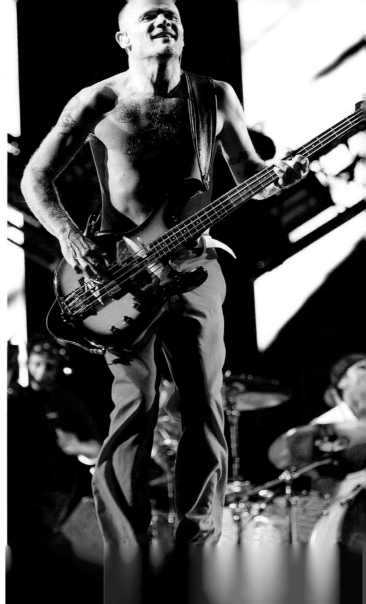

ROTTEN SHOW

JOHN LYDON (JOHNNY ROTTEN),
VOCALIST WITH SEMINAL PUNK BAND
THE SEX PISTOLS, ON STAGE AT THE
ISLE OF WIGHT FESTIVAL. THE SINGER
REMAINED AS OUTSPOKEN AS EVER,
BERATING THE CROWD AND OTHER
ARTISTS APPEARING ON THE BILL.

14th June, 2008

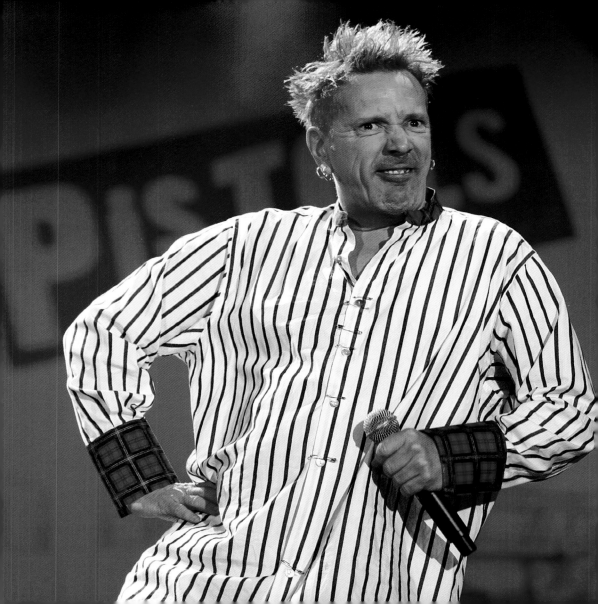

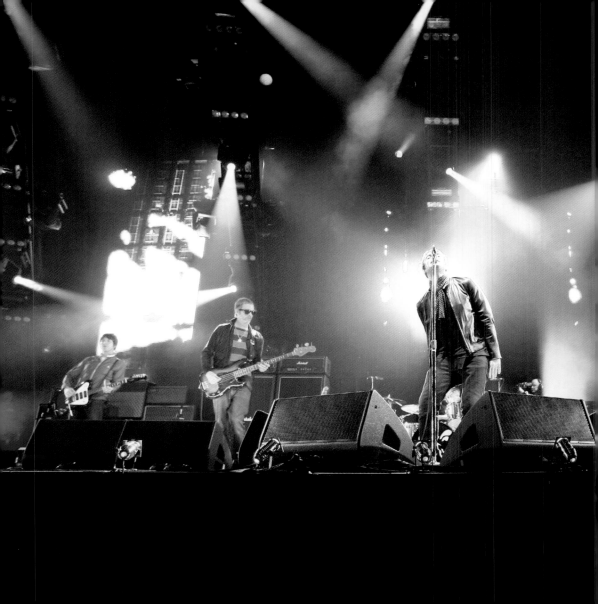

PLAYING WEMBLEY

LEFT: OASIS PERFORMING AT WEMBLEY ARENA. WITHIN THE YEAR, NOEL GALLAGHER WOULD LEAVE THE BAND, WHILE HIS BROTHER, LIAM, AND THE REMAINING MEMBERS WOULD CONTINUE UNDER THE NAME BEADY EYE.

16th October, 2008

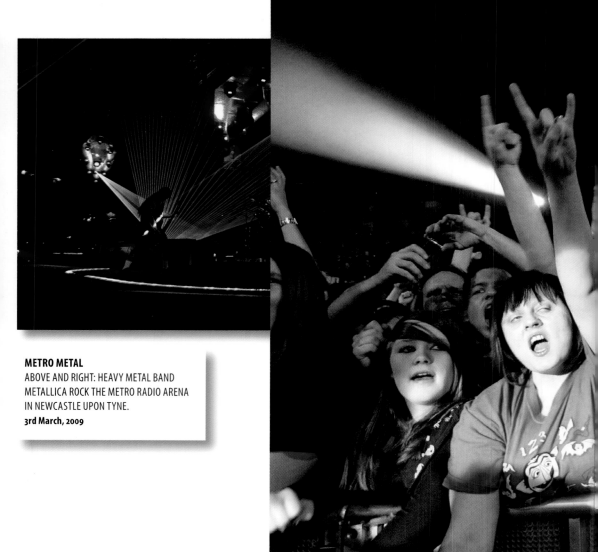

METRO METAL
ABOVE AND RIGHT: HEAVY METAL BAND
METALLICA ROCK THE METRO RADIO ARENA
IN NEWCASTLE UPON TYNE.
3rd March, 2009

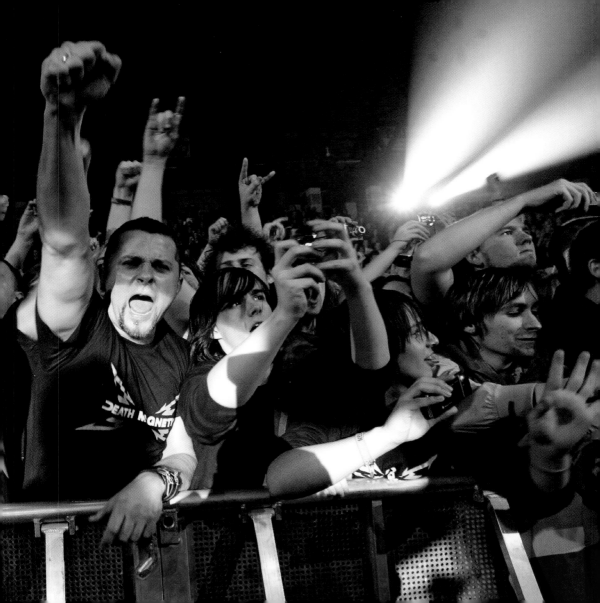

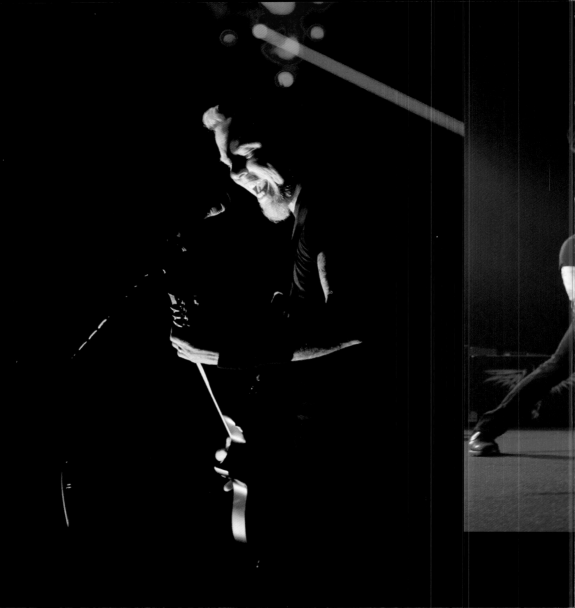

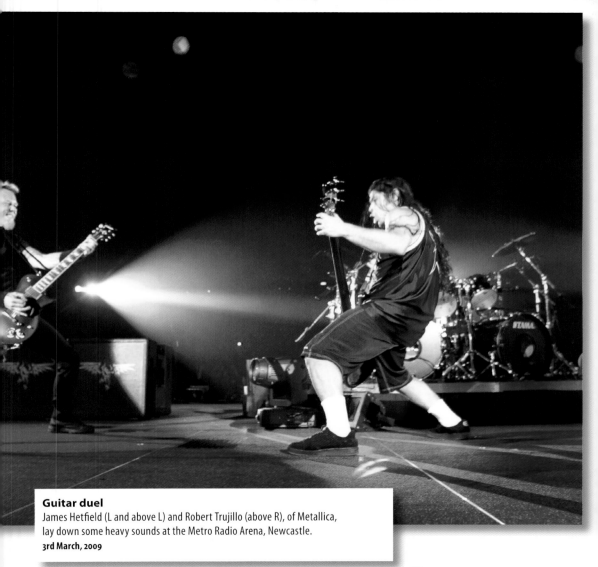

Guitar duel
James Hetfield (L and above L) and Robert Trujillo (above R), of Metallica,
lay down some heavy sounds at the Metro Radio Arena, Newcastle.
3rd March, 2009

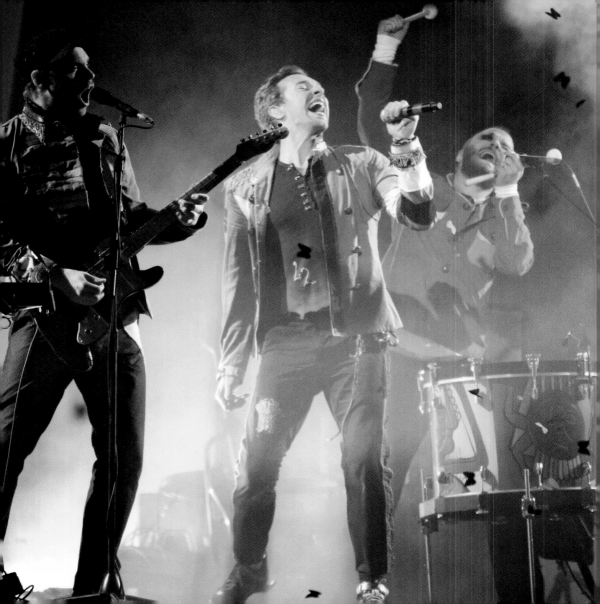

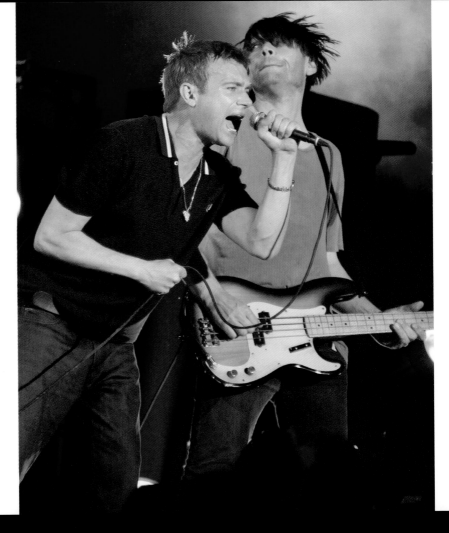

NOMINEES
LEFT: ALTERNATIVE ROCK
BAND COLDPLAY SING THEIR
HIT *VIVA LA VIDA* AT THE
BRIT AWARDS, EARLS COURT,
LONDON, WHERE THEY
WERE NOMINATED FOR FOUR
AWARDS. L–R: GUITARIST
JONNY BUCKLAND, VOCALIST
CHRIS MARTIN, DRUMMER
WILL CHAMPION.
18th February, 2009

BLURRED MOTION
RIGHT: ALTERNATIVE
ROCK BAND BLUR MAKE
THEIR COMEBACK AT THE
GLASTONBURY FESTIVAL,
SOMERSET: VOCALIST DAMON
ALBARN (L) AND BASSIST
ALEX JAMES.
June, 2009

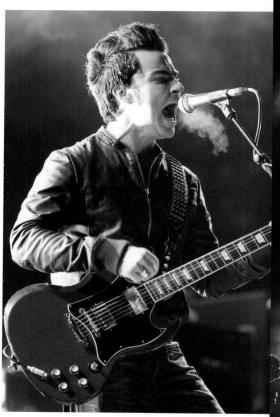

Stereo sounds

Above and right: Alternative/indie rock band
the Stereophonics on the main stage at the Isle of Wight
Festival (vocalist Kelly Jones above). The band has
been praised for their live performances.

June, 2009

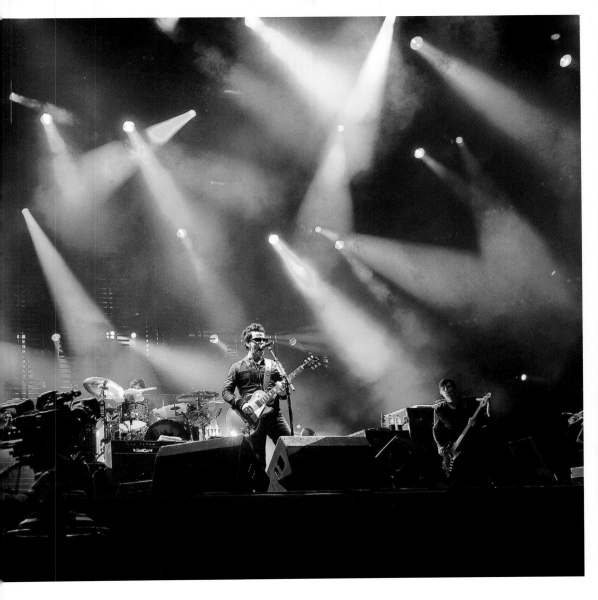

SUPER BAND
ABOVE AND ABOVE RIGHT: SUPERGROUP THEM CROOKED VULTURES PLAYING A SECRET SET IN THE NME TENT AT THE READING FESTIVAL. THE BAND
WAS FORMED IN 2009 BY (L–R) BASSIST JOHN PAUL JONES (LED ZEPPELIN), GUITARIST JOSH HOMME (QUEENS OF THE STONE AGE) AND DRUMMER
DAVE GROHL (NIRVANA/FOO FIGHTERS).
29th August, 2009

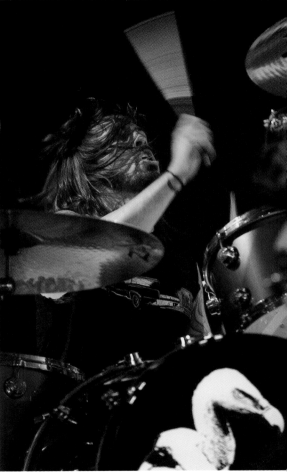

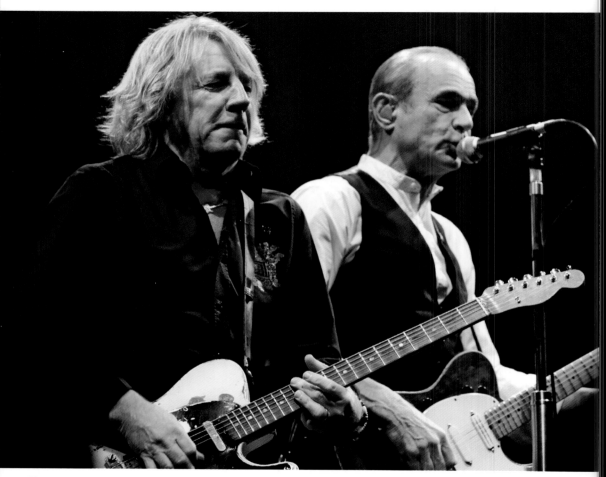

Still rockin' all over the world
Rick Parfitt (L) and Francis Rossi of Status Quo play to a packed City Hall, Newcastle.
16th December, 2009

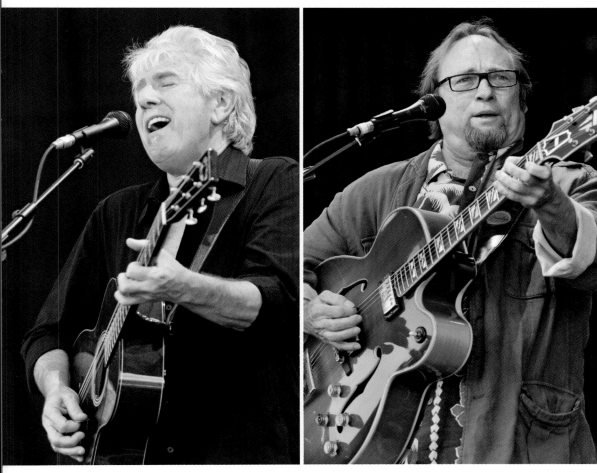

Two thirds
Above left and right: Graham Nash (L) and Steven Stills (R) of Crosby, Stills and Nash, play the Glastonbury Festival.
June, 2009

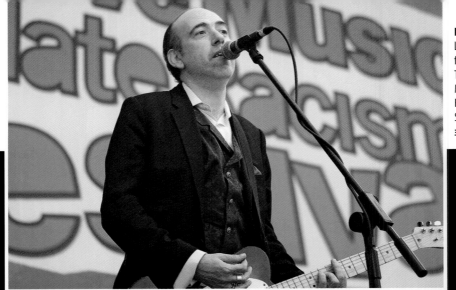

No clash
Left: Mick Jones, former guitarist with The Clash, at the Love Music Hate Racism Festival, Britannia Stadium, Stoke.
30th May, 2009

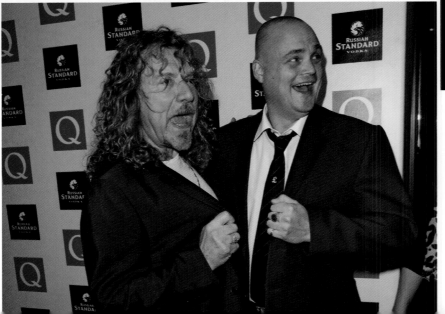

Queuing up
Left: Robert Plant (L), former singer with legendary band Led Zeppelin, and comedian Al Murray arrive for the Q Awards at the Grosvenor House Hotel, London.
25th October, 2009

Coming clean

Stuart Cable, former drummer with the Stereophonics, at the launch of his autobiography, *Demons and Cocktails – My Life with the Stereophonics*, in which he described his addiction to alcohol and drugs. His death in 2010, at the age of 40, was alcohol related.

26th March, 2009

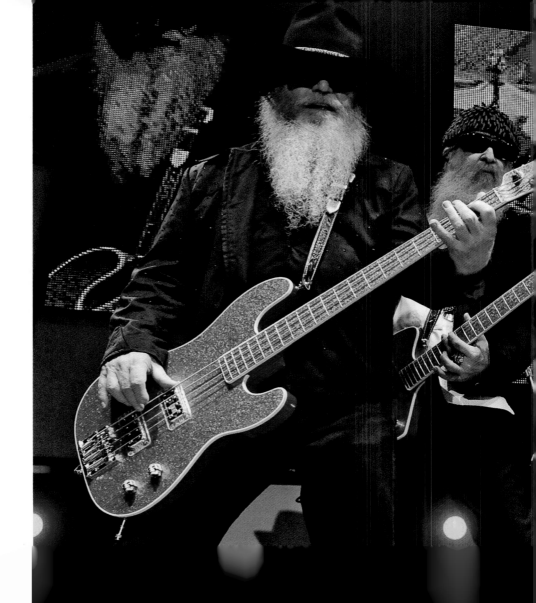

TRIO OF BEARDS
AMERICAN BOOGIE/
HARD ROCK BAND ZZ
TOP IN CONCERT AT THE
WOLVERHAMPTON CIVIC
HALL. L–R: DUSTY HILL
(BASS), BILLY GIBBONS
(GUITAR), FRANK BEARD
(DRUMS; NO BEARD). THE
BAND HAS SOLD OVER
50 MILLION ALBUMS
WORLDWIDE.
27th October, 2009

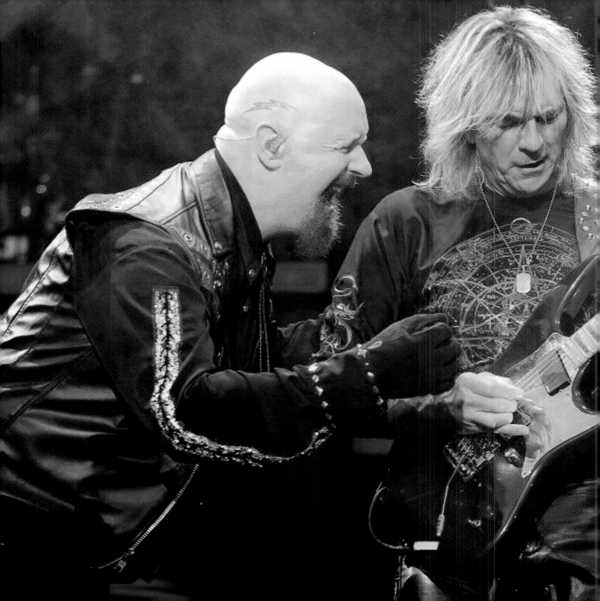

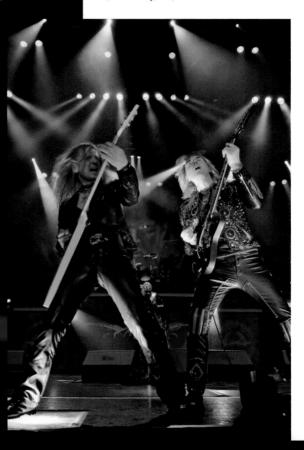

Full volume

Heavy metal/hard rock band Judas Priest rock the NEC Arena, Birmingham. Left: singer Rob Halford raises the decibels with guitarist Glenn Tipton. Below: Kenny Downing (L) and Tipton synchronise their playing.

14th February, 2009

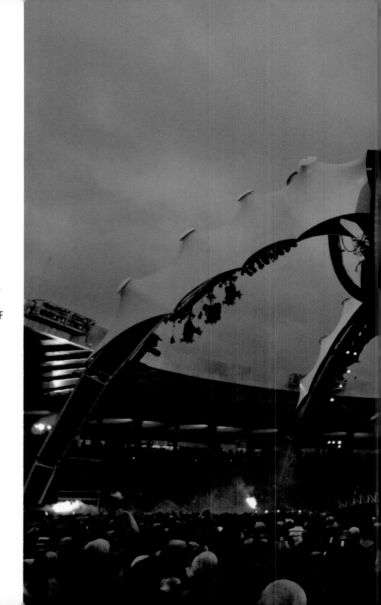

U2 UFO
THE MASSIVE LIGHTING AND VIDEO RIG AT A
U2 CONCERT AT HAMPDEN PARK STADIUM,
GLASGOW. THE GIG WAS PLAYED AS PART OF
THE BAND'S '360°' TOUR, WHICH ALLOWED
THE AUDIENCE ALMOST TO SURROUND THE
STAGE. THE FOUR-LEGGED RIG, NICKNAMED
'THE CLAW', WAS BUILT FOR THIS VERY
REASON. THE STRUCTURE WAS SAID TO BE
THE FIRST OF ITS KIND.
18th August, 2009

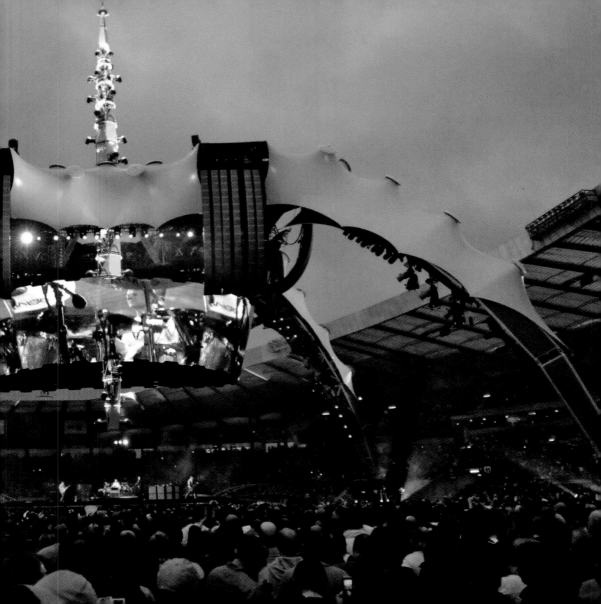

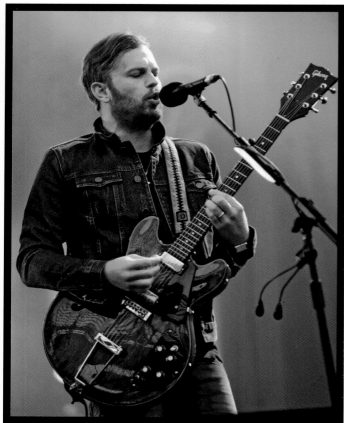

Right: Nick Mason of Pink Floyd at Abbey Road Studios in London, where he was recording a charity album, called *Bandaged Together*, for the BBC's Children in Need appeal. Other stars participating included Bill Wyman, Midge Ure, Roger Taylor, Bryan Ferry, Imelda May, Hugh Cornwell and Peter Gabriel.

2009

In the family

Above: Caleb Followill, on stage with American alternative rock band the Kings of Leon, at Ricoh Arena, Coventry. The band was formed by brothers Caleb, Ivan and Michael with their cousin Cameron.

30th May, 2011

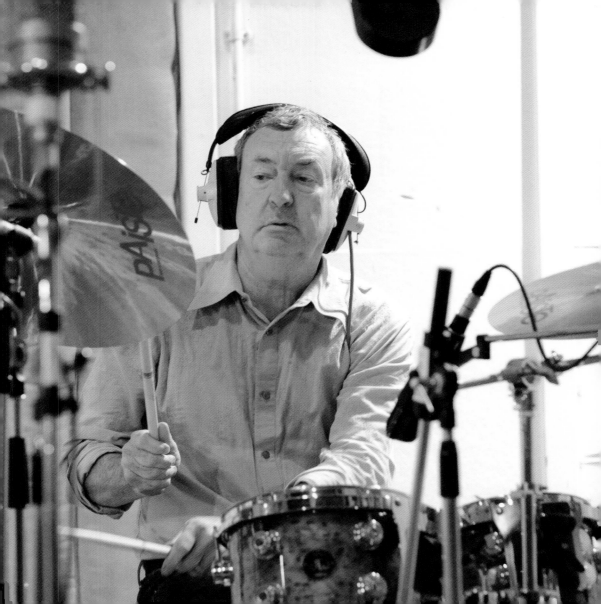

Strokes in the park
American indie rock band The Strokes perform on the NME stage at the Scottish music festival T in the Park, at Balado in Kinross-shire. The band's debut album, *Is This It*, was well received and they have a large fan base in the UK, USA, Canada and Australia.
10th July, 2011

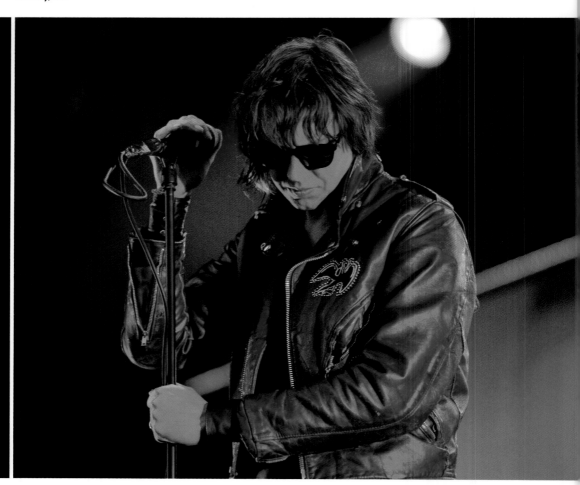

Hair play

Below: Dave Grohl of American band the Foo Fighters on stage during the T in the Park Festival, Balado, Kinross-shire.

10th July, 2011

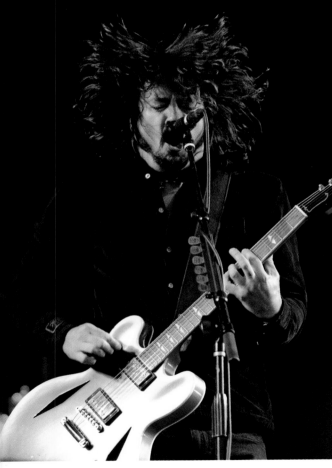

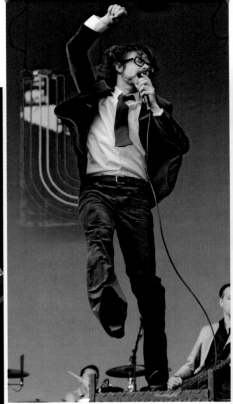

JUMPIN' JARVIS

ABOVE: JARVIS COCKER OF PULP AT THE T IN THE PARK FESTIVAL IN KINROSS-SHIRE. IN ADDITION TO SINGING, COCKER IS ALSO A BROADCASTER, OCCASIONAL ACTOR AND CULTURAL AMBASSADOR FOR THE EUROSTAR INTERNATIONAL TRAIN SERVICE.

10th July, 2011

ROCK The culture in pictures

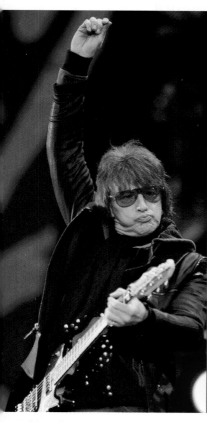

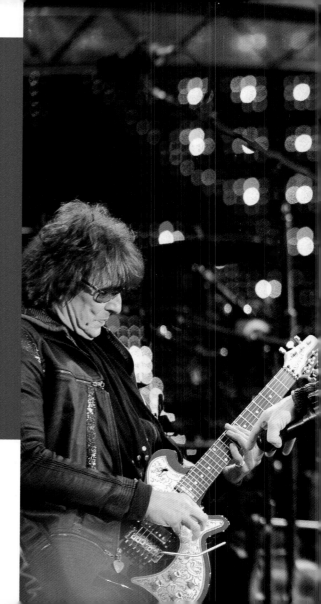

Taking the mike

Above and right: American band Bon Jovi perform at Murrayfield Stadium, Edinburgh. Guitarist Richie Sambora (R) and singer Jon Bon Jovi (far R) have both released successful solo albums. As a band, they have sold over 130 million records worldwide.

22nd June, 2011

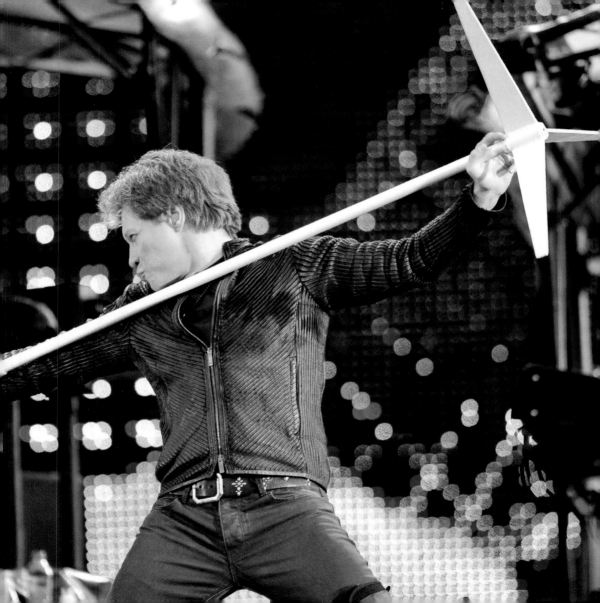

Shock rock

American rock legend and former hell raiser Alice Cooper,
who is now into more leisurely pursuits, such as playing golf.
However, he continues to tour with his horror-inspired act,
which includes guillotines, electric chairs, fake blood and snakes.

6th June, 2011

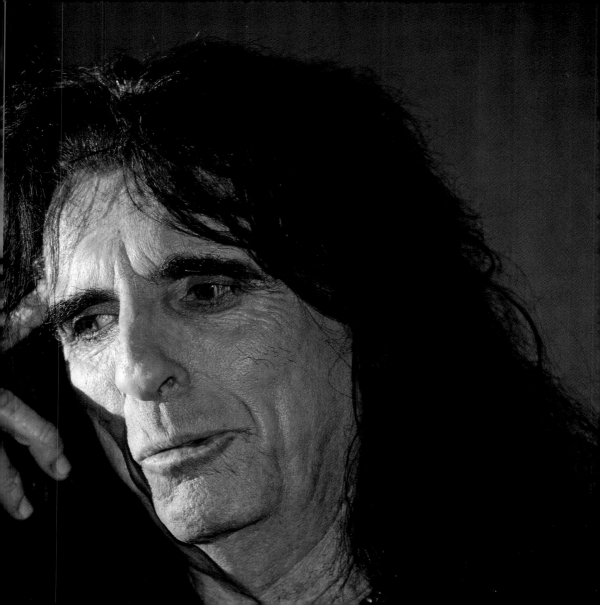

The publishers gratefully acknowledge Mirrorpix, from whose extensive archives
the photographs in this book have been selected.

AMMONITE
PRESS